teamLab

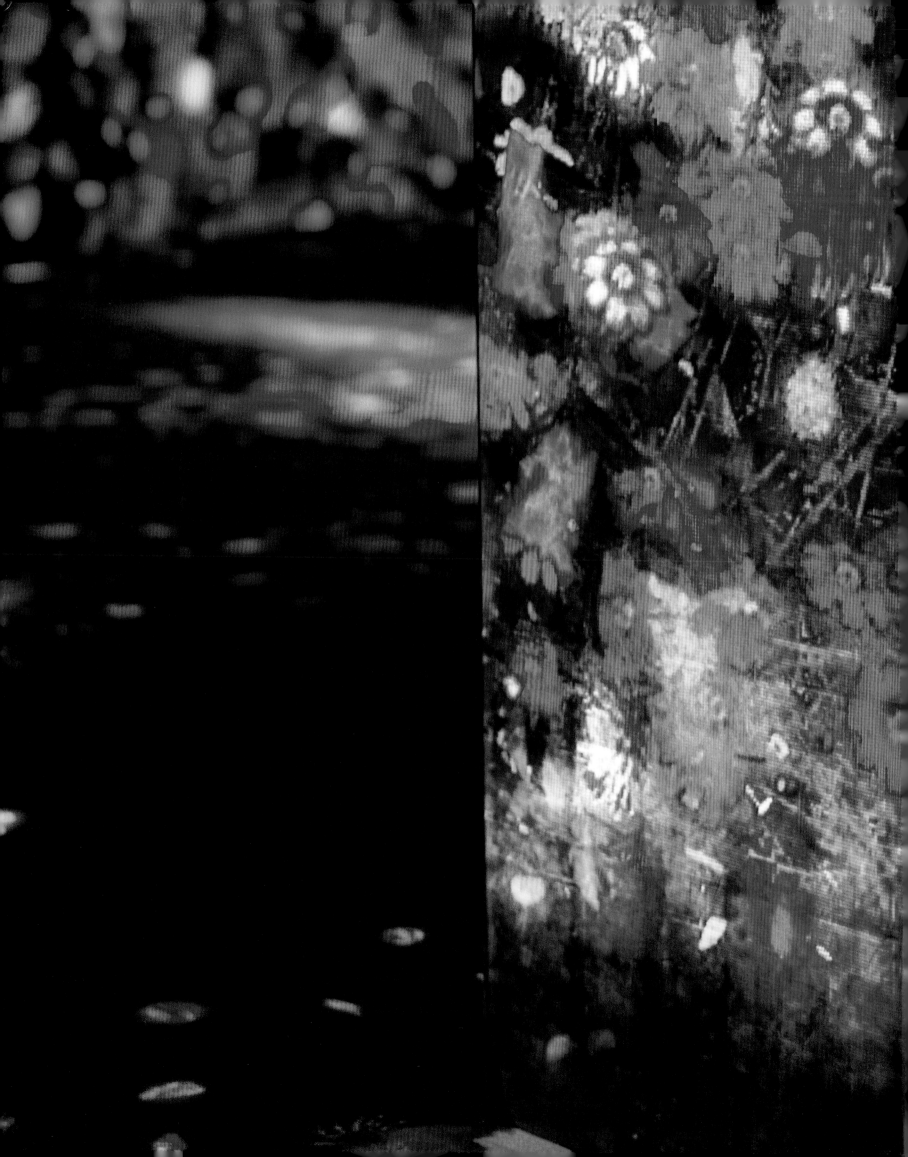

teamLab

EDITED BY
Karin G. Oen and
Clare Jacobson

WITH PHOTOS BY
Yuri Manabe
AND TEXTS BY
Yuki Morishima and
Miwako Tezuka

Asian Art Museum
SAN FRANCISCO

CONTINUITY

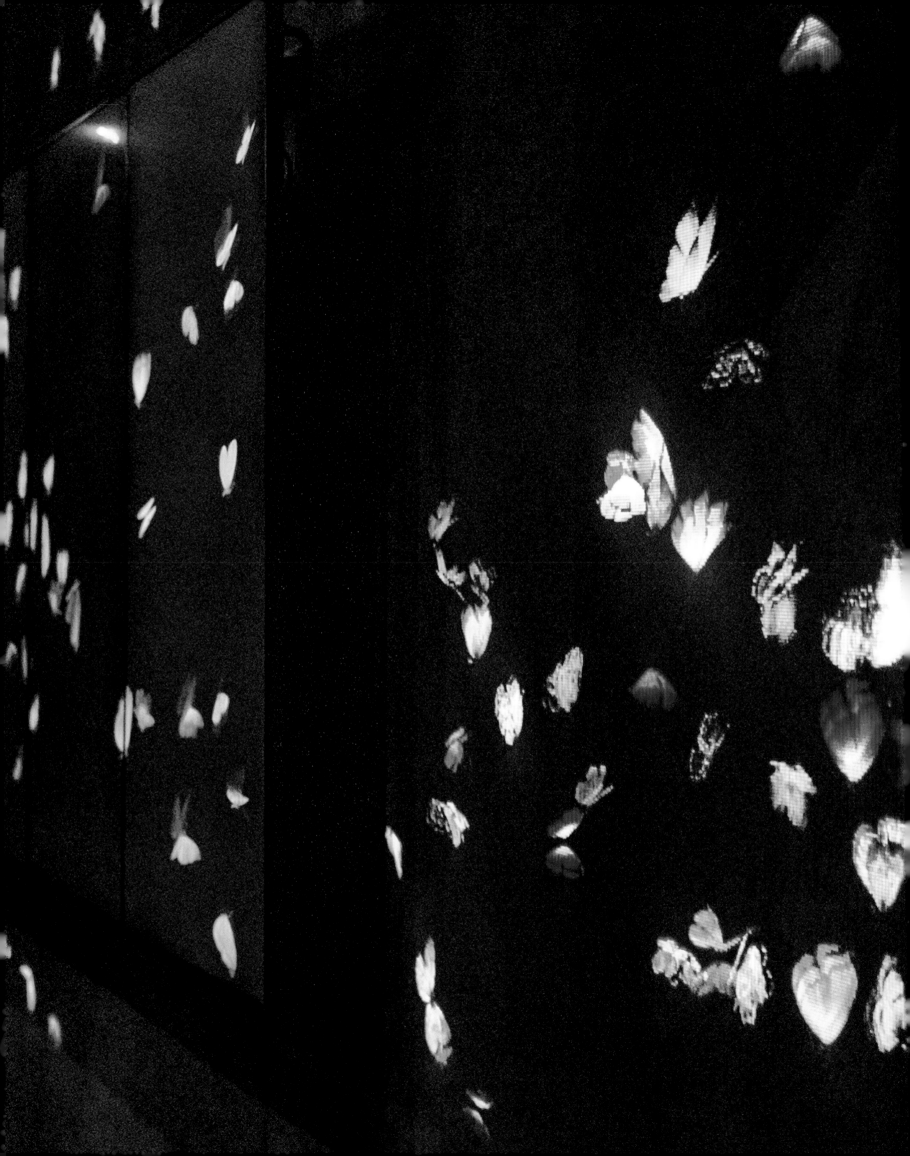

About teamLab

teamLab (f. 2001) is an art collective,
interdisciplinary group of ultratechnologists
whose collaborative practice seeks to
navigate the confluence of art, science,
technology, design, and the natural
world. Various specialists such as artists,
programmers, engineers, CG animators,
mathematicians, and architects form
teamLab.

teamLab aims to explore a new
relationship between humans and nature,
and between oneself and the world through
art. Digital technology has allowed art
to liberate itself from the physical and
transcend boundaries. teamLab sees no
boundary between humans and nature, and
between oneself and the world; one is in the
other and the other in one. Everything exists
in a long, fragile, yet miraculous, borderless
continuity of life.

Foreword

Jay Xu

When I first encountered teamLab's work years ago, I just fell in love with it. It created an experience that I had never had—one that was lively, interactive, and immersive. I applauded teamLab's avant-garde approach that was unique at the time, and still is. I also appreciated that the work had such deep roots in traditional art. In 2015, the Asian Art Museum of San Francisco became the first museum in the United States to acquire teamLab's work.

Our museum chose teamLab for the inaugural exhibition of our Akiko Yamazaki and Jerry Yang Pavilion because we wanted to unveil a new artistic spirit with a transformative contemporary-art experience. For more than fifty years we have been a celebrated institution for traditional, classical Asian art. That is a focus we will continue to sustain and grow. At the same time, we are embarking on a major effort to expand our presentation of contemporary art.

In the past, the museum had produced meaningful projects in the contemporary-art arena. Yet we never had the kind of facility or stage, if you will, upon which we could present larger-than-life programs or exhibitions. For the first time, we have this with the new pavilion. The exhibition *teamLab: Continuity* is a shout-out to our audience that the Asian Art Museum will be a leader in contemporary Asian art.

I am very mindful that we are at the north end of Silicon Valley, which is a capital for innovation. And I think artistic innovation and technological innovation go hand in hand. While teamLab's work is a completely immersive and interactive experience developed out of advanced technology, the stories behind it allude to traditional Japanese art. Forging meaningful organic connections between art of the past and art of the present is an important dimension of the museum's work. In doing so, we can meaningfully connect our world-famous traditional art with our growing strength in contemporary art.

I believe that art museums exist in the interface between academia and the general public, that everything we do must be rooted in and based on the best scholarship. Our job is to translate that scholarship into the most engaging and visitor-friendly experience so that we can serve the larger population. I believe *teamLab: Continuity* has achieved that goal.

Thanks to all the people who made *teamLab: Continuity* possible. To Karin G. Oen, who developed the exhibition over many years and refined it to its successful and engaging completion. To Clare Jacobson, who joined Dr. Oen in producing this, its accompanying catalog. And to the dozens of other staff of the Asian Art Museum of San Francisco who contributed to this important project.

My deep appreciation to Toshiyuki Inoko and the entire teamLab team for entrusting us with their first major museum exhibition in North America. Their creative ideas and willing participation made this project a model for shows to come.

Thanks to Diane B. Wilsey, Karla Jurvetson, M.D., and an anonymous patron for their generous support of this project. I am grateful for the support of Ann and Paul Chen, Sakurako and William Fisher, and Beverly Galloway and Chris Curtis. Special thanks to the Henri and Tomoye Takahashi Charitable Foundation for their support of this publication and of Japanese art-related programs at the museum. I am enormously thankful for the sustained support of the Akiko Yamazaki and Jerry Yang Endowment Fund for Exhibitions, and the Kao/Williams Contemporary Art Exhibitions Fund.

I am ever grateful to Akiko Yamazaki and Jerry Yang for their generous donation that enabled us to construct this world-class platform for launching the next episode of art exhibitions and storytelling. I want to particularly thank Akiko for her leadership and partnership with me, with her serving as the board cochair and also as our campaign committee chair. Her work has been very meaningful.

Finally, I want to thank the museum board and the staff in general for believing in my vision for launching the museum into the twenty-first century with a major push for contemporary art, under the leadership of Abby Chen, head of contemporary art.

Art

in the Age of

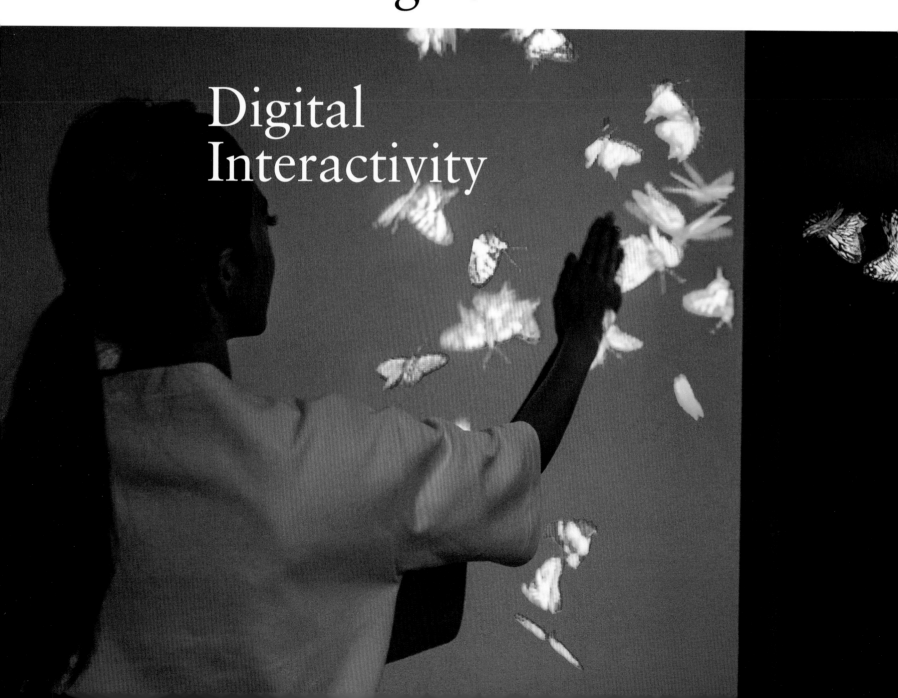

Digital
Interactivity

I

Karin G. Oen

1
Flutter of Butterflies Beyond Borders.

TEAMLAB'S WORLD

At *teamLab: Continuity,* an exhibition at the Asian Art Museum of San Francisco envisioned and designed by the Tokyo-based art collective teamLab, installations cover a vast territory of 1,200 square meters. In one section, visitors enter a small, darkened space, only to find nothing. At least it might seem like nothing. If visitors stand still in this dark room for a moment, they will notice the slow growth of a swarm of butterflies. The colorful butterflies take flight around the room, traveling across flat screens and over the walls (fig. 1).[1] They fly in groups and clusters, flitting about, intersecting with one another, taking indirect paths (fig. 2). The room is rapidly populated with a large swarm of jewel-toned, flapping wings. Eventually, they fly away.

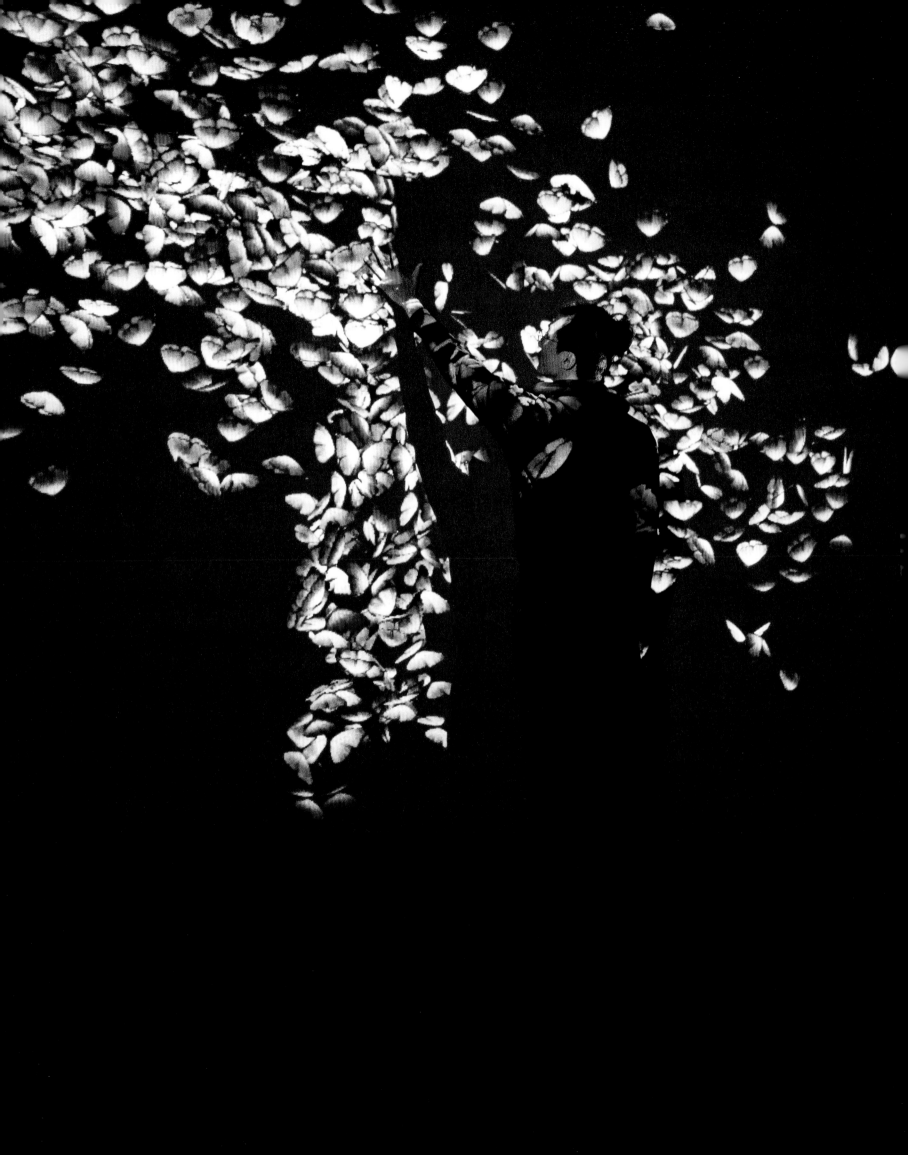

The butterflies are animated in the true sense of the word—lively and lifelike, and a bit chaotic. The visitors' impulse to reach out and touch them reveals that this is not a traditional animation in the sense of a preset movie sequence. Rather, it is governed by a dynamic algorithm that reacts to the physical presence of people in the room. Touching the butterflies (or, to be more precise, touching the area of the floor or wall where their image is projected) kills them. Their flapping wings fold down and the lifeless butterflies fall to the ground, disintegrating or disappearing instantly.

This work, *Flutter of Butterflies Beyond Borders*, encapsulates that which makes teamLab's interactive installations so mesmerizing: they respond to people and they draw visitors into their world intuitively. But the work also acknowledges that death is part of nature—the life cycles of the butterflies end with people. They are only briefly sheltered from their vulnerability to human touch when they fly onto and across an array of screens, which people cannot touch. They behave completely indifferently to this protection and they quickly exit the screens, flying onto the walls nonchalantly. From there, they exit their room, dispersing into a larger, busier installation, *Forest of Flowers and People* (fig. 3).

The logic of the world of these butterflies is similar to that of our real world, although theirs is expressed in a manner that is simpler and idealized. It tells us that nature is beautiful, fragile, and often at the mercy of humans who have the power to both foster and destroy life. Natural life cycles, interconnected ecosystems, and the intertwined relationship between uniqueness and predictability in nature have always propelled teamLab to create art, and the collective's use of technology is a way to truly engage and immerse viewers in their surroundings. teamLab's notable recent exhibition projects—including *teamLab Borderless* in Tokyo (opened in 2018), *teamLab: Au-delà des limites* (Beyond the limits) in Paris (2018), and *teamLab: Continuity* (2020) at the Asian Art Museum of San Francisco—invite visitors to go beyond passively observing works of art. Instead, as unfolds in *Flutter of Butterflies Beyond Borders*, visitors become immersed in the evolution of artworks over time. As in life, they are active protagonists in decentered narratives. They enter and exit *in medias res*.

teamLab holds several core concepts that underpin each of its artworks regardless of their particular subject matter: the digital domain can expand art; the presence of others can create a positive experience; and premodern conceptions of space can affect our perception of the contemporary world. All of these ideas point to embodied experiences as laboratorial experiments.[2] Immersive installations—essentially controlled interpretations of blooming flowers, of strokes of ink, of soaring birds, or of schools of fish—can almost feel like windows into adjacent realms. Each can be episodically explored to a finale, rather than a conclusion, with the option to return, revisit, and re-explore.

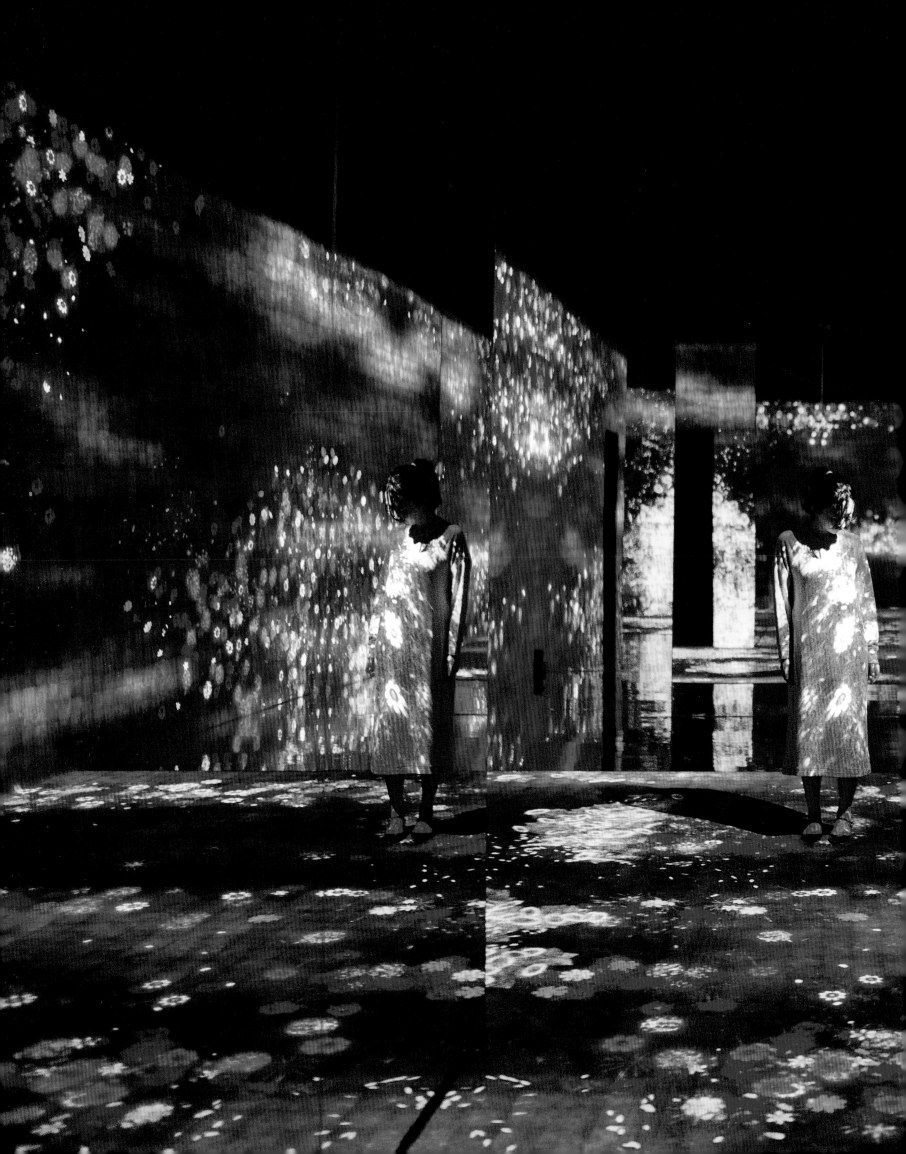

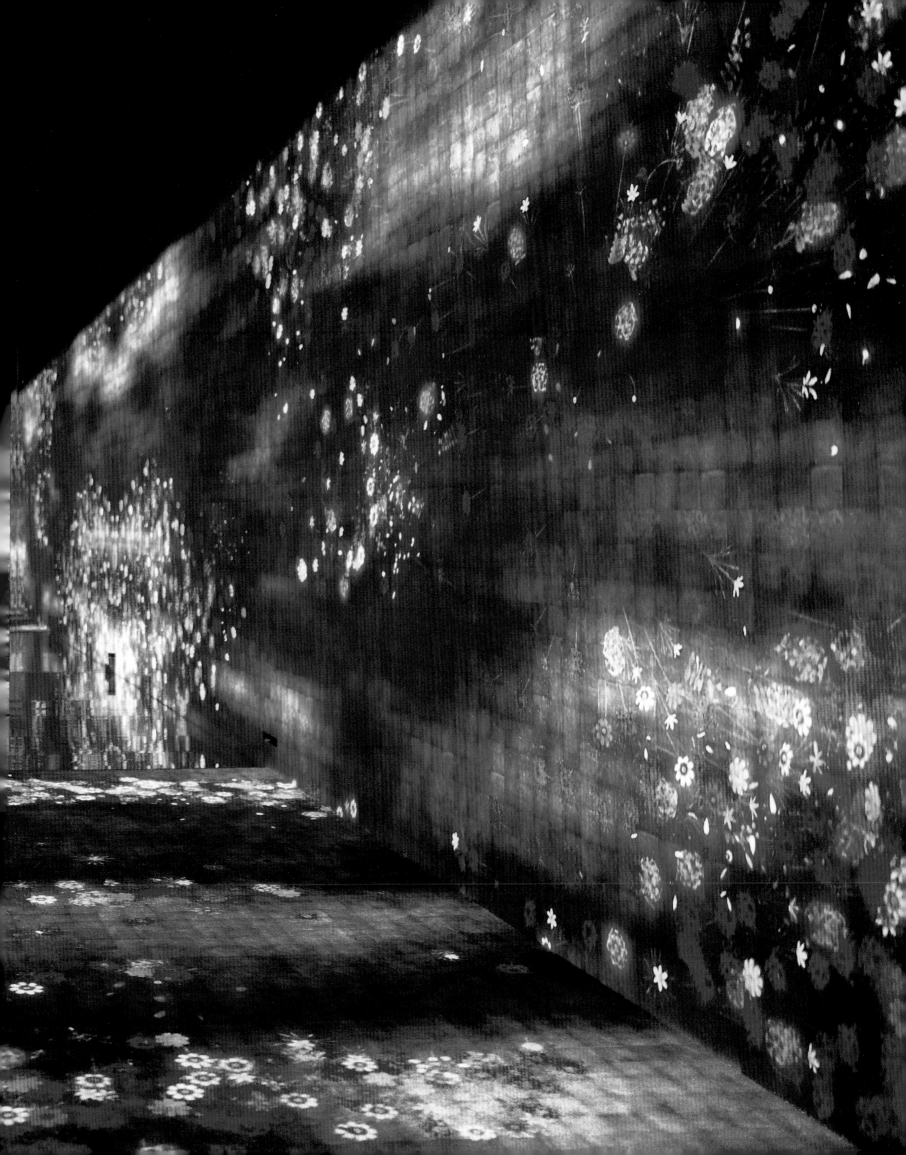

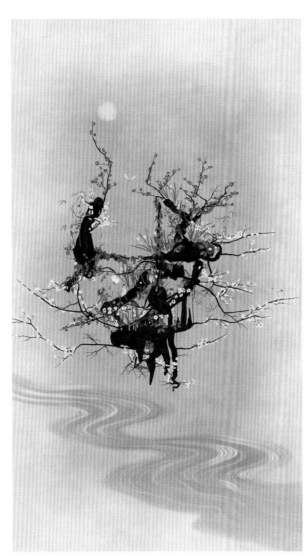
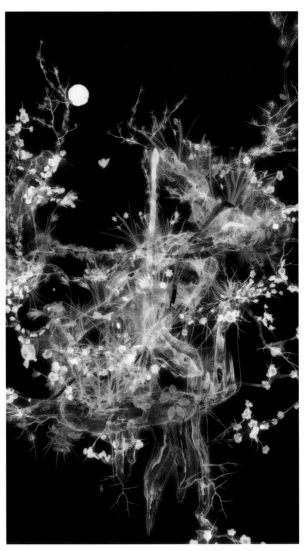

EVOLVING TECHNOLOGY

Often lauded for their full embrace of a digital toolkit, teamLab's team members are quick
to point out that their use of technology is merely a means to an end. They do not want their
art to stand out for its use of computer-generated imagery, although their ability to render
imagery with mesmerizing attention to detail has increased exponentially in recent years.

Take, for example, two works in the Asian Art Museum's collection. The first,
Life Survives by the Power of Life (2011, fig. 4), is a monitor-based work that renders the
Japanese character for "life" in three dimensions. The character, based on the calligraphy of
teamLab's collaborator Sisyu, is delineated with dark "ink" that billows as if it were
vaporizing or partially dissolving in water. Animated on a parchment-colored background,
with a small hazy sun holding its place in an otherwise plain horizon, the strokes of ink are
assembled into a character that resembles a tree in winter. Snow falls and collects on its
"branches" as the character slowly rotates. The snow gradually gives way to the blossoms
of spring, their attendant butterflies, and a faint (then expanding) glistening rivulet. At
the same time, the character grows green pine needles that eventually cover its surface.
This rendition of the abundance of life and its seasonal cycles employs elemental computer-
generated imagery: an idealized painterly quality, bright colors that lack the variations in
hue found in nature, and animation that follows relatively simple laws of motion.

Just three years later, the same character became the central element in the
museum's second work, *Cold Life* (2014, fig. 5). *Cold Life* revisits this character, composed

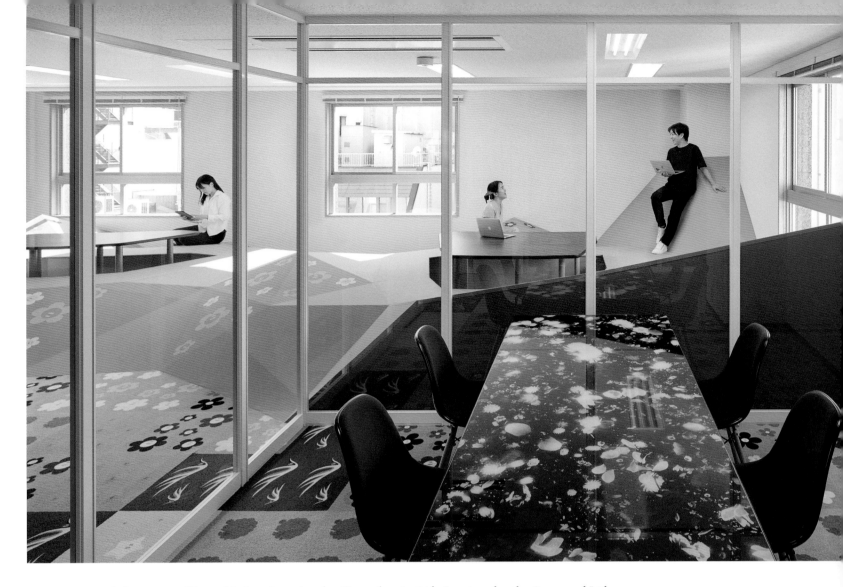

of the same calligraphic brushstrokes by Sisyu that in *Life Survives by the Power of Life* appear to give off ink in the form of liquid or vapor, with an entirely different look and feel. Again the character transforms into a tree that becomes its own ecosystem. It changes with the seasons, becoming a home for flowers, pine, butterflies, and birds. This imagery and its animation are slightly more sophisticated and rendered in a way that reveals more detail than in *Life Survives by the Power of Life*.

But the main difference, as teamLab describes it, is that the character's surface has been "peeled away" to reveal the mesh-like wire-frame structures used to render the image in three dimensions.[3] Taking an existing library of code and revisiting, reexamining, and re-presenting it in different ways has become teamLab's signature mode of artistic production. Adapting previous works to newly available technology, new exhibition venues, and new ideas from team members allows for a type of iterative scaffolding that keeps the art evolving in new directions.

TEAMLAB'S TRAJECTORY

teamLab's digital rendering and its ability to periodically play with imaging opposes the viewer-facing consumption of art that has been active for much of human history. teamLab's founder Toshiyuki Inoko says that his initial impulse in creating art was to find a way to dissolve the boundaries between the viewer and the artwork. In his experience,

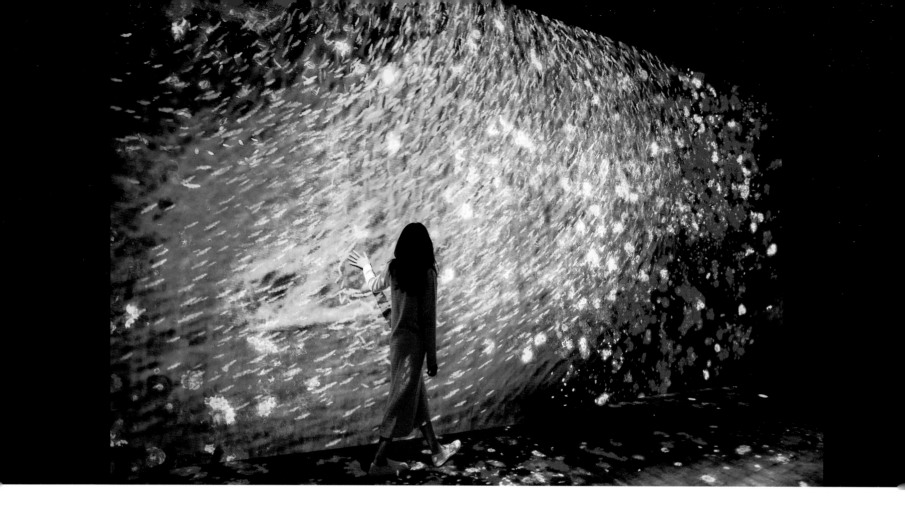

representations—whether on the television or in a photograph—lose something fundamental to the real experience of being immersed in nature or in the bustling metropolis of Tokyo.[4] Creating art that could be experienced through the body rather than consumed visually and intellectually propelled him to assemble a team that works collaboratively to find the answers.

Inoko grew up in Tokushima, on the island of Shikoku, then moved to Tokyo to attend university. Prior to living in Tokyo, his impressions of that city were largely mediated by photography, television, and film—not real, lived experiences. His awareness of his own constructed impressions of Tokyo was made even more keen by his vivid memories of his childhood in Tokushima. Immersed in his natural surroundings, spending unstructured time in forests and on mountains, he felt he was part of the landscape rather than an observer, separate from the scenery.

When Inoko founded teamLab in 2001, he had a goal of creating an experimental, creative collective that could marshal the resources available to it based on its combined talents and the tools at its disposal. As a recent graduate of the department of Mathematical Engineering and Information Physics at the University of Tokyo, Inoko was interested in drawing together individuals with diverse technical backgrounds (including architecture, digital imagery, art history, education, and responsive design) to experiment with images, projects, and venues. Underwritten by commercially viable work, akin to that produced by a creative agency, teamLab has always been a group effort without a traditional corporate hierarchy.

The team members boast hard skills in coding and digital-image rendering that many fine artists do not have at their command, but they are also well-rounded individuals with expertise in a variety of fields. They have diverse backgrounds in terms of age, hometown, and particular interests in art and culture, but they all seem to believe in the conceptual underpinnings of their work and of teamLab as a whole. The office environment

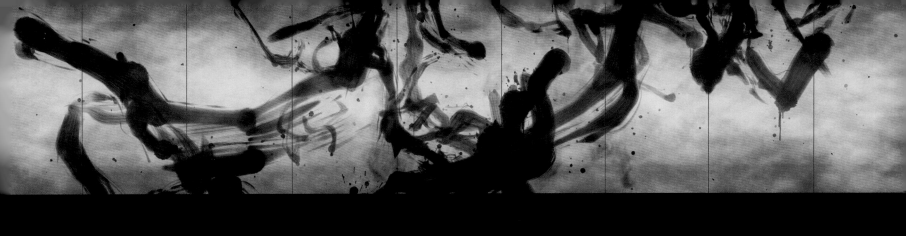

(fig. 6) reflects teamLab's commitment to play, exploration, and collaboration. Team members work together on site rather than remotely. They maintain a start-up's mentality of running the organization lean in order to help fund their ambitious projects.

teamLab began showing work in exhibitions and other public venues, mostly in Japan and occasionally internationally, throughout the first decade of the 2000s. The frequency of its exhibitions increased beginning around 2011, when the number of employees swelled to the hundreds, populating several floors of an unassuming office building in Tokyo. By 2014, when the number exceeded 400, teamLab began to achieve recognition in more traditional art-world venues, including participation in the Japan Society's New York exhibition *Garden of Unearthly Delights: Works by Ikeda, Tenmyouya, & teamLab* curated by Miwako Tezuka. Already in the collection of a few museums in Japan and Singapore, teamLab's work was first collected in North America by the Asian Art Museum of San Francisco in 2015.

In 2017, a shift in teamLab's ability to revisit and intertwine libraries of code created a particularly important watershed moment for the group. It began to realize the idea of transcending boundaries in a visible way, with elements of one installation flying or swimming into another. Since then, these "borderless" installations have been executed on a massive scale in several exhibitions including *teamLab Borderless* in Tokyo. Around the same time, teamLab opened the exhibition *teamLab Planets* in a building that it designed specifically to accommodate a carefully curated sequence of immersive experiences. These included wading into knee-high water while gazing down at projected images of swimming fish.

Inoko's interest in dissolving the borders between people and artwork eventually led teamLab to its current métier—large-scale room-size installations comprising interconnected interactive digital projections. While it might seem that this type of creative team is the product of our Internet-fueled age, when technological convergence allows

for an unprecedented integration of digital systems, there is a much longer history to be considered. The idea of new technologies as factors in theorizing the relationship between humans and their environment has been a component of negotiating modernity in many different times in history. A few comparable theories seem particularly relevant here when considering the unique place that teamLab has come to hold in the cultural landscape. Offered in reverse chronological order, these include the experience economy identified in the late 1990s, the field of media studies that emerged with Marshall McLuhan in the 1960s, the understanding of art in the age of mechanical reproduction articulated by Walter Benjamin in the 1930s, and art historical framing initiated by Giorgio Vasari in the 1500s.

EXPERIENCES IN THE AGE OF EXPERIENCE ECONOMY

Experience has been a critical means of convening people and art during the longer history of art and technology. Caroline A. Jones has explored "the practices and appetites fueling artists' and viewers' commitments to *art as experience*" from nineteenth century world's fairs to the "festal structures" of art biennials.[5] International expositions and world's fairs—offshoots of Enlightenment-era thinking about systematically organizing and consuming knowledge—created a temporary physical manifestation of sensory engagement. Jones's ideas are elucidated by Immanuel Kant's summary of the interconnectedness of experience and understanding: "There can be no doubt that all our cognition begins with experience [*Erfahrung*]. For what else might rouse our cognitive power to its operation if objects stirring our senses did not do so?"[6]

teamLab's experience-based exhibitions are able to thrive in an era affected by a mass cultural shift from tangible, repeatable transactions to something more expansive and impossible to quantify. Breaking away from the model of the art exhibition as a thoughtfully assembled group of individual art objects, teamLab crafted its suite of experiences in exhibitions like *teamLab: Continuity* to engage viewers in rethinking the way people interact with art and with other people.

teamLab's core concepts address some decidedly nonbusiness questions. How does digital technology allow art to express the capacity for change? How might the public nature of exhibitions (and the presence of other people) shift from a negative to a positive characteristic? The approach to these ambitious organizing principles is often associated with selfie-prone Millennials, but this generation's affinity for memorable experiences goes far beyond their social-media channels.

The larger questions raised by teamLab's exploration of digital interactivity, art, and the public sphere are underpinned by a similar type of disruption that has come to define business in the twenty-first century: the experience economy, articulated by B. Joseph Pine II and James H. Gilmore in 1999.[7] Pine and Gilmore investigated the idea of

a value added to potentially straightforward transactions that instead create a much more complicated web of engagements, relationships, and memories.

For example, in teamLab's tour de force *Forest of Flowers and People,* luscious, brightly colored flowers bloom and grow when people stand still, but they wither and their petals fall off and die when people move. The work cannot be removed to a private location and is not meant to be passively observed. Instead it begs to be experienced in a specifically designed space over time. Visitors do not take turns viewing or compete for space, but rather become an integral part of the experience for others, affecting the number of flowers and the speed of their life cycles.

In *Born From the Darkness a Loving, and Beautiful World,* another example of teamLab's inclusive approach, viewers can engage with the work and its imagery regardless of whether they can read the characters. The game-like quality of this work is similar to that of *The Way of the Sea* (fig. 7), where large schools of fish swim across the walls, parting and changing colors when people touch the place where they are swimming. These two works unfold at a quicker pace than the butterflies or flowers and with more immediate results, although all four works operate on the same principle— inclusivity for all ages and all levels of ability that can only be experienced for a limited time in a public venue.

Similarly teamLab's *Reversible Rotation* (fig. 8),[8] a new take on teamLab's long-running series *Spatial Calligraphy* in which works animate three-dimensional renderings of calligraphic ink, strips away the cultural references or lexical meanings that might limit the appreciation of these artworks. The artists present strokes and globules of suspended liquid as studies in the mesmerizing beauty of gradations in black hue and tone. In this way the work can be appreciated by those without insider knowledge of ink painting. As its title suggests, these digital ink studies play with optics, appearing to rotate either toward or away from viewers based on their perspective and what details they focus on. These works are guided by a respect for aesthetic beauty and a sense of sublime wonder, and they are propelled by thoughtfully designed user interfaces and interactions. They appeal broadly to a wide audience rather than an exclusively tech- or art-literate population and reward close looking with details that unfold slowly.

IS THE MEDIUM STILL THE MESSAGE?

It is impossible to avoid the question of the relationship between new media and our media-saturated world when tracing the central phenomenon of teamLab's interactive experiences with respect to the way people come in contact with art and with other people. This speaks directly to the lived evolution of Marshall McLuhan's 1960s media theories, which are still relevant in surprising ways. McLuhan's key observation, three decades before the experience economy and more than fifty years before *teamLab: Continuity,* was that in the modern age

9
Born From the Darkness a Loving,
and Beautiful World.

10
Crows are Chased and the
Chasing Crows are Destined to be
Chased as well.

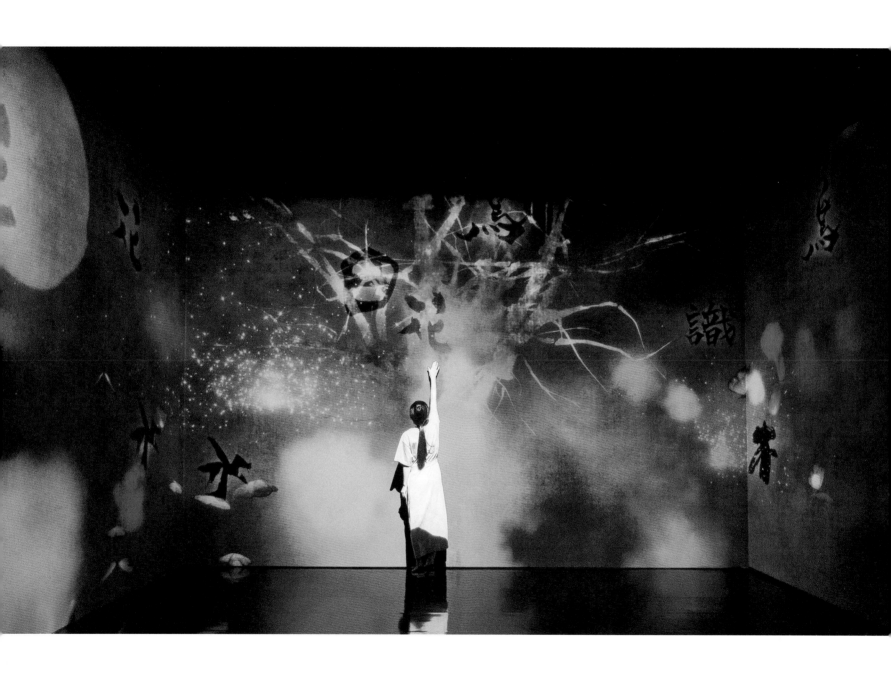

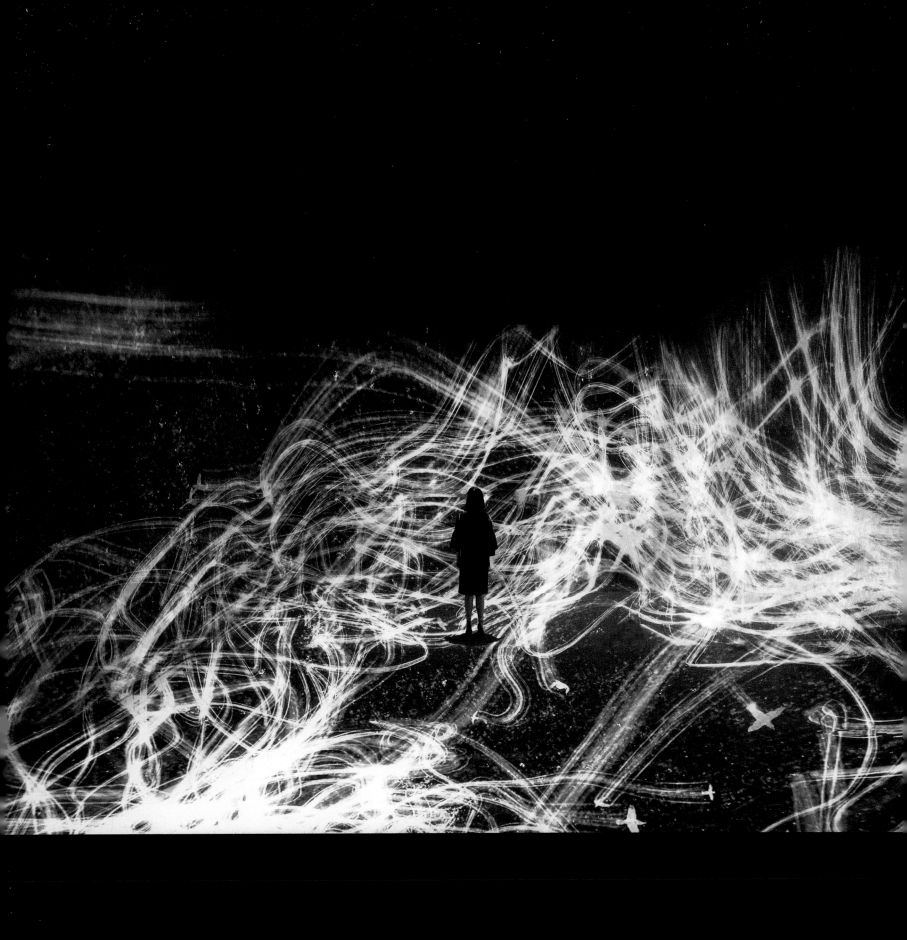

human consciousness was undergoing a qualitative change based on the fusion of individual selves and a global consciousness enabled by telecommunication and broadcast networks. McLuhan wrote:

> During the mechanical ages we had extended our bodies in space. Today, after more than a century of electric technology, we have extended our central nervous system itself in a global embrace, abolishing both space and time as far as our planet is concerned.[9]

In observing shifts in human consciousness and a desire for increasingly networked existences, McLuhan contemplated the pervasive presence of broadcast media. He recognized the new mode of experiencing information simultaneously with hundreds of thousands of others in the age of global telecommunications, and he pronounced that " 'the medium is the message,' because it is the medium that shapes and controls the scale and form of human association and action."[10] This way of seeing the interdependence between the subject and its means of delivery was revelatory.

McLuhan expanded our collective understanding of media by highlighting how an image behaves fundamentally differently when viewed in print versus on a TV screen, or in color versus black and white. He gave the mode of transmission equal status to the image itself. As the media landscape has evolved in the intervening five decades, the questions that come to mind are, What is the medium, and is the medium still the message?

In this age of digital interactivity, when the media of mass communication has become the means of convening opinions and reactions as well as sharing writing and images, the answers seem to revolve around the portability of digital images. A movie screen, a television, a computer, a tablet, and a phone create a range of experiences and modes of social interaction associated with any given still or moving image.

The work of teamLab can be considered in the context of this fundamentally altered terrain, when viewers translate art into portable, casual documentation. teamLab's series of immersive digital installations have been captured extensively in video, photographs, and, particularly, selfies that document the viewer's own immersion in the dynamic colored experience. None of these methods of documentation, or their channels for distribution, can truly capture the sensory experience of teamLab's large installations. While an artwork's medium is, in basic terms, interactive digital installation, often with a soundscape, the modes of interaction between viewers within an installation are key components of teamLab's craft. Is the medium—an interactive installation with a positive social experience—still the message? In an age where technology often separates and isolates people, teamLab's work is not just beautifully rendered imagery and its response to bodies in the room. It is the way this work facilitates a simultaneously social and personal experience.

It should be noted that there is a bias toward the upper-middle class, the young, and the able bodied in both McLuhan's belief that "all technologies are extensions of our physical and nervous systems to increase power and speed"[11] and Pine and Gilmore's experience economy. The digital divide, a massive equity gap between those who have ready

access to information and communications technology and those who do not, is a serious barrier to realizing McLuhan's proposed "aspiration of our time for wholeness, empathy and depth of awareness...[and] a faith that concerns the ultimate harmony of all being."[12]

teamLab's artworks, though similarly oriented toward the upper-middle class and able-bodied consumers, attempt to reorient this divide by creating large public exhibitions that are fueled by technology but do not require visitors to be tech-literate. There is a surprising resonance between teamLab's work and McLuhan's mid-century take on technology as a means of encouraging humanity's wholeness and empathy. Both offer an optimistic outlook influenced by a technological convergence at a much greater scale than was previously possible.

The interactivity of both *Flutter of Butterflies Beyond Borders* and *Forest of Flowers and People* relies upon viewers' increasing awareness of how their movements affect the behavior of the projected images. This is also true in the work *Born From the Darkness a Loving, and Beautiful World* (fig. 9), an installation with animated Japanese characters executed in calligraphy. The characters transform when touched into images based on their meanings. *Crows are Chased and the Chasing Crows are Destined to be Chased as Well* (fig. 10), a beautifully choreographed intersection of silhouetted crows' flightpaths that become chrysanthemums, is similarly centered on visitors even though it is not interactive in a way that yields immediate visual change. An "experiment in visual experience," *Crows* combines distortions of space employed by pioneering Japanese animators and premodern Japanese painters.[13] Dense depictions of the three-toed crow *yatagarasu*, a symbol of divine intervention, are followed by trails of light, creating a stark contrast. Reacting to the location of visitors in the installation, the timed, choreographed sequence is rendered in real time as the entire room seems to turn and warp around the visitor.

ART AND TECHNOLOGY, A LONGER HISTORY

Thinking back even further to historical watershed moments in the relationship between the public experience of art and the appearance of new image technology, Walter Benjamin's writing in the early twentieth century also touched on the notion of collective responses. Benjamin observed a significant difference in the way humans perceived the world since the advent of film and photography:

> Just as the entire mode of existence of human collectives changes over long historical periods, so too does their mode of perception. The way in which human perception is organized—the medium in which it occurs—is conditioned not only by nature but by history.[14]

Where McLuhan, writing approximately thirty years later, theorized a shift in human consciousness, Benjamin detected a shift in the "mode of perception." He considered how the mediums of film and photography had changed the way images were made and viewed, and particularly how this affected works of art. According to Benjamin, the "aura" of a

traditional work of art, comprised of its authenticity, originality, and uniqueness, was fundamentally diminished or eliminated when reproduced. Simply put, "by replicating the work many times over, it substitutes a mass existence for a unique existence."[15] This concept of a "mass existence" for a work of art correlates with earlier Marxist theories around capitalist modes of production and speaks to the social and political conditions under which "the masses" experienced art. Benjamin wrote that the decline of aura was directly linked to "the desire of the present-day masses to 'get closer' to things, and their equally passionate concern for overcoming each thing's uniqueness."[16]

Benjamin was thinking of reproductions in illustrated magazines and newsreels. Yet his words are equally interesting in considering smartphones, their embedded cameras, and many social-media platforms that can be instantly deployed to share user-generated "reproductions" of art. It is striking that the aura of which Benjamin wrote is largely intact, or at least re-created, in visitors' images of teamLab artworks despite the fact that the interactive digital installations demand immersion and personal engagement. The works' complex media work well when elements of the experience are documented, although the exhibitions as a whole resist reproduction. Neither video nor photography nor sound recording can come close to capturing the full-body, sensory engagement in a public, social setting. Still, the snapshots and snippets of video taken as souvenirs provide a connection to the embodied experience and social interaction. Perhaps what Benjamin saw as degradation—a work of art that went from a unique to a mass existence when reproduced—is replaced with a sort of amplification when the medium itself is inscribed with its own reproducibility.

CROSSING BOUNDARIES

teamLab's immersive, interactive exhibitions—although designed with focused intention that speaks to the culture of the experience economy as it manifests itself in the twenty-first century—have an event quality that appeals to the general public. This is certainly not an exclusively contemporary phenomenon. It brings to mind the type of engaged and educated but amateurish audience that Giorgio Vasari had in mind when he wrote *The Lives of the Most Excellent Painters, Sculptors and Architects* in 1550, a founding art historical text. The book provided context and built appreciation for individual artists' technique and style, and it was written for a broad readership. Yet nineteenth-century English translations of the Italian original tended to formalize the writing to better serve a professional audience of art connoisseurs, a relatively new category at that time.

The rigor and critical apparatus of the field of art continue to flourish today. Yet the parallel worlds of the art experience and art historical framing are entirely dependent upon one another. It is important to note that the appeal of teamLab's art—which combines aesthetics of the world of gaming and science fiction with elements drawn from historical Japanese art—is just one example of this interdependence.

teamLab has managed to deftly incorporate this complicated idea of interconnected systems into both its artwork and its collective work structure. At the same time, its installations address the persistence and continuity of both nature and culture over long periods of time. The interdependence of parallel art worlds, of the spheres of art and technology, and of the realms of nature and culture depend upon not just cohabitation, but also understanding that these seeming dualities are actually hybrid systems.[17] In our current hybrid state, relying upon but not yet physically fused with our technology, it is particularly refreshing to think about boundaries, and the productive blurring of boundaries, as both necessary and enjoyable. The boundary-crossing nature of teamLab's work offers us a chance to do both in a manner that is subtle and enjoyable, and quietly revolutionary.

1 Unless otherwise noted, images of teamLab works in this essay were shot at *teamLab Borderless,* Tokyo. The works are similar to those shown at *teamLab: Continuity.* Throughout this essay, shortened titles are used to refer to these artworks. For complete information on works shown at *teamLab: Continuity,* see the Exhibition Checklist on page 148.

2 For statements on these core concepts authored by the artists themselves, see teamLab's comprehensive catalog of works: teamLab, *teamLab 2001–2016* (Tokyo: teamLab, 2016), 4, 38, 55.

3 Ibid., 78.

4 See "Inside teamLab: Blurring the Border between the Self and the World" in this volume.

5 Caroline A. Jones, *The Global Work of Art: World's Fairs, Biennials, and the Aesthetics of Experience* (Chicago: University of Chicago Press, 2017), 86.

6 Immanuel Kant, *Critique of Pure Reason [Kritik der reinen Vernunft],* trans. and ed. Paul Guyer and Allen W. Wood, 2nd ed. (1781; repr. Cambridge, UK: Cambridge University Press, 1998), 43, quoted in ibid., 195.

7 B. Joseph Pine II and James H. Gilmore, *The Experience Economy: Work Is Theatre & Every Business a Stage* (Boston: Harvard Business School Press, 1999).

8 *Reversible Rotation—Cold Light,* featured in the exhibition *teamLab: Continuity,* differs from *Reversible Rotation—Continuous, Black in White,* the work pictured here and throughout this book. Most noticeably, *Reversible Rotation—Cold Light* presents ink-like strokes of light on a

dark background instead of strokes of black ink on a light background.

9 Marshall McLuhan, *Understanding Media: The Extensions of Man* (New York: Mentor, 1964), 11–12.

10 Ibid., 9.

11 Ibid., 90.

12 Ibid., 66.

13 "Crows are Chased and the Chasing Crows are Destined to be Chased as Well, Division in Perspective—Light in Dark," in teamLab, *teamLab 2001–2016,* 126.

14 Walter Benjamin, *The Work of Art in the Age of Its Technological Reproducibility and Other Writings on Media* (1936; repr., Cambridge, MA: Harvard University Press, 2008), 23.

15 Ibid., 22.

16 Ibid., 23.

17 Donna J. Haraway, writing in the 1980s, transformed the conversation around feminism and bio-politics with "The Cyborg Manifesto," including this useful introductory passage, "The cyborg is a condensed image of both imagination and material reality, the two joined centers structuring any possibility of historical transformation." She goes on to declare that "this essay is an argument for pleasure in the confusion of boundaries and for responsibility in their construction." Donna J. Haraway, "The Cyborg Manifesto" (1985) in *Simians, Cyborgs and Women: The Reinvention of Nature* (New York: Routledge, 1991), 150.

Toshiyuki

Inoko

Founder

Blurring the Border between the Self and the World

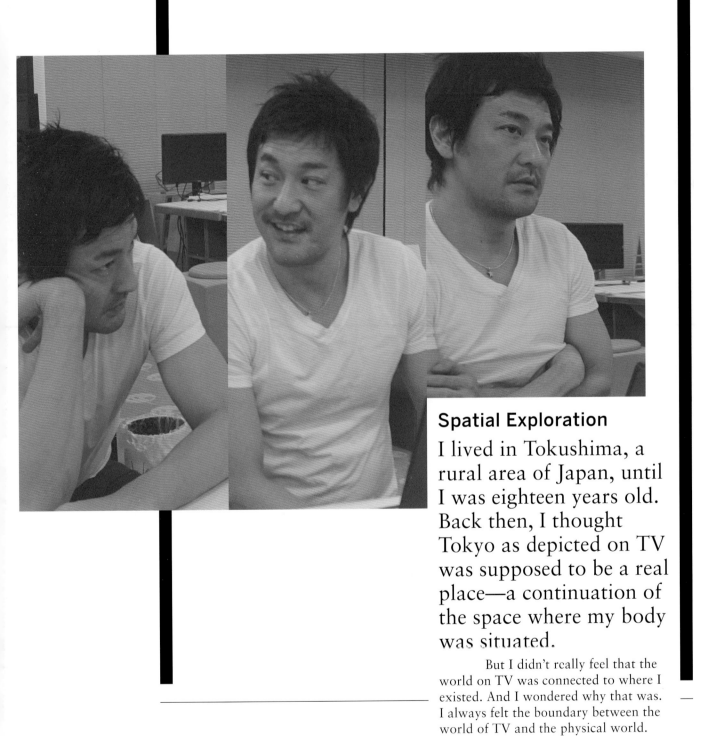

Spatial Exploration

I lived in Tokushima, a rural area of Japan, until I was eighteen years old. Back then, I thought Tokyo as depicted on TV was supposed to be a real place—a continuation of the space where my body was situated.

But I didn't really feel that the world on TV was connected to where I existed. And I wondered why that was. I always felt the boundary between the world of TV and the physical world.

When I went to the mountains as a kid, surrounded by trees, I experienced something really immersive. I was amazed by it and I wanted to capture it and record it. But the experience I had in the forest was completely different from what I could capture in a photograph.

When I looked at premodern East Asian paintings, I was told that the images were intentionally flattened in a different way than works that used perspective. I started thinking it was not that the people in historical times flattened a physical space onto the surface of the paper. But it was actually the way they saw the space around them and then drew it. There was a logical structure to that space, just like in photography. I have been trying to explore that.

Founding teamLab

I founded teamLab in 2001 and began creating 3-D models of space within computer space. We tried to project that space onto a 2-D surface in a different way, much like that of premodern East Asian paintings. In the early 2000s, teamLab started to create artworks based on the idea of ultrasubjective space, analyzing works of the past. At that time computers weren't so powerful, so teamLab created only one piece every two years or so. Works we created around 2002 don't exist anymore. The earliest remaining piece, a video work, is from 2004.

By exploring the concept of ultrasubjective space, I thought I could create an experience where the boundary between ourselves and the world around us kind of disappears. But people didn't really get it. In 2014 we had an exhibition at Pace Gallery in New York titled *teamLab: Ultra Subjective Space*. But the audience said they didn't understand it at all.

I kept wondering why that was. I thought instead of approaching the piece as a visual perception of space, I would think of other ways to compel people to a boundless, borderless experience. In 2010, and especially in 2014, I started to do more projection-based pieces. It enables people to feel that they are actually walking inside the work of art instead of watching from outside. The world being projected feels like it's beyond the wall.

Artistic Influences

There's no particular artist or work that I am inspired by. I was trying to find a fundamental, universal logic of capturing the world of space. But there are pieces we made that make reference to or are particularly inspired by certain artworks.

Flowers are Crimson from 2005 is inspired by *Chōjū-jinbutsu-giga* (Scrolls of Frolicking Animals) from the twelfth and thirteenth centuries. The four hand scrolls were created by different people and are early examples of anime and manga illustration. Their marching animals also appear at *teamLab Borderless*, which teamLab opened in Tokyo in 2018.

Nirvana, 2013, was inspired by the screen paintings *Birds, Animals, and Flowering Plants in Imaginary Scene* and *Trees, Flowers, Birds and Animals* by Itō Jakuchū (1716–1800). *Flowers and People* has evolved a lot over the years, but one of its inspirations was the Rinpa painting *Morning Glories* by Suzuki Kiitsu (1796–1858). In Rinpa paintings, the framing or composition within the panels doesn't really matter. It's almost like those flowers infinitely expand, and the painter just cut out one section of it. In that sense, it's really similar to the way we look at the visual world.

Digital and Physical Worlds

When I entered college, the world was being connected through the Internet. I found that somehow romantic. I was excited about the new world that would be created. I started to focus on digital art rather than just painting with oil or casting a sculpture.

At the same time, I recognized that people were trying to understand the world through TV, photography, or, later, YouTube. But I found that situation—similar to that of looking at painting or sculpture—different from how I thought it should be: humans looking at the world through movement. I thought people were giving up on their bodies in order to understand the world logically. It's strange to see that that has become the standard way of looking at things. For similar reasons, virtual reality doesn't really interest me at the moment.

I'm not interested in the latest technology. If you're a painter and there's a new line of oil paint, you'll try it. But it's not like you're always looking for a new product to arrive. But *teamLab Borderless*, since it's so complex, required that we use new technology and create a new sort of foundation to operate the whole thing.

Permanence and Impermanence

Many of our installation pieces have been revisited and realized in more than one way. That's just us wanting to continuously create something new. It's the nature of the creative process.

Still, preserving and maintaining the previous versions are important for us. We have been working to create a system to archive the work. I hope that in a hundred years, two hundred years, people will still be able to see our works. What we create is something that represents our time. And we hope that what we do is somewhat meaningful to human beings. Maybe what we create affects the aesthetic standard of our time, which may change the way we behave or think about the world. We want to be looked at as a moment that changed human history.

Yet impermanence is something really natural in the way we see the world, the way we are. We are most interested in blurring the border between the self and the world. And we're curious why it's so difficult to recognize ourselves as a part of the world. We exist in a long, long continuity, and time is always continuous. But we tend to think about time within our lifespan—not beyond. A hundred years, a thousand years—it's difficult to grasp that. I wanted to go beyond that limit.

We have an annual outdoor exhibition, *A Forest where Gods Live*, in Saga. It's at a vast garden that incorporates the surrounding mountain and forest. We have about twenty artworks there. At the beginning I didn't know why I was so intrigued by the landscape, although the place was obviously powerful. We once presented an artwork on a waterfall, deep in the mountains of Shikoku Island. There I realized it was not the waterfall but the shape of rock created by the waterfall over a long period of time that allowed us to transcend our typical perception of time. In *A Forest where Gods Live*, there are many boulders formed over millions of years. We used one of the largest in an artwork, and on it our flowers bloom and scatter in very short cycles, influenced by the visitors.

This text is edited and excerpted from an interview with Karin G. Oen on December 22, 2018, with consecutive interpretation by Kazumasa Nonaka.

FOREST OF FLOWERS AND PEOPLE

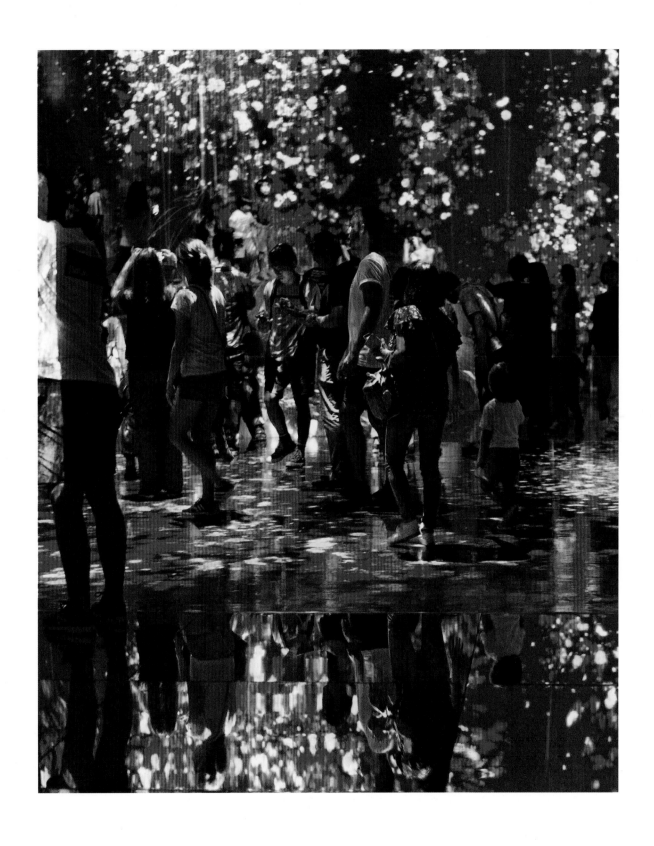

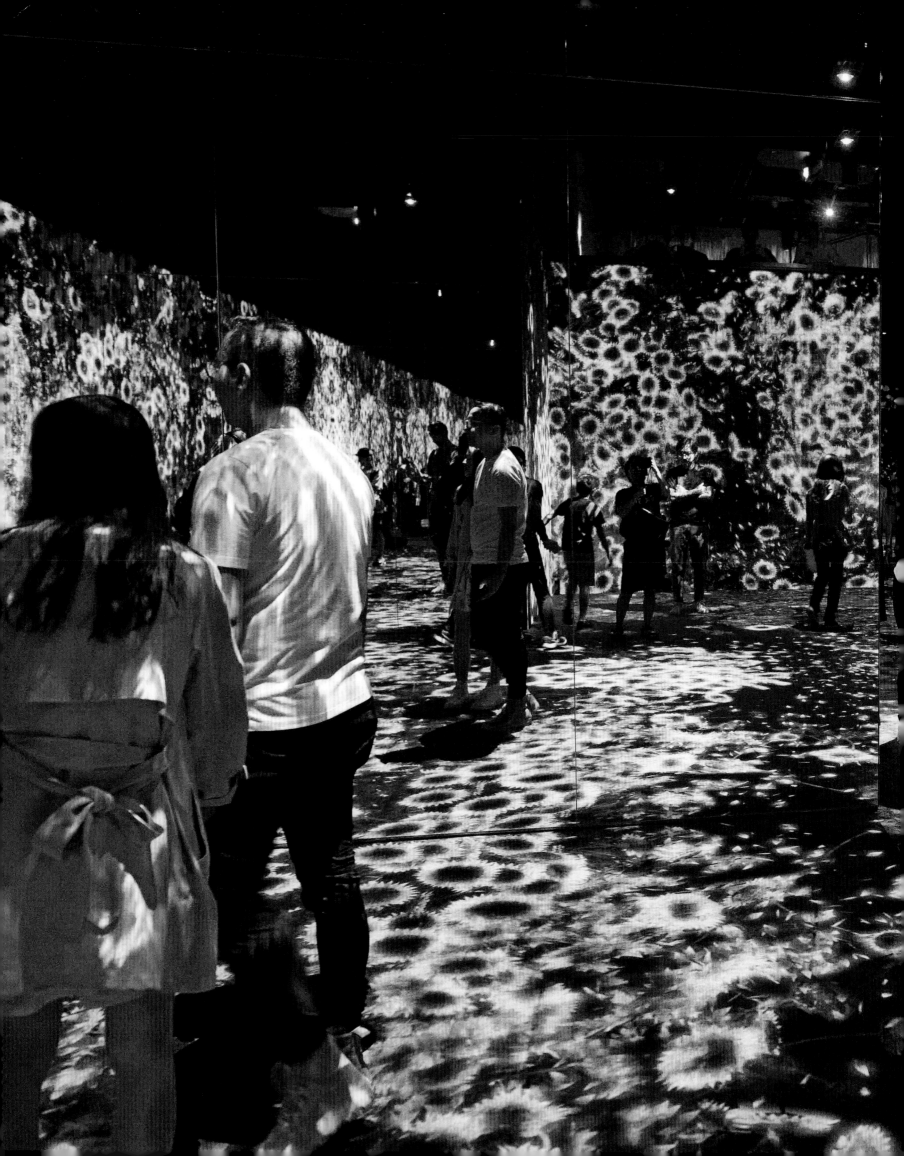

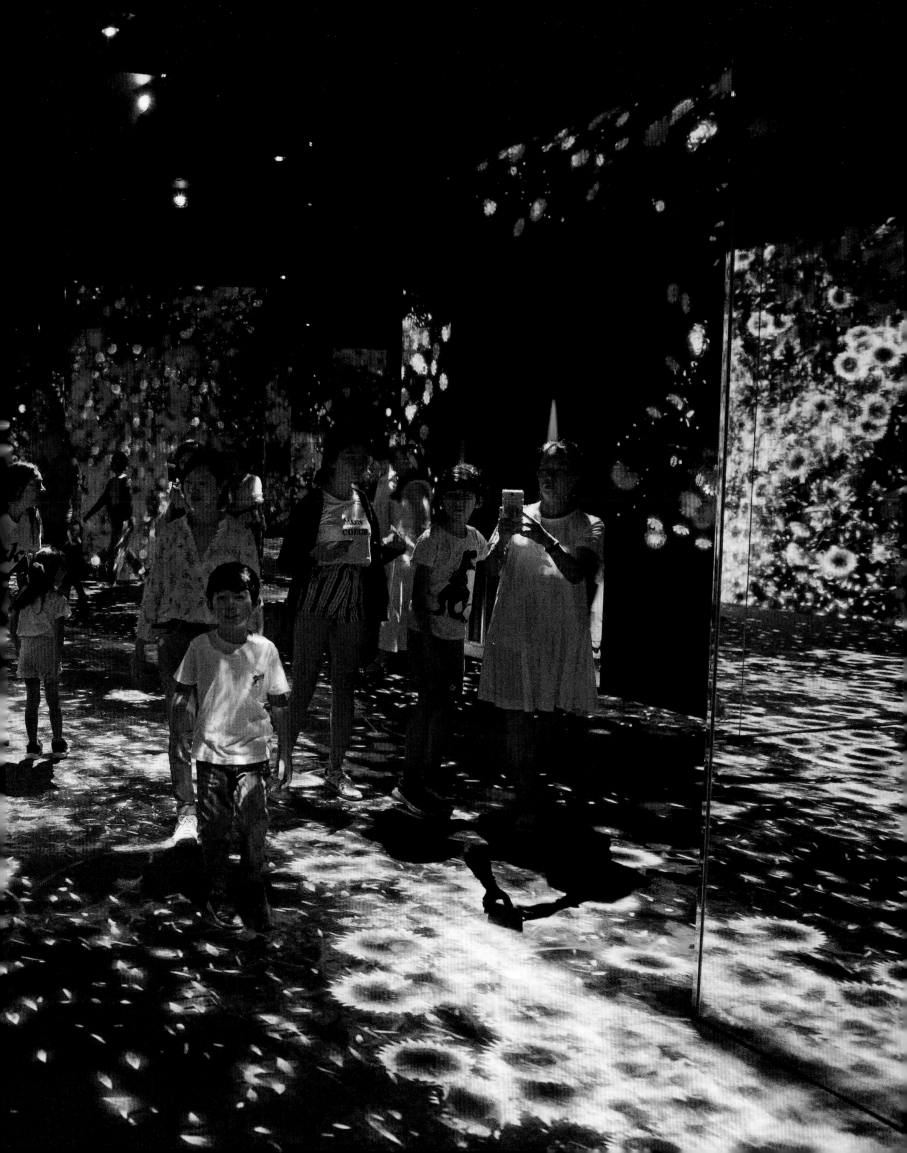

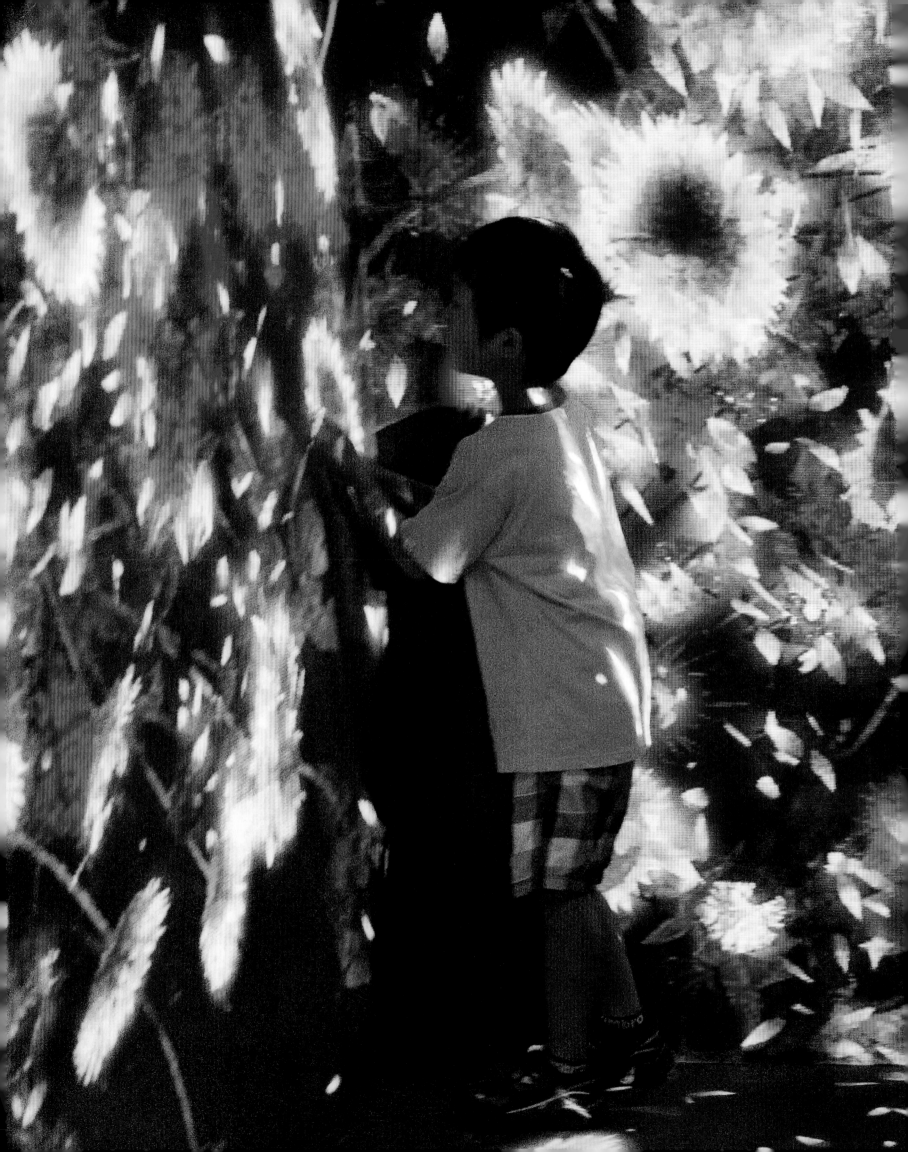

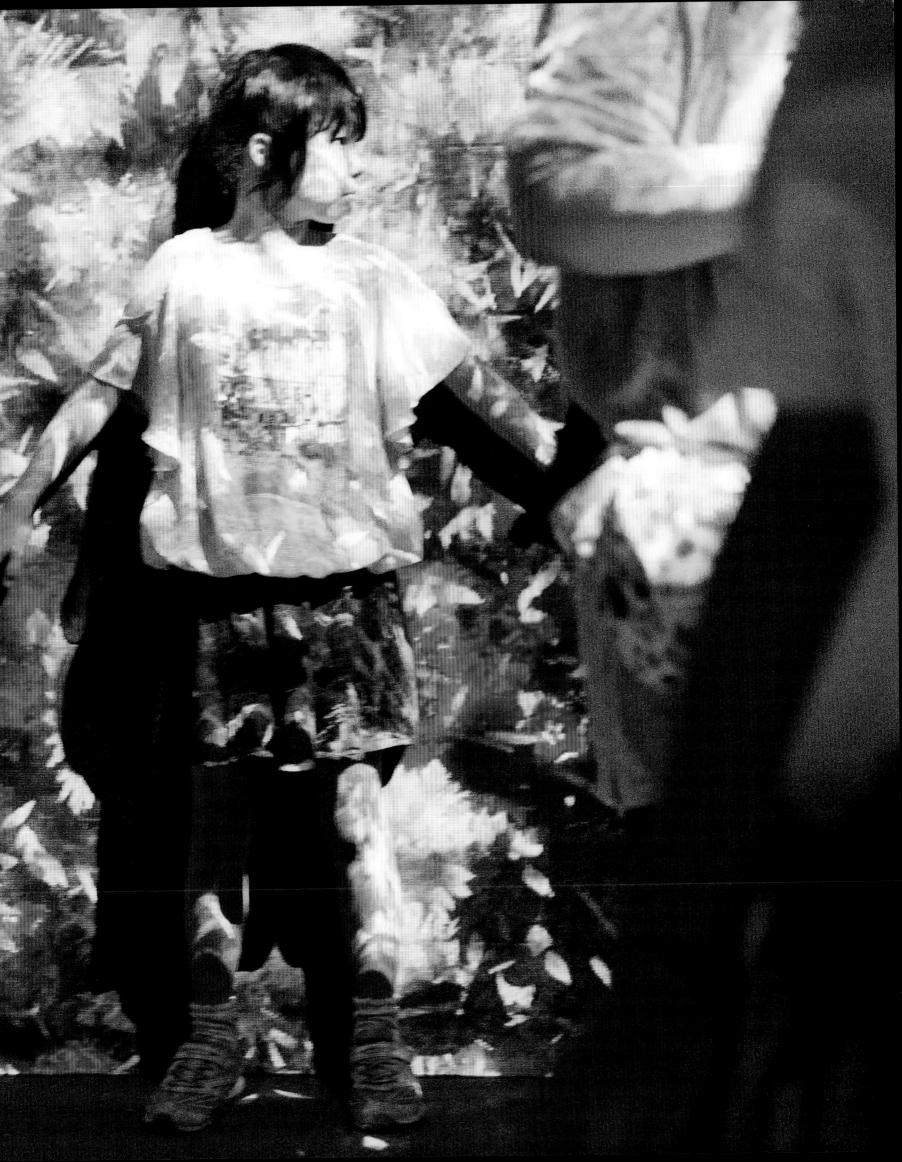

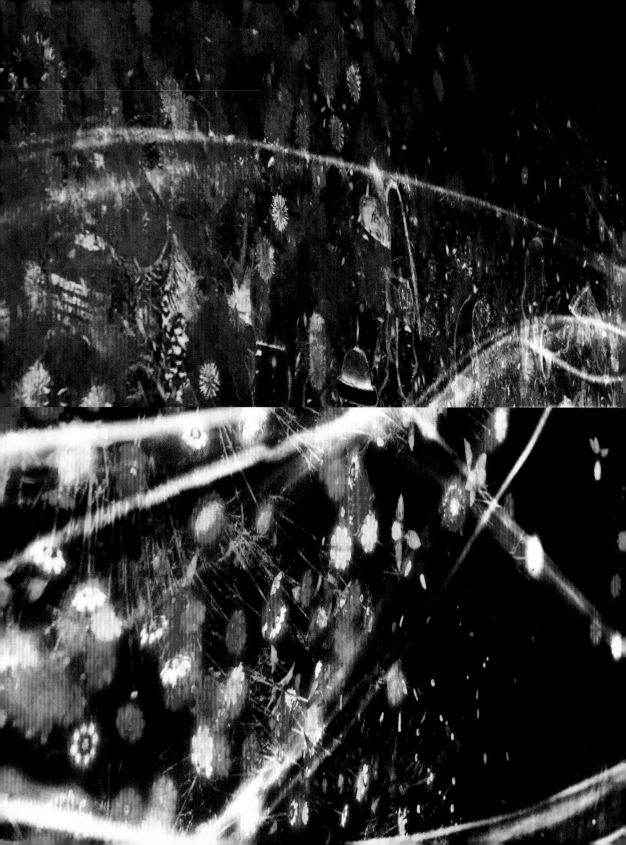

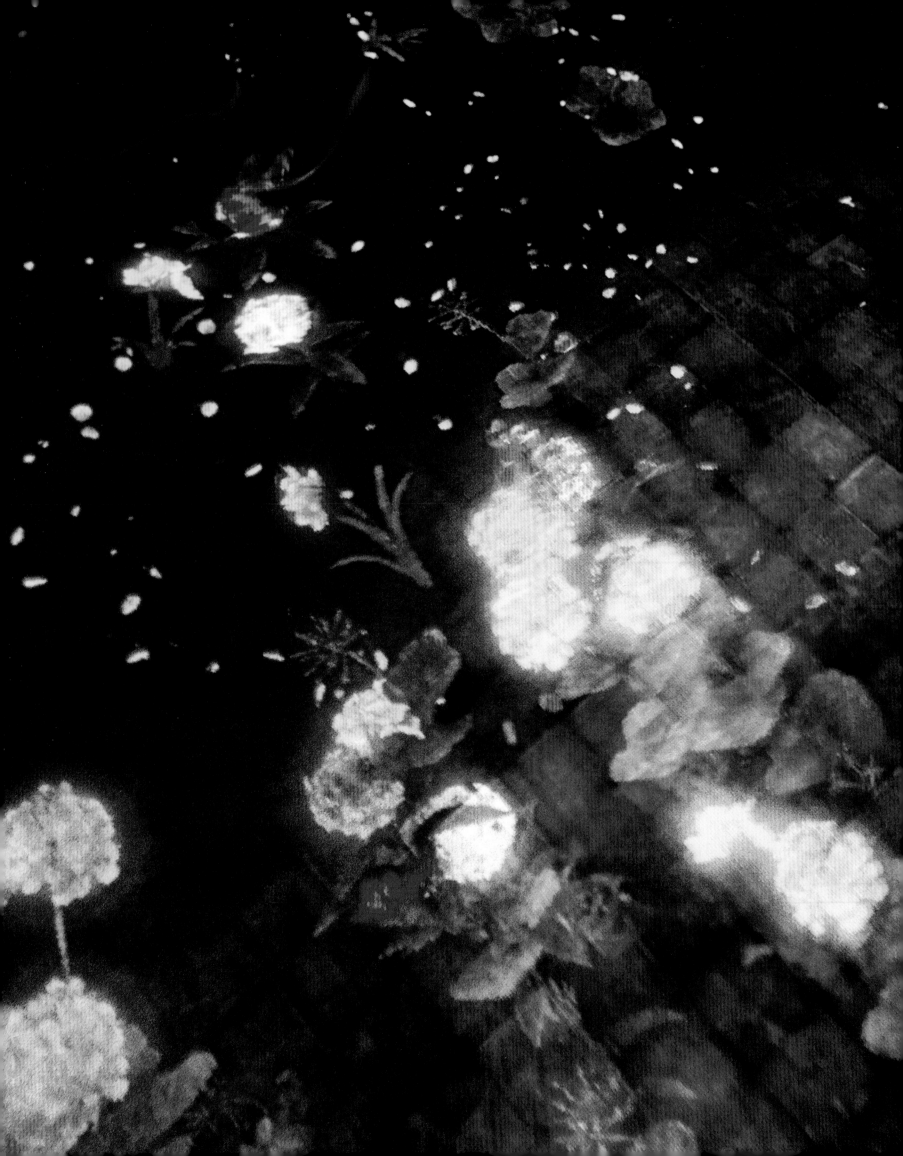

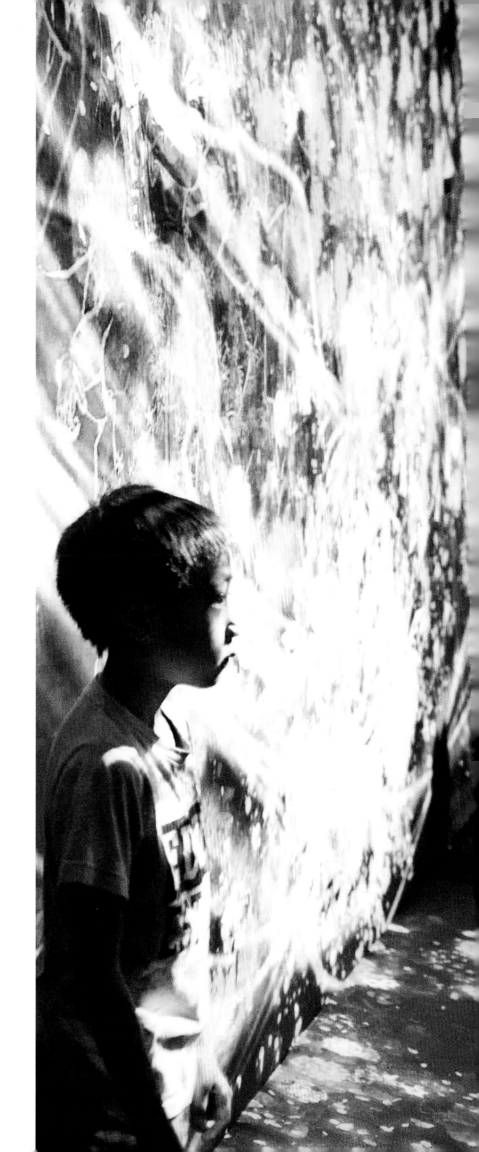

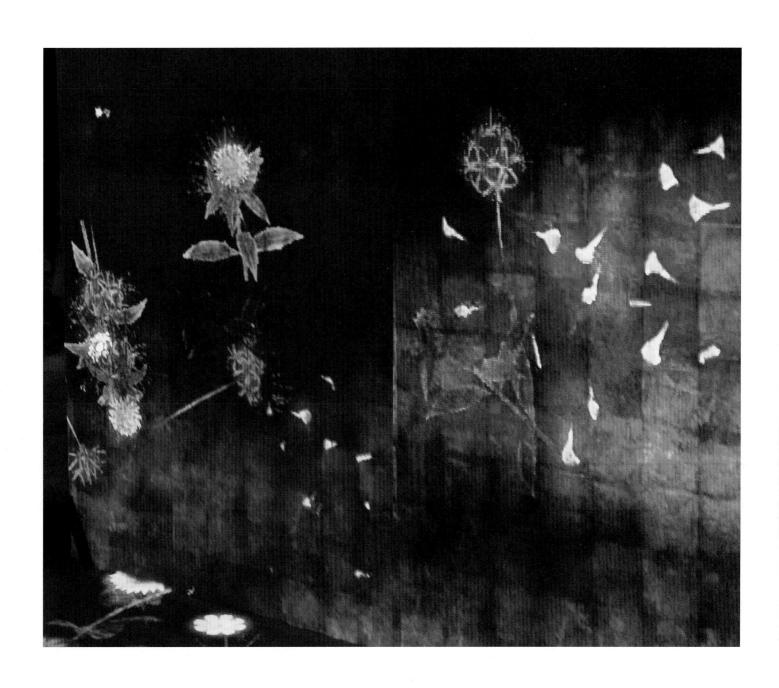

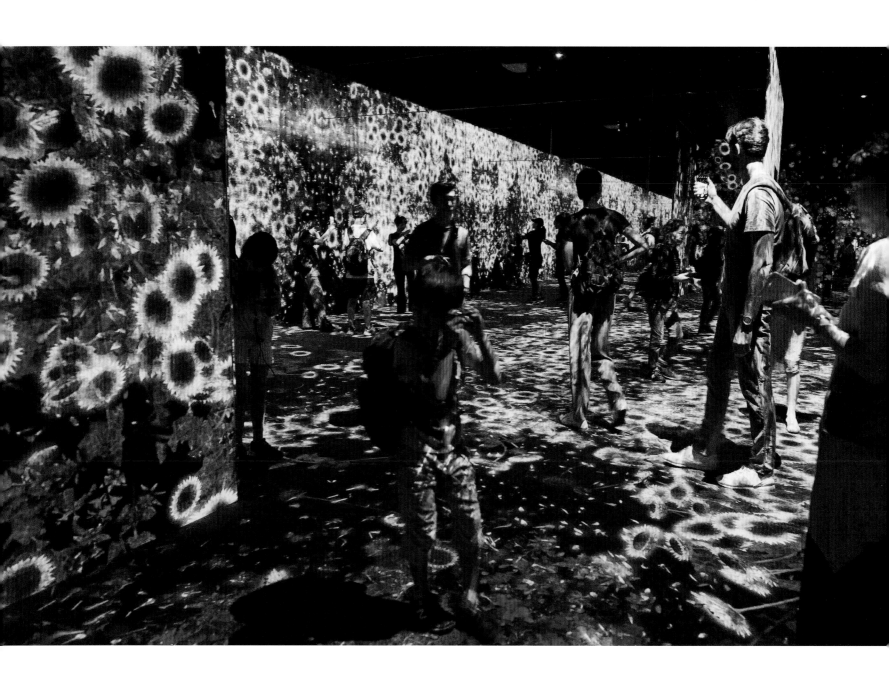

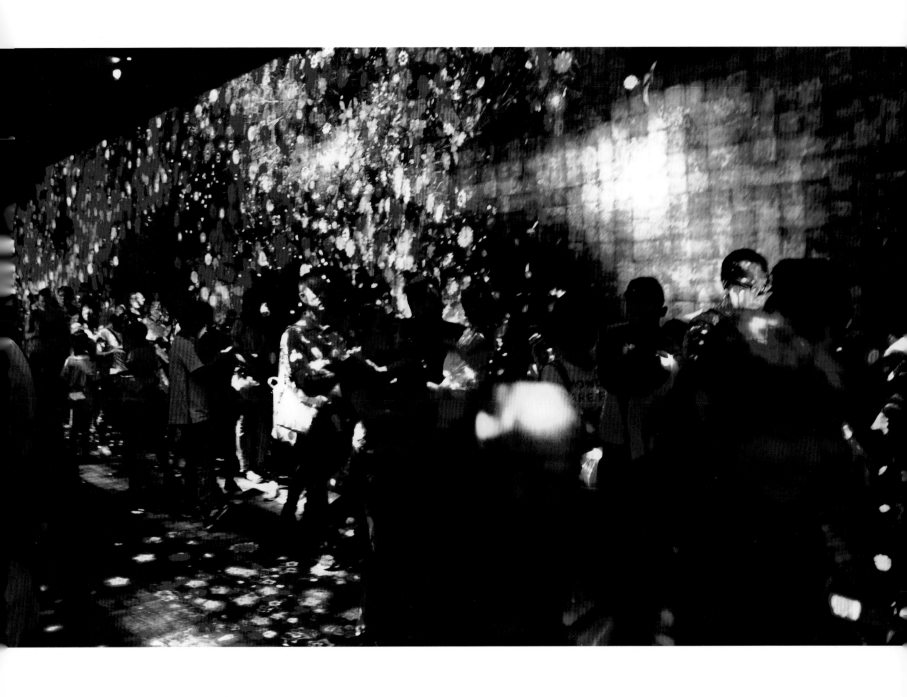

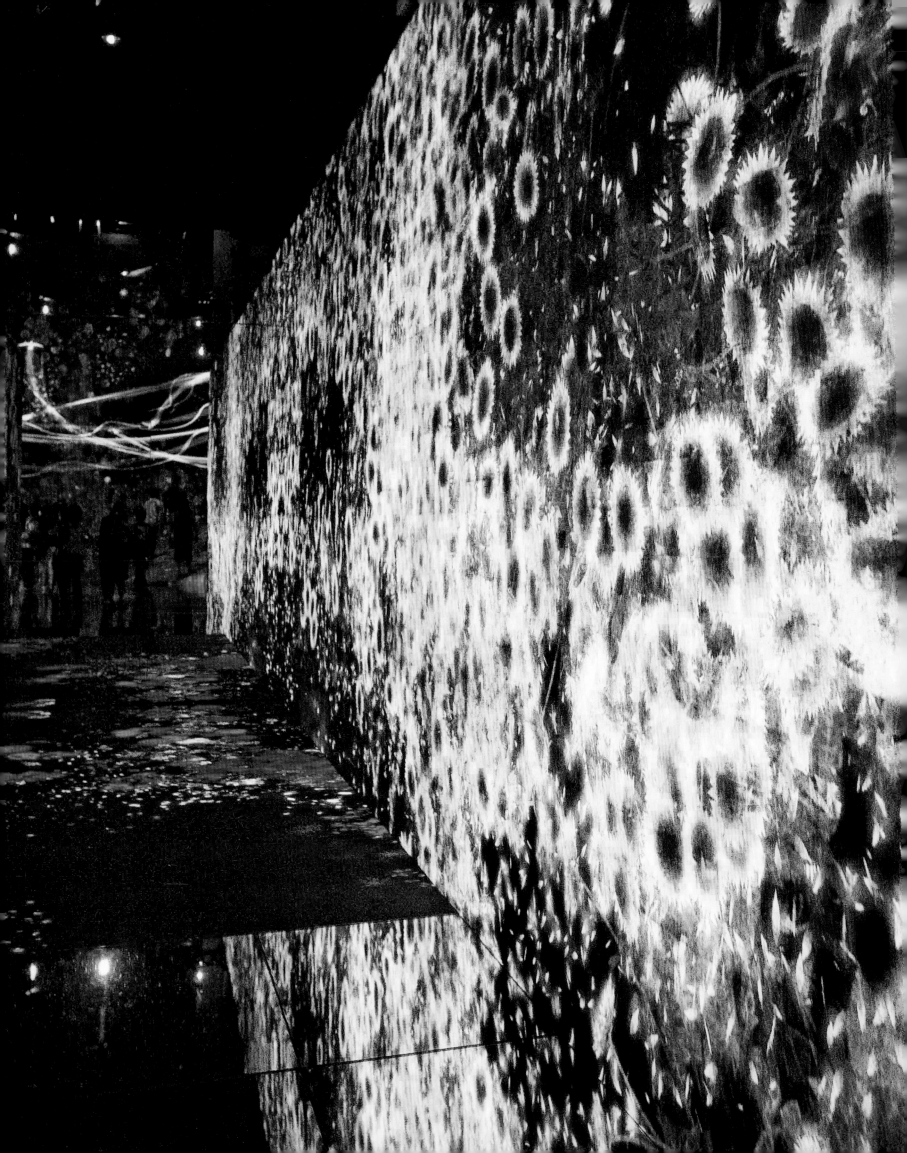

Ultrasubjective Space:

Exploration of

Premodern
Japanese

Spatial

Construction

I

Yuki Morishima

Premodern Japanese spatial awareness—which teamLab calls "ultrasubjective space" (*chōshukan kūkan*)—fundamentally differs from the linear perspective developed in Renaissance Europe.[1] Until the late nineteenth century, most Japanese painters rendered space differently from post-Renaissance artists, as they did not employ Western techniques such as one-point perspective. Japanese art's complex depiction of space is neither two nor three dimensional; it is subjective expression rather than objective documentation of space. Viewers accustomed to Renaissance realism might dismiss premodern Japanese optical depth as primitive or false.[2] Yet teamLab takes ultrasubjective space as the frame for its twenty-first century art. An introduction to some of the basic techniques used to depict spatial relationships in premodern Japanese painting is helpful to understanding teamLab's work.

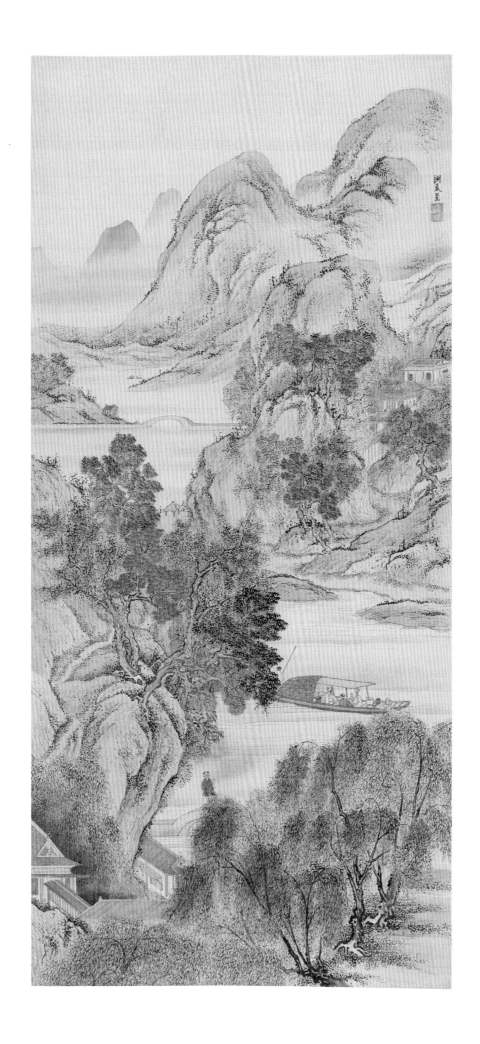

PREMODERN JAPANESE SPATIAL AWARENESS

Until the late nineteenth century, the majority of Japanese painters employed an optical logic that differed from that in Renaissance Europe. Premodern Japanese art, like the premodern Chinese and Korean art that influenced it, used the principle of height equals distance in its spatial representations. Objects were perceived to be in the same optical depth if they were rendered on the same horizontal line, which is similar to Western perspective. However, early East Asian painters, unlike Western Renaissance painters, expressed optical depth by vertically arranging the ground plane so that low means near and high means far.

An example of this technique is found in *West Lake in Spring* (fig. 1), a circa 1777 landscape painted by Yosa Buson (1716–1783), a master of Chinese-style painting (*nanga*). A man on an arched bridge at the bottom of the scroll is perceived to be closer than the older gentlemen on a boat who are rendered higher. Buson placed a second arched bridge even higher up in the painting, suggesting it is far in the distance. Interestingly, the scale of objects in paintings such as this does not always correspond to their relative distance, as defined by their vertical position in the composition. According to Western linear perspective, the buildings in the lower left corner should be larger in relation to the man on the bridge, as they are presumed to be closer to the viewer. But the "height equals distance" technique allowed Buson to indicate that the buildings are nearer without employing realism.

Premodern Japanese artists often painted landscapes from a bird's-eye view (*fukan hyōgen*), from high above and afar. They rendered scenes from shifting viewpoints within the same composition, which allowed the viewer to freely travel around and through the space. Shifting viewpoints meant there was no boundary between the figures in the painting and the viewer of the painting.[3]

West Lake in Spring by Buson exemplifies such perspective. At first glance, the landscape seems to be rendered from a bird's-eye view; however, the two bridges are depicted as if seen from the lakeshore. The top and the bottom parts of the lower bridge (colored in pink) are visible simultaneously, while the rooftops of the buildings in the foreground are seen from above. Unlike Renaissance artists who used a single vantage point to render space, Buson employed multiple viewpoints. Through these constantly shifting vantage points, the viewer can see both macro and micro worlds simultaneously. It is as if one is located within the painting (as one of the figures) viewing the landscape, at the same time one is located outside of the painting, seeing the overview of the landscape from a distance.

The two compositional techniques discussed above are commonly found in Chinese and Korean artworks. However, the use of gold clouds (*kin'un*) and backgrounds to manipulate space is a technique innovated by Japanese artists.[4] In *Honchōgashi,* a history of Japanese painting and compendium of artists' biographies published in 1691, Kano Einō (1631–1697) and his father Sansetsu (c. 1589–1651) explain this ancient Japanese painting method as follows: "Give perspective by placing clouds at the top and the bottom of the

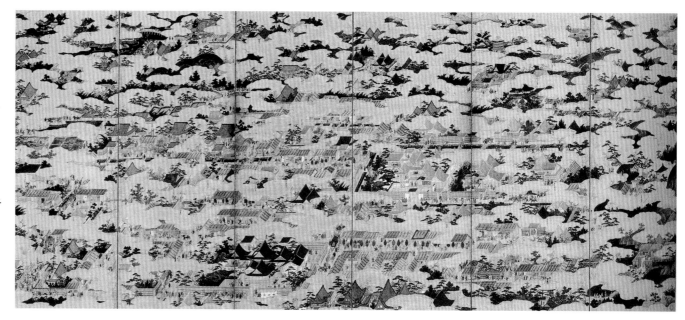

2
Rakuchū rakugai zu Uesugi-bon
(Scenes in and around the
Capital), c. 1565. By Kanō Eitoku
(Japanese; 1543–1590).
Pair of six-panel screens; colors and
gold paint on paper. Height 160.6
cm, width 364 cm each. Yonezawa
City Uesugi Museum.

3
Illustrated Scroll of the *Tale of
Ginji*.
Handscroll; ink and colors on paper.
Height 21.9 cm. Tokugawa Art
Museum, Nagoya.

pictorial plane. This placement of clouds allows you to eliminate unimportant objects and events and make clear the main theme of the painting."[5]

Premodern Japanese painters strategically applied decorative bands of golden clouds as a compositional tool in the genre of screen paintings called *rakuchū rakugai zu* (Scenes in and around the Capital), which captures the lives of townspeople in Kyoto from a bird's-eye view. In the mid-sixteenth-century *rakuchū rakugai zu* screens known as Uesugi-bon (fig. 2), Kanō Eitoku (1543–1590) depicted among the gold clouds important places such as the Imperial Palace, the Shogun's residence, famous temples and shrines, and scenes of seasonal festivals and activities of daily life. He covered almost half of the screens with clouds that compartmentalized the cityscapes and framed the screens emphatically. The stylized clouds obscure the distances in order to manipulate a viewer's interpretation of those distances so that the important buildings would fit in the limited pictorial plane.

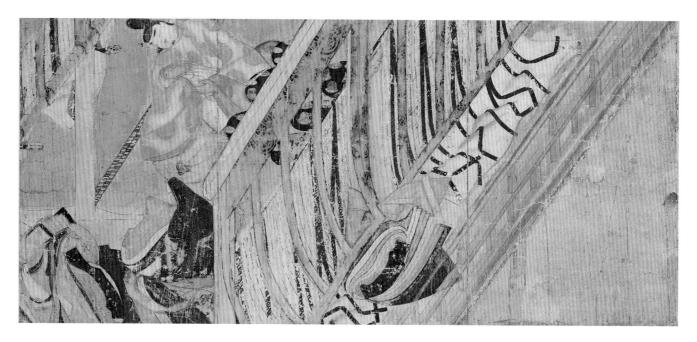

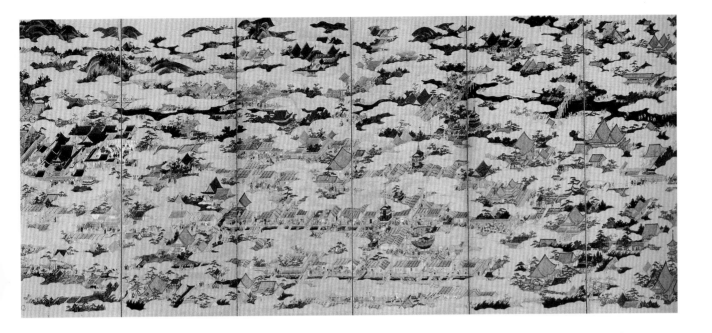

The clouds cover and conceal details, emphasizing highlights of the festival and the ancient capital. In addition, Eitoku included four seasons in this screen by depicting seasonal plants and festival scenes, such as New Year's celebration and the Gion Festival in summer, and the gold clouds helped the artist divide and frame time and seasons. Even though Eitoku did not precisely and realistically illustrate the cityscape, his compositional technique is innovative and effective, and it successfully directs the viewer's attention.

Another premodern Japanese approach to spatial representation that informs teamLab's work is *Fukinuki yatai* (literally "blown roof"). This is a drawing technique that depicts the interiors of buildings shown from a top view with the roof removed. *Fukinuki yatai* allows the viewer to simultaneously see the exterior and peek into intimate interior scenes from above. An example is found in the twelfth-century *Genji monogatari emaki* (Illustrated scroll of the *Tale of Genji*), based on the early-eleventh-century novel written by Murasaki Shikibu (c. 973–c. 1031).[6] In this classical novel, Prince Hikaru Genji's life events and love affairs often take place inside aristocratic residences. The painter omitted the roof to illustrate indoor space so that the viewer can discreetly observe the private activities. In "The Oak Tree" (Kashiwagi) chapter, Hikaru Genji is depicted holding a baby in his arms (fig. 3). In this emotionally charged scene, Genji looks at the child, knowing that the newborn is not his son but the son of Kashiwagi, his adulterous wife's lover. Here, the blown-roof technique allows us to observe this moment while the sharply angled cloth screens, tatami mats, and veranda on the uptilted ground plane express his unsettled feelings.

The depiction of multiple times in space is another premodern Japanese approach to spatial representation that inspired teamLab. *Iji dōzu* (literally "different times in a single illustration") is a compositional technique used to depict successive events within one frame of an illustration.[7] The technique often incorporates the same figure or figures multiple times. It is generally used to depict action scenes in narrative scrolls.

Ban Dainagon ekotoba (Illustrated history of the Great Minister Ban's conspiracy) from the late twelfth century exemplifies this technique. In the scene of a boys' fight, three successive actions are depicted within one setting in a clockwise composition. At the upper part of the scene, a father runs to separate two boys. At the bottom, the same father defends his son by kicking the other boy. Then at the upper left, the mother pulls the same son away from the scene. In premodern Japanese paintings such as this, multiple events can take place in a single space.

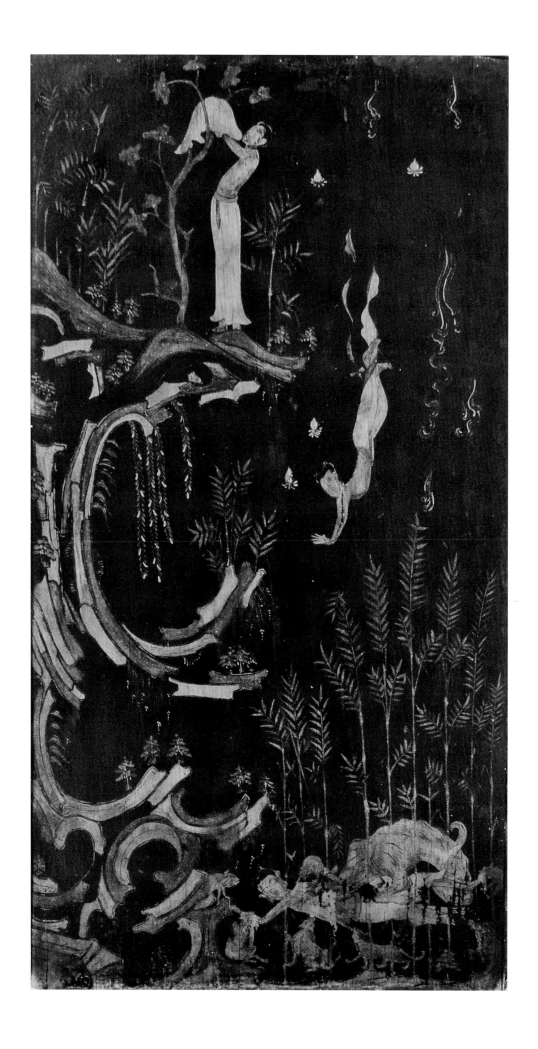

48

A painting on the *Tamamushi zushi* ("beetle-wing" shrine; fig. 4) from the seventh century also creates a space in which multiple events occur. The shrine's right panel depicts a scene of the Buddha-to-be throwing his body over a cliff to save an emaciated mother tiger and her cubs from starvation. Here, the Buddha appears three times—at the top of the cliff taking his clothes off, in the air falling to his death, and at the bottom of the cliff being eaten by the tigers. *Iji dōzu* helps artists not only to organize actions occurring over time within a single space but also to create interesting compositions.

Another means of expressing multiple moments in a unified space is paintings of the four seasons (*shiki-e*), which became popular in the late ninth or early tenth century.[8] Here, the progressive seasonal change reflected in the compositional layout takes place on a single pictorial plane. In landscape paintings, flora and fauna and people engaging in annual activities signify certain seasons. For example, chrysanthemum flowers and deer symbolize fall, and people celebrating the Gion Festival signify summer. A pair of seventeenth-century screen paintings, *Shiki kōsaku-zu* (Rice cultivation scenes in the four seasons), by Kanō Tan'yū (1602–1674) contains all four seasons. Time progresses from right to left in this pair of screens. While the right screen represents spring and summer by capturing activities such as plowing fields and planting rice, the left screen depicts fall and winter with scenes of harvesting rice and threshing grain.

Although there are more techniques of spatial construction found in premodern Japanese art, these key methods are helpful to understand teamLab's ultrasubjective space and what it calls the "logical structure of ultrasubjective space."[9]

ULTRASUBJECTIVE SPACE

teamLab uses ultrasubjective space as its guiding logic to create many of its artworks. By converting the sense of spatial awareness present in premodern Japanese artworks into a basic formula through digital technology, the art collective intends to create multimedia installations that allow visitors to visualize and experience ultrasubjective space. teamLab's early work titled *Flower and Corpse Glitch Set of 12* (fig. 5), roughly based on the eighth-century *Kojiki (Records of Ancient Matters)* and the eleventh-century *Tale of Genji,* is an example. The work consists of twelve animated screens themed on subjects such as collision, circulation, and symbiosis between nature and civilization. It contains all the aforementioned premodern Japanese spatial methods: height equals distance, shifting of vantage points, bird's-eye view, gold clouds, blown-roof technique, and depiction of multiple times in a single space.

At first glance, the work's twelve screens look as if they are based solely on the concept of traditional Japanese spatial representation; however, their underlying framework is established based on teamLab's logic (or algorithm) of ultrasubjective space using digital technology. Toshiyuki Inoko (b. 1977), founder of teamLab, has emphasized that the

5
Capital City & Noble, from
*Flowers and Corpse Glitch Set of
12*, 2012. By teamLab (est. 2001).
Twelve-channel video, 2 min.

6, 7
Two views of 3-D objects in a
3-D space, from *Disaster &
Prosperity*, from *Flowers and
Corpse Glitch Set of 12*, 2012.
By teamLab (est. 2001).
Twelve-channel video, 2 min.
6. Flattened using perspective.
7. Flattened using the logic of
ultrasubjective space.

collective does not simply animate screens by drawing pictures on two-dimensional planes. Instead, it starts with computer-generated three-dimensional objects, architecture (with the roofs lifted off), and figures in a three-dimensional space (fig. 6). It then flattens the representations by applying a custom-written algorithm (fig. 7). Intentionally, some surface sections of *Flower and Corpse Glitch* peel off to expose the lines of the underlying three-dimensional structure. This hints at how teamLab shifted the three-dimensional space to a two-dimensional surface, thereby mimicking premodern Japanese spatial representation. For teamLab, revealing the digital production process is an important part of *Flower and Corpse Glitch*.[10]

teamLab suggests that the shifting multiple viewpoints borrowed from premodern Japanese art, unlike Western linear perspective that creates "boundaries" between the viewer and the world that is being observed, allow the viewer to move freely in and out of their digital works.[11] The way premodern Japanese painters presented their landscape from above, the side, and below, zooming in and out of the space and allowing viewers to travel around and through it (as seen in *West Lake in Spring* by Buson) inspired teamLab. teamLab went a step further with this concept and created an interactive installation, *Crows are Chased and the Chasing Crows are Destined to be Chased as well* (see pages 108–121), which is set in a dark room where viewers are completely surrounded by projections on all sides.[12] As the boundary between the wall and the floor disappears, the work creates an immersive experience where one seems to float in the dark space. Mythical three-legged crows (*yatagarasu*) fly around the projected space, with bright lines trailing their flight paths. The crows chase each other until they crash into one another or a viewer, then scatter and transform into flowers. Viewers who walk through the room can initiate changes in this projected artwork.

teamLab borrows ideas for its sense of ultrasubjective space not only from traditional painting, but also from anime. It believes that anime artists have recognized the concept of ultrasubjective space, as they often place no boundaries between their work and viewers.[13] For example, anime artist Ichirō Itano (b. 1959) pioneered a unique style of flying action scene known as "Itano Circus," which teamLab thinks is connected to ultrasubjective space.[14] Like *Crows*, Itano's missiles are rendered in lights as they shoot around the space.[15] Itano fills a screen with flying missiles that are drawn in a distorted perspective. He achieves shifting perspectives by making a dogfight scene looks as if a high-speed camera is chasing after the missiles. Such distortions and camerawork create a strong sense of dynamic movement. Here, Itano sacrifices a realistic representation in order to create a sensational experience for the viewers.

Inspired by Itano, teamLab intends to re-create this distortion of space formerly illustrated in two-dimensional animation in three dimensions in *Crows*. teamLab members explain, "This is an exploration of 1) what sort of logical structure of perception constitutes this distortion of space pioneered by Japan's animators, and 2) the hypothesis that this is in line with the continuous tradition of Japanese spatial perception."[16] As seen in *Crows*, teamLab's concept of ultrasubjective space has evolved as it explores the relationship between amine and the ultrasubjective world.

Ultrasubjective space adopts the spatial awareness found in the art of premodern Japan. Inoko has expressed his interest in developing a formula to prove that the premodern Japanese had a logical structure to their sense of space.[17] The pursuit of such a formula to digitally interpret premodern Japanese spatial awareness has encouraged teamLab to combine Japanese traditional art with cutting-edge digital technology to create something interactive and exciting. As technology keeps advancing, teamLab will continue to grow and push spatial boundaries in its digital artworks.

1 Different disciplines draw varying lines between premodern and modern Japanese history. In Japanese art history, premodern Japan generally spans from the Muromachi period (1392–1573) to the outset of the Edo period (1615–1868). In this essay, however, I define "premodern" as the time prior to when Renaissance European perspective influenced Japanese artists—that is, prior to the late nineteenth century.

2 To a certain extent, Renaissance perspective is also artificial, as it creates an illusion of reality.

3 Western linear perspective establishes a fixed position for the viewer. The picture plane and everything within the picture are defined in relation to the viewer. teamLab explains this concept as follows: "When you are looking at the world as depicted in Western perspective, it appears to be distinct from your reality and you cannot fully become a person in that world….[Y]ou can understand how a clear boundary divides you from the world you are observing." This concept is explained in teamLab, *teamLab 2001–2016* (Tokyo: teamLab, 2016), 57–59.

4 Byzantine artists also employed gold backgrounds in religious mosaics. In these cases, a gold background was used not as a compositional device, but to signify divine presence.

5 Masaaki Kasai et al., *Honchō gashi* (The history of painting in this realm) (Kyoto: Dōhōsha, 1985), 374–75.

6 The earliest known extant painting using the blown-roof technique is *Shōtoku Taishi e-den* (Biography of Prince Shōtoku), dating to the mid-eleventh century, from the Tokyo National Museum.

7 This technique can be found throughout early Asian art, especially Buddhist art.

8 Paintings depicting activities and events associated with the months of the year are known as *tsukinami-e*.

9 teamLab, *teamLab*, 55.

10 By showing the digital production process, teamLab intends to reveal the concept of ultrasubjective space. "Flower and Corpse Glitch Set of 12," teamLab, accessed June 4, 2019, http://exhibition.team-lab.net/bangkok/art/art05.html. Toshiyuki Inoko explains that teamLab included the words "glitch" in the title "to draw attention to that process and how the flatness is created by peeling off the surface." teamLab uses the same technique in another work titled *Cold Life*. Anna Dickie, "Toshiyuki Inoko in Conversation," *Ocula* (January 13, 2014), https://ocula.com/magazine/conversations/toshiyuki-inoko/.

11 Western linear perspective establishes a fixed viewpoint outside of the painting. As the viewer is detached from the painting, this vantage point creates "boundaries" between viewer and artwork. On the contrary, premodern Japanese perspective offers multiple vantage points and allows the viewer to enter the depicted landscape and observe the scenes as if you are one of the figures in the painting. teamLab explains this concept in teamLab, *teamLab*, 56–59.

12 teamLab has created many different versions of *Crows are Chased and the Chasing Crows are Destined to be Chased as well*. The subtitles of these different versions are: *Division in Perspective—Light in Dark* (2014); *Black in White* (2014); *Blossoming on Collision—Light in Space* (2016); *Life on Collision—1 Crow where 16 Light Rays Cross* (2017); *Transcending Space* (2017); *Layered Ultrasubjective Space* (2018); *Flying Beyond Borders* (2018); and *Floating Nest* (2018). Early versions of this work are basic digital installations, while later versions incorporate interactivity.

13 Dickie, "Toshiyuki Inoko in Conversation."

14 Ibid. Anime series such as *Space Runway Ideon* (1980–1982) and *The Super Dimension Fortress Macross* (1982–1983) often employed "Itano Circus."

15 The bright lines trailing behind the missiles (and crows) in their flight paths are similar to the illustration of a flying messenger trailing a ribbon of clouds from the mid-twelfth century handscroll painting of *Shigisan engi* (Legend of Mount Shigi Temple).

16 "Crows are chased and the chasing crows are destined to be chased as well, Division in Perspective—Light in Dark," teamLab, accessed June 4, 2019, https://www.teamlab.art/w/crows_dark.

17 Inoko, Toshiyuki, ed., *Chīmu Rabo tte nanimono?: Nihon bijutsushi ni aratana pēji o kuwaeru saisentan āto shūdan no shikō to sakuhin* (Who is teamLab?: Thoughts and works of cutting-edge art group that adds a new page to Japanese art history) (Tokyo: Magajin hausu, 2013), 18–19.

THE WAY
OF THE SEA

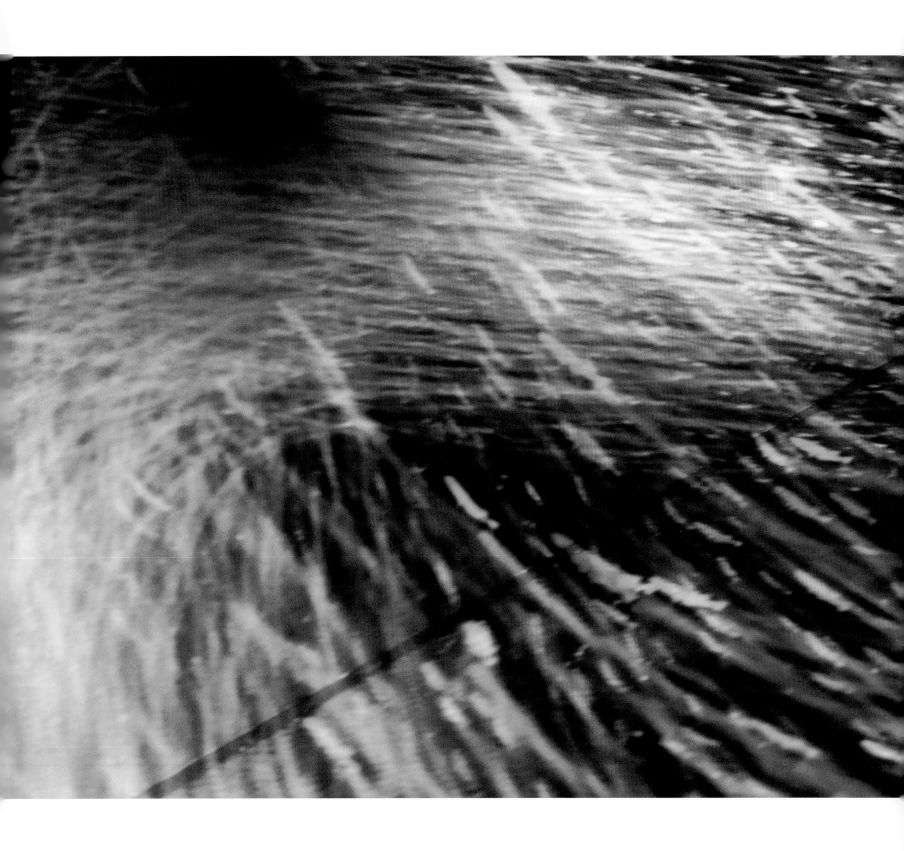

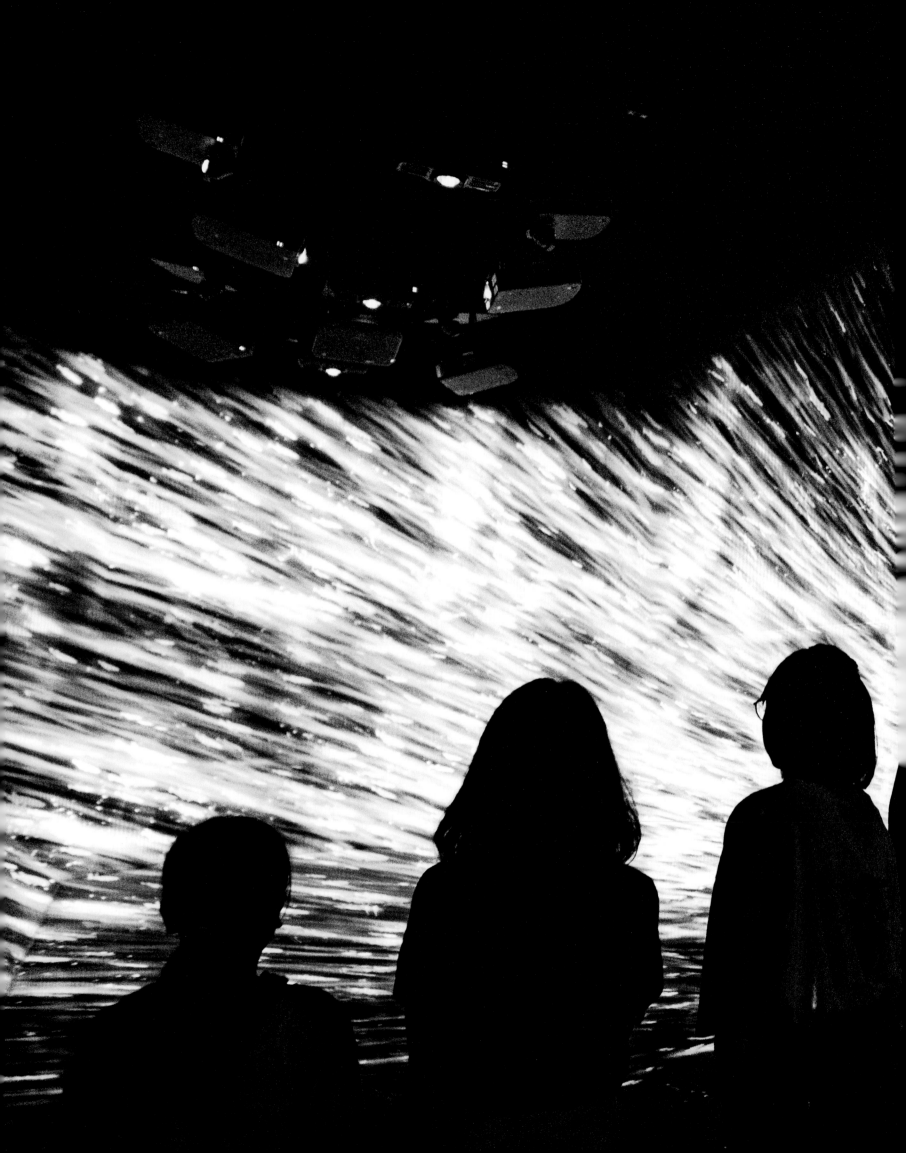

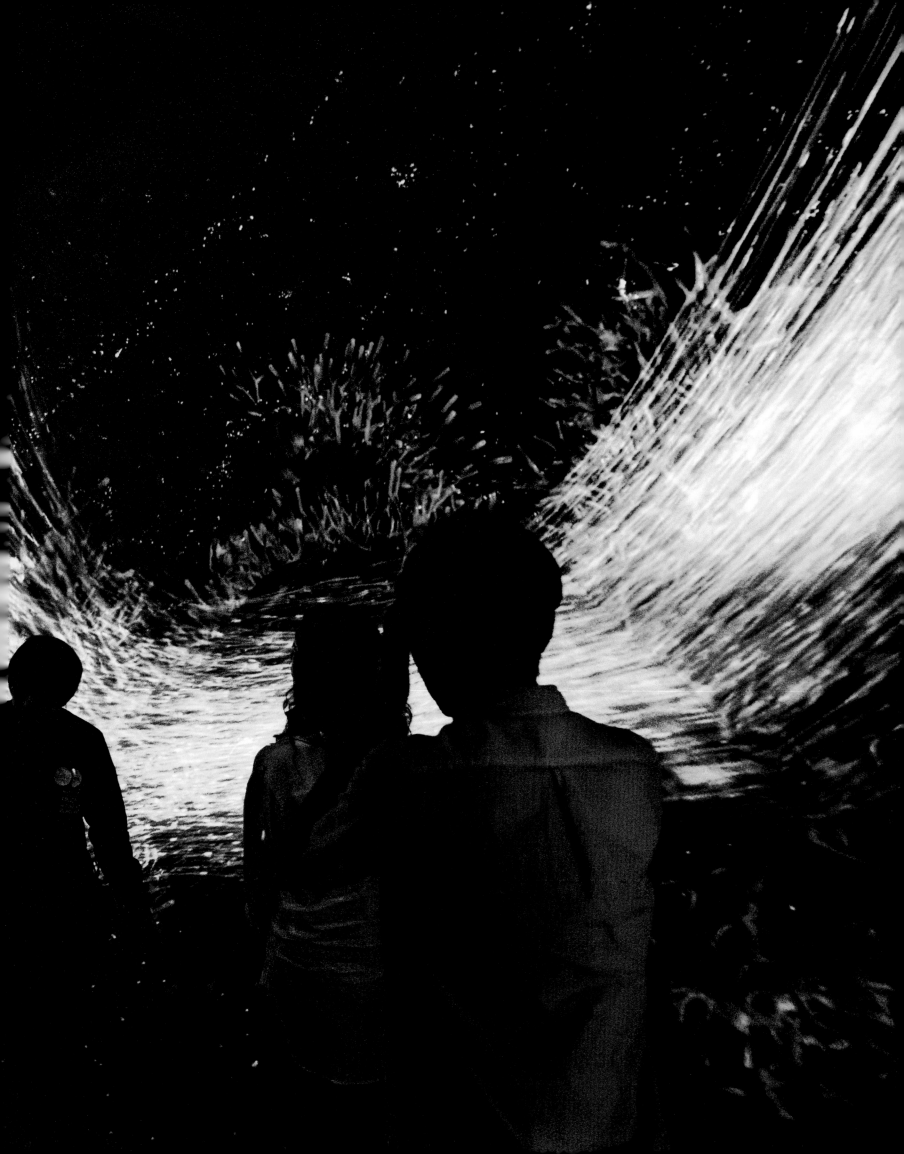

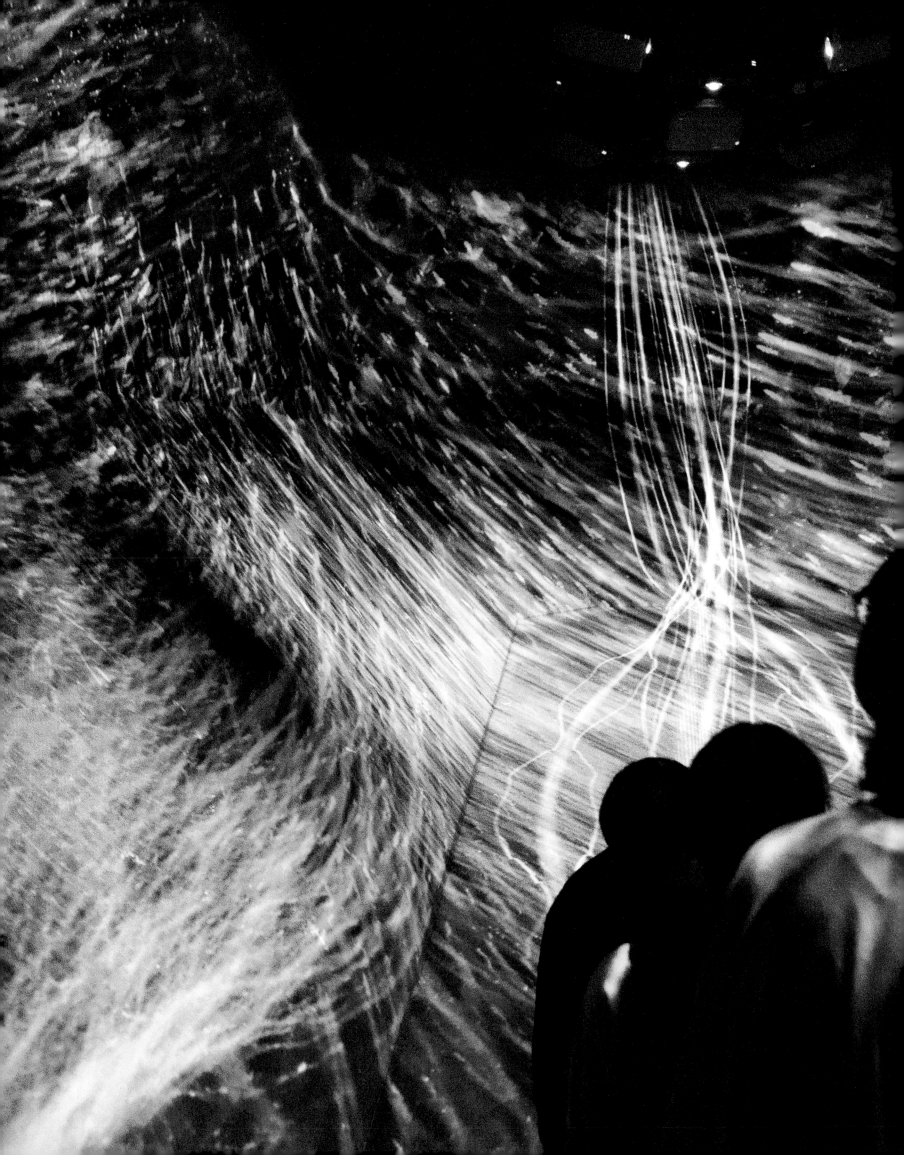

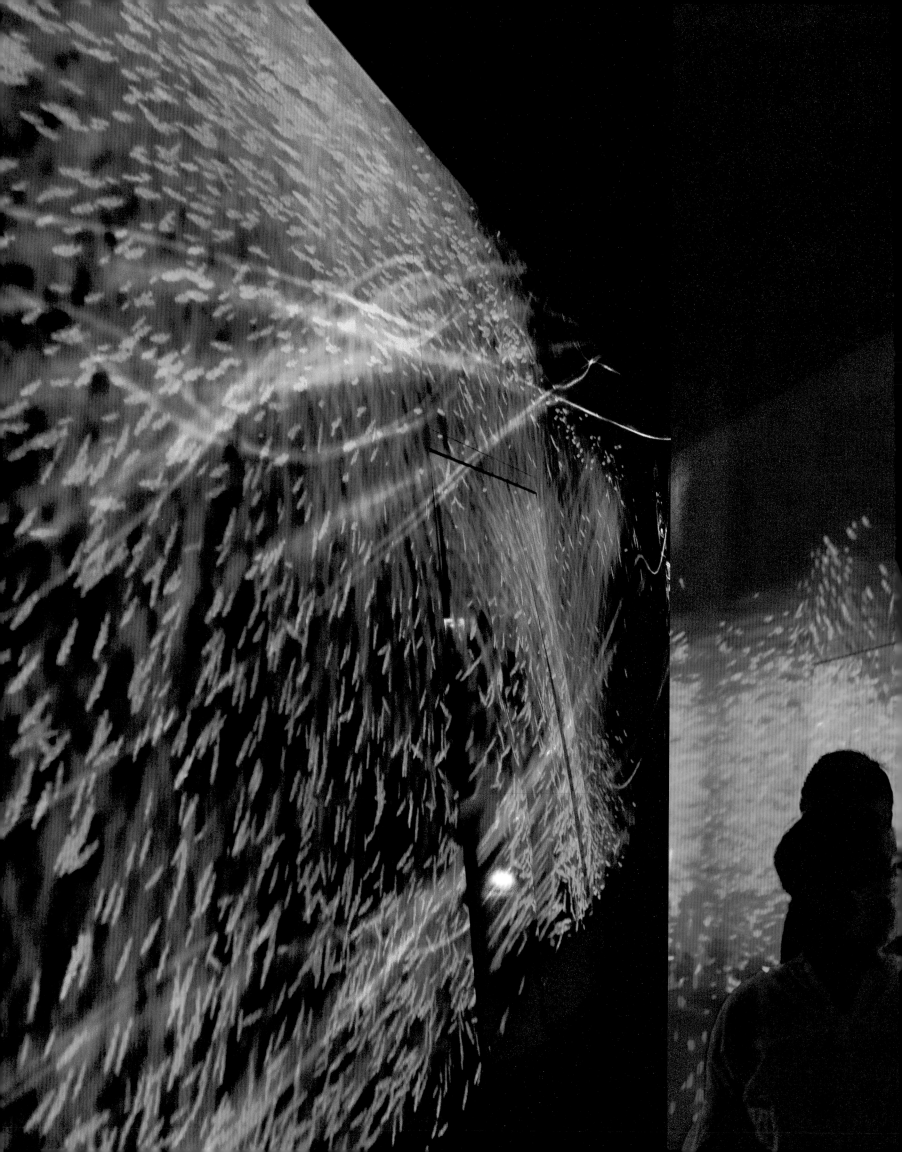

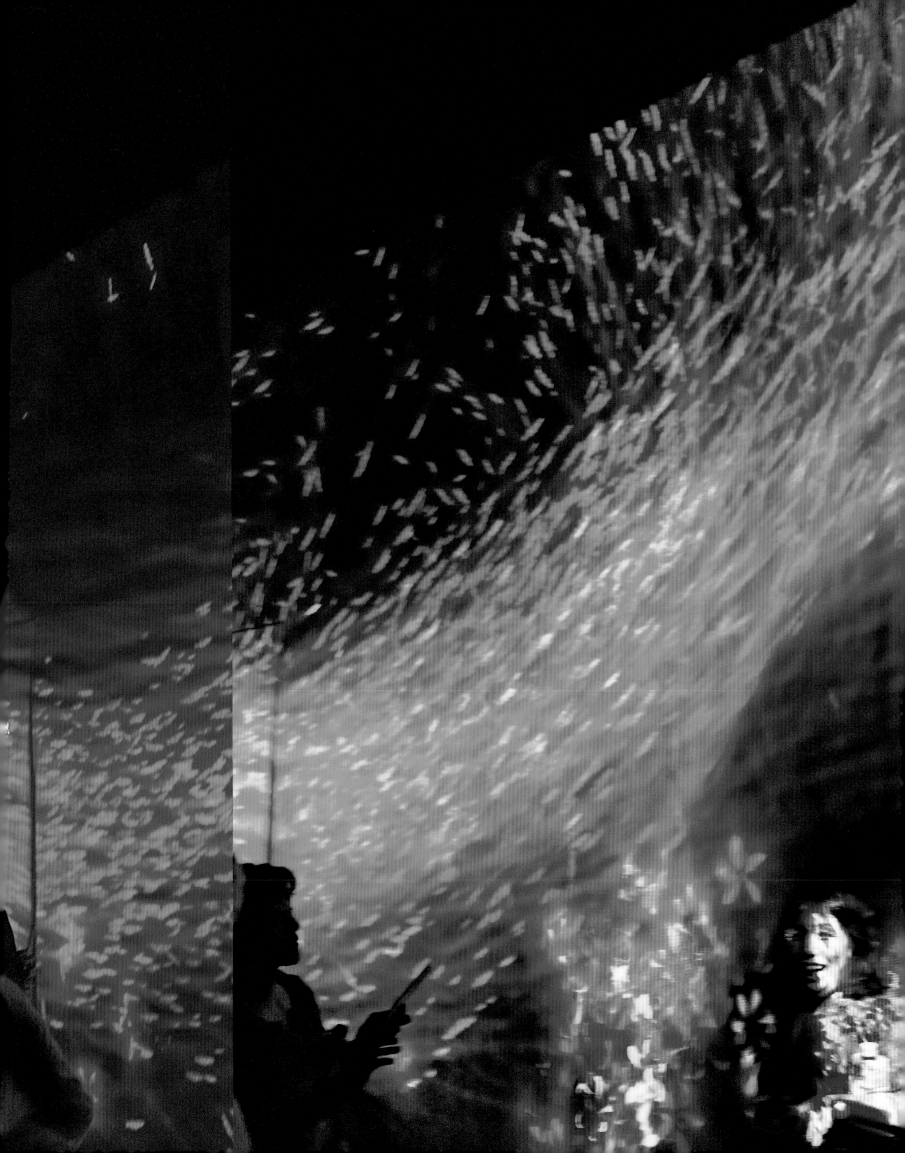

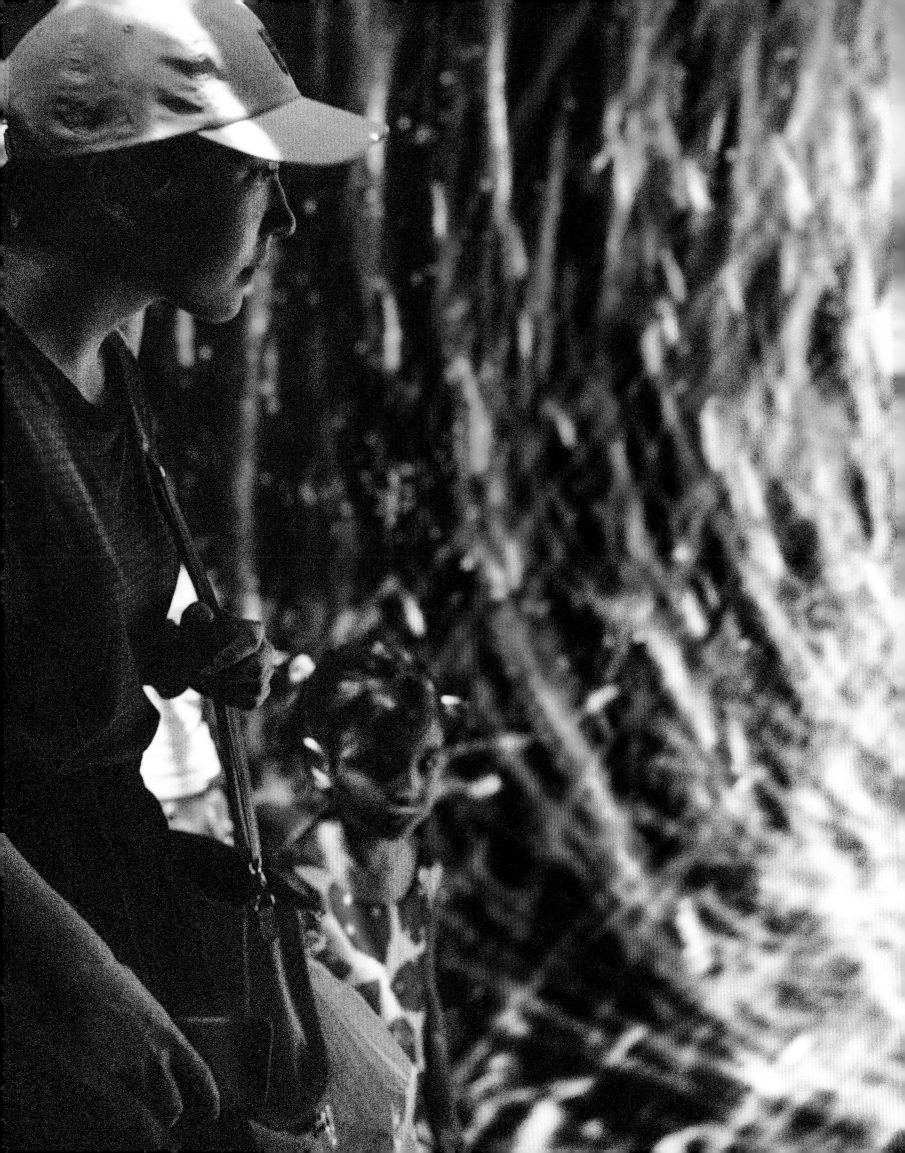

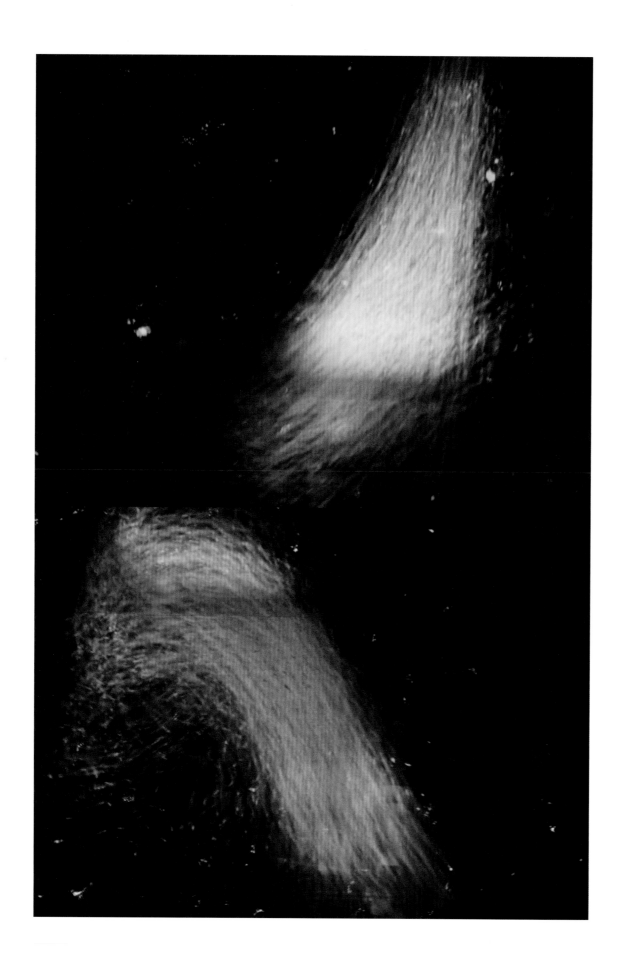

Hiroaki

Oishi

Interactive Systems Engineer

The Human Is the Center of the Work

Background

I'm a programmer from Fukuoka, Kyushu. I create movies and media for teamLab, and I also develop apps for artworks. Originally, I was working in website development, but now I'm entirely devoted to art, installation, and production.

I studied art education at Chiba University, and then I studied design at Kyushu University in a program that merged art and technology. This educational background covered both the analog part and creative production.

I became interested in teamLab when I saw its work featured in the June 2011 issue of *Bijutsutecho* magazine. Then I became fascinated by teamLab's work *Flowers and Corpse*. I joined teamLab in April 2012.

A Day at teamLab

Work at teamLab really depends on the day, and it depends on the people. But on a typical day, I come into the office around noon—a little past noon—and stay until the last train, which is around midnight. During the day I have meetings. But then toward late afternoon, early evening, I'm done with meetings, so I focus on programming and development tasks.

The most atypical work for me this year was the outdoor exhibition *A Forest where Gods Live* in Saga. Toshi [Toshiyuki Inoko, teamLab's founder] called me at around 10 o'clock in the evening two days before the opening of that exhibition saying he wanted to do a new installation. I worked until the morning to create something, then flew to Saga and worked until the sun set. In the evening I tested and continued to program until the next day, and then it was opening night. That's the shortest time I was ever given.

One artwork in *A Forest* seems like just a simple projection of a grid onto trees, but when someone approaches it a new grid is created. Depending on the density of the grids, you start to see the trees with a little more three-dimensionality, or, if the density is less, the trees look more flattened.

The Team

A recent work in which I was involved is *Moving Creates Vortices and Vortices Create Movement*, shown in 2017–2018 at the NGV Triennial in Melbourne. It's a variation from other teamLab waterfall-based interactive pieces. But what's different here from other works is that nothing happens if there's no visitor. It's just completely black. So once the visitor goes inside it really activates the flow of water. I think it really shows what interactive 3-D art is—that the human is the center of the work. Now it's in the NGV's collection. I think this is one of the first projection installations that went into the collection of any public institution.

It took about half a year to create this work. Yuki [Uebo] was the lead project catalyst, and there was another catalyst who specializes in more technical aspects like hardware. I was the software engineer. For this piece I used myoelectric sensors that read the movement of muscle fibers; I studied these in my college days. We had a sound team, and also a guy who did the mapping of the space. In terms of the team size, *Moving Creates Vortices* is relatively small compared to other works. It's not a very complex work.

To create a new teamLab artwork, first Toshi, a catalyst, and engineers sit together and discuss its general direction. Then it goes to art direction, where they create a series of image boards, while the technical team discusses its feasibility. That's where I'm directly involved. Once I create something that is ready for review, I meet with Toshi, the catalyst, art directors, and the animation or visual design team. We repeat that several times—or more than several times, depending on the time scale of the project—before exhibiting the work.

Defining teamLab

The organization of teamLab is like a studio during Europe's Renaissance, where there is one master and a group of apprentices who create artworks. But in terms of expression it's more like Japan's Rinpa school. People gather and create things aiming toward a certain style, a certain expression. We're doing that in the digital world.

What I find unique and interesting about teamLab is that we create artworks and at the same time we work on more corporate design solutions. Typically these two areas don't cross paths. But because of the solution works we get to do the art projects, which are so costly. Daisuke [Sakai, one of the founders of teamLab and head of digital solutions] is the guy who's running the company behind Toshi. Because of Toshi and Daisuke, teamLab has been able to be what it is now.

This text is edited and excerpted from an interview with Karin G. Oen on December 24, 2018, with consecutive interpretation by Kazumasa Nonaka.

REVERSIBLE
ROTATION

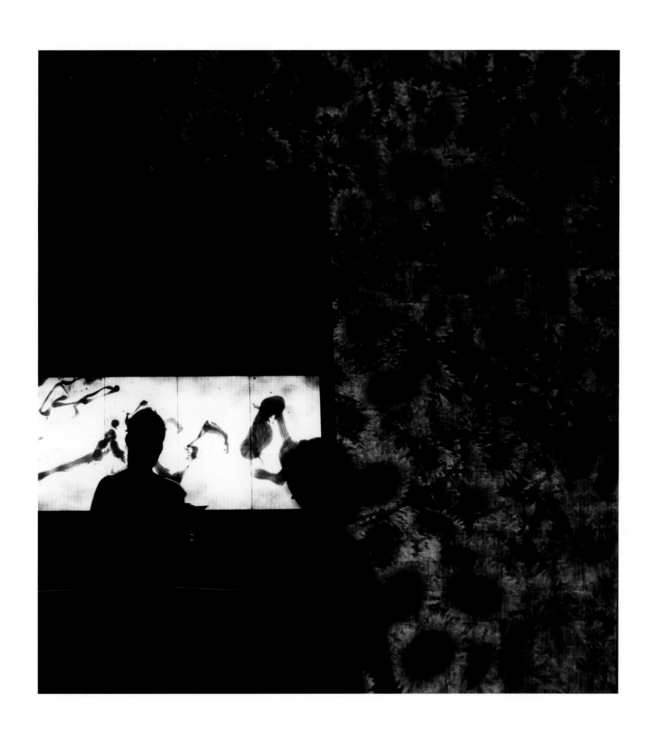

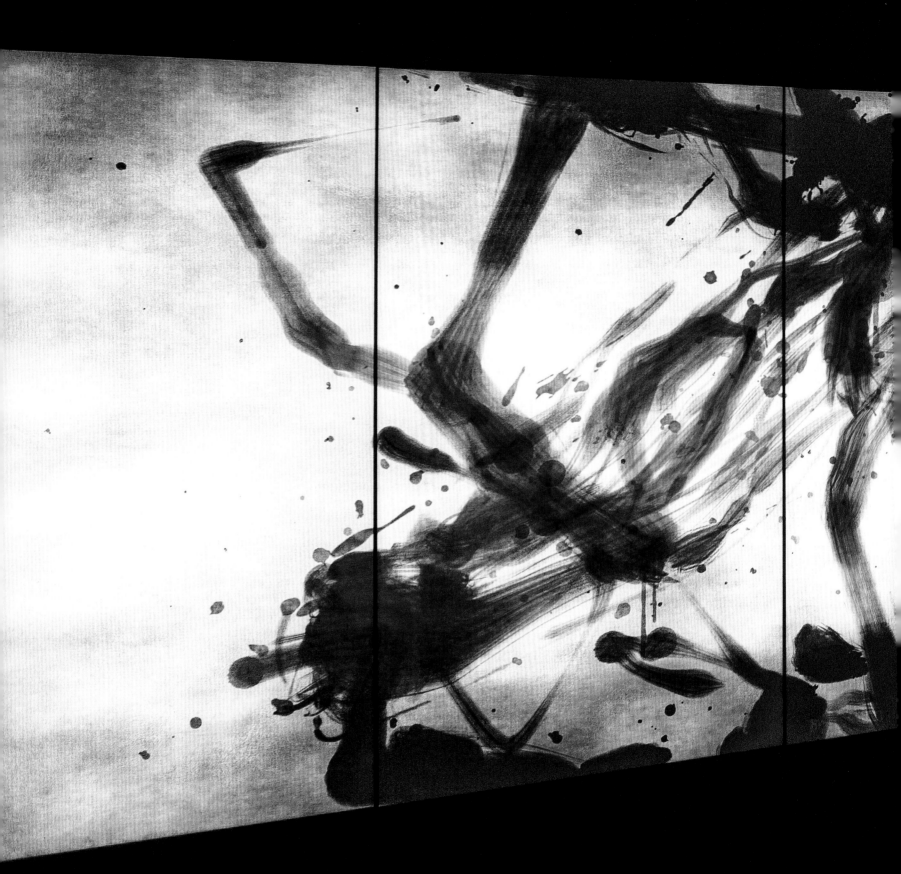

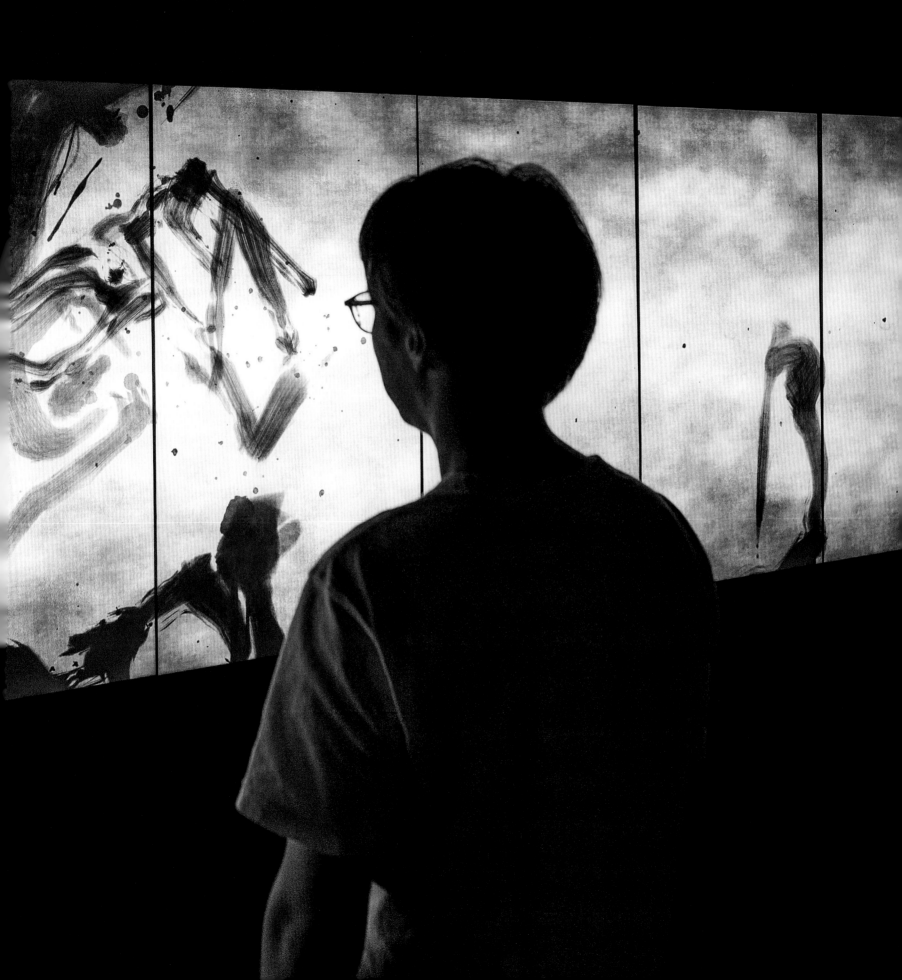

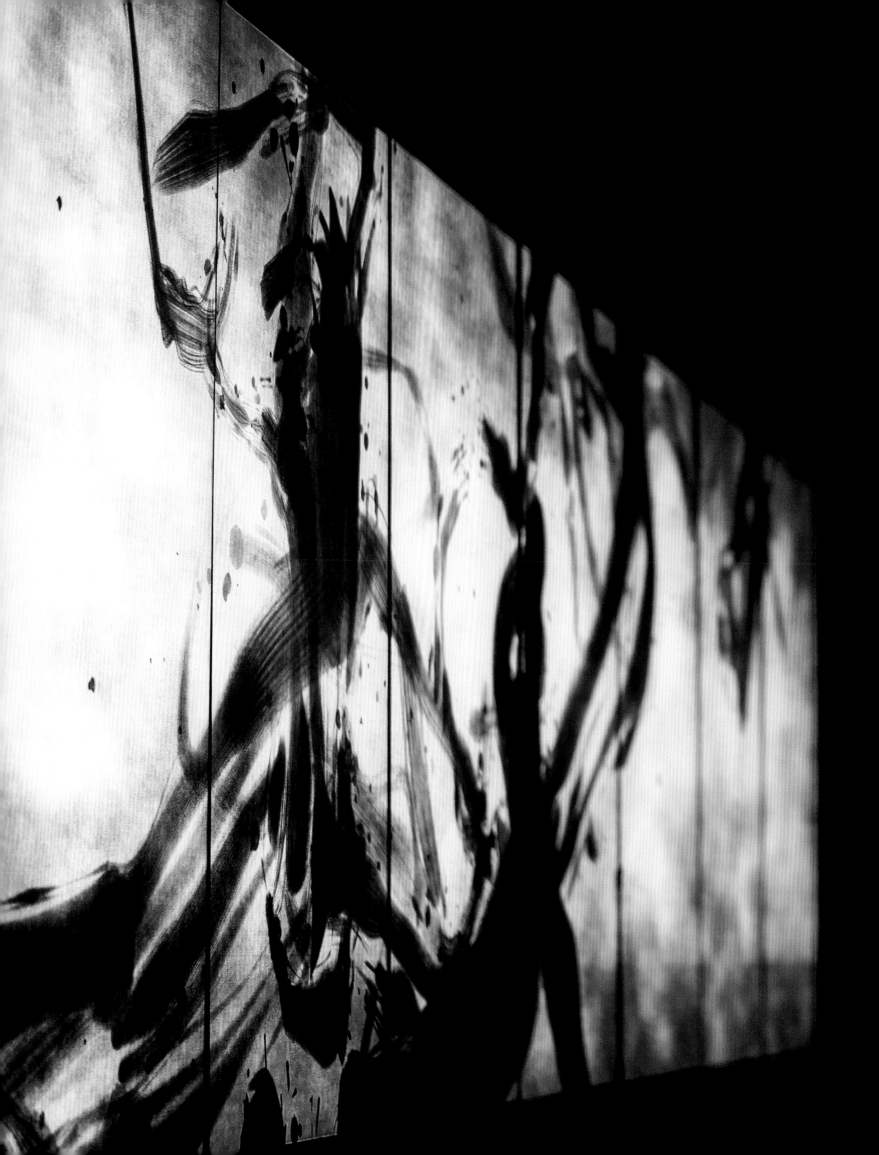

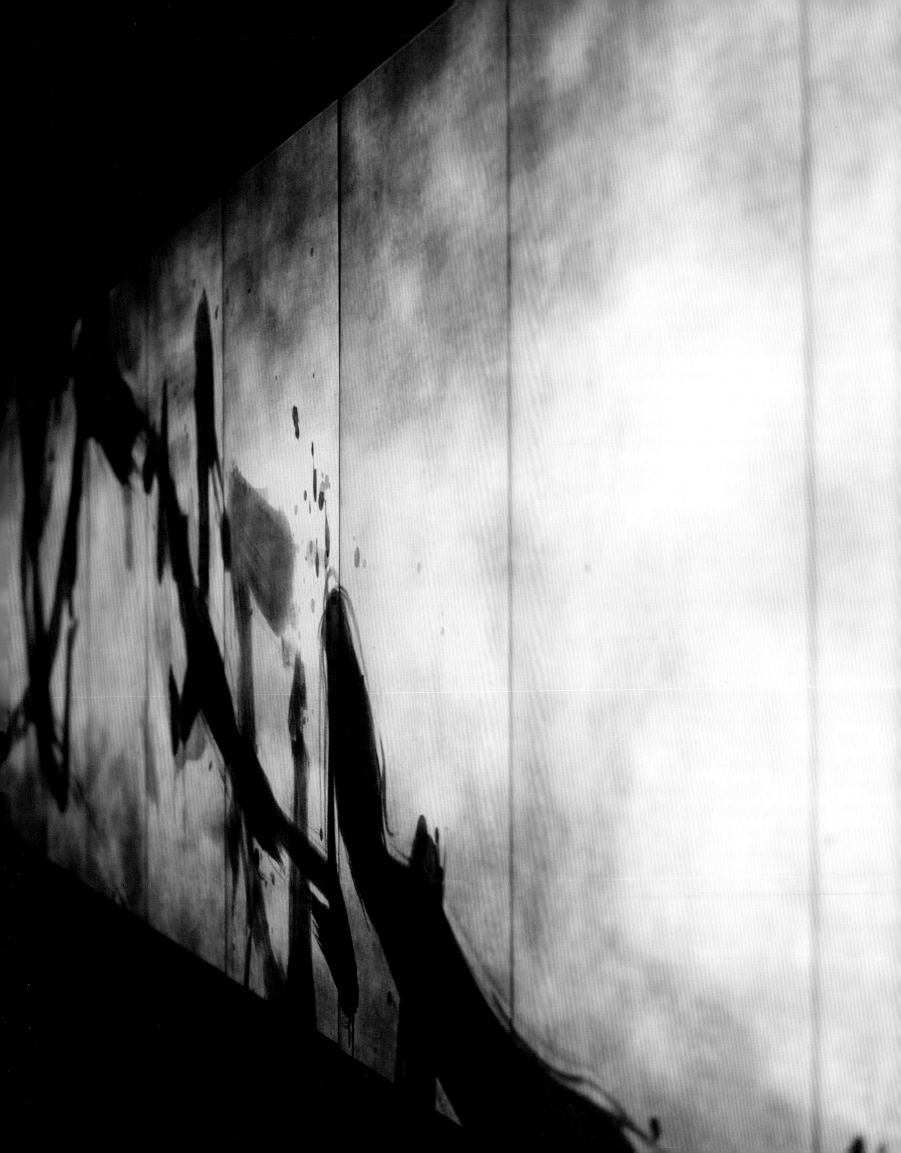

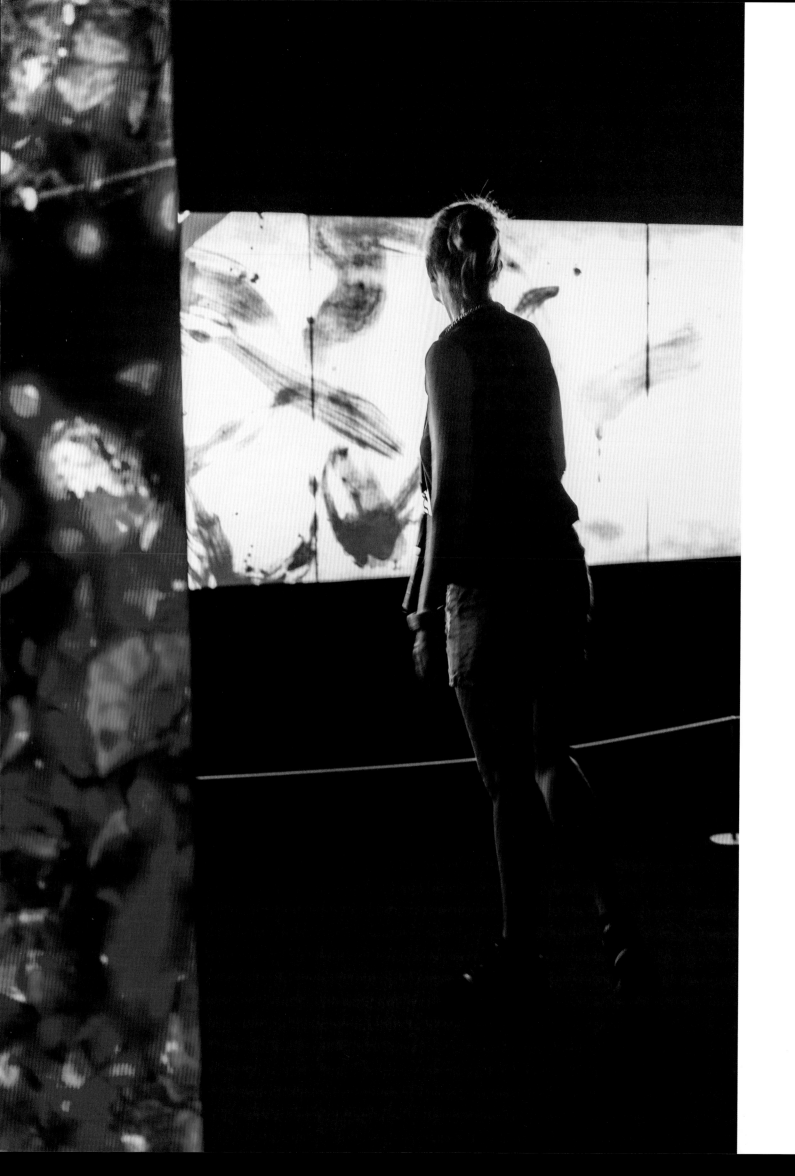

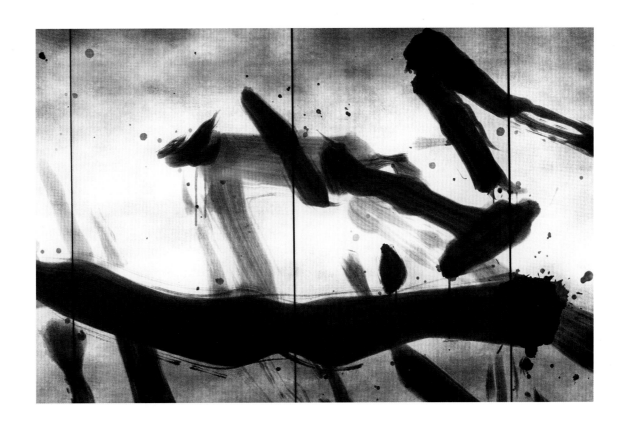

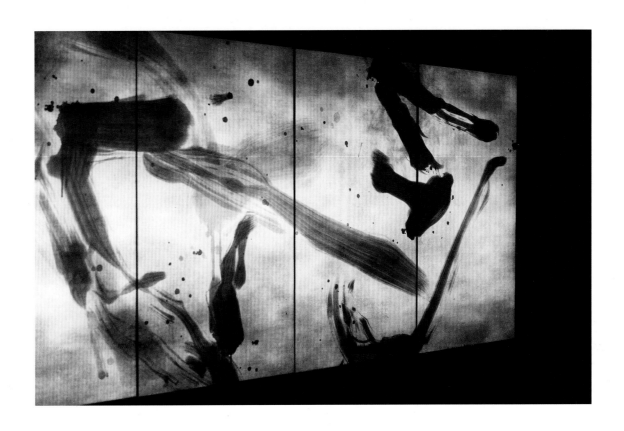

FLUTTER OF BUTTERFLIES BEYOND BORDERS

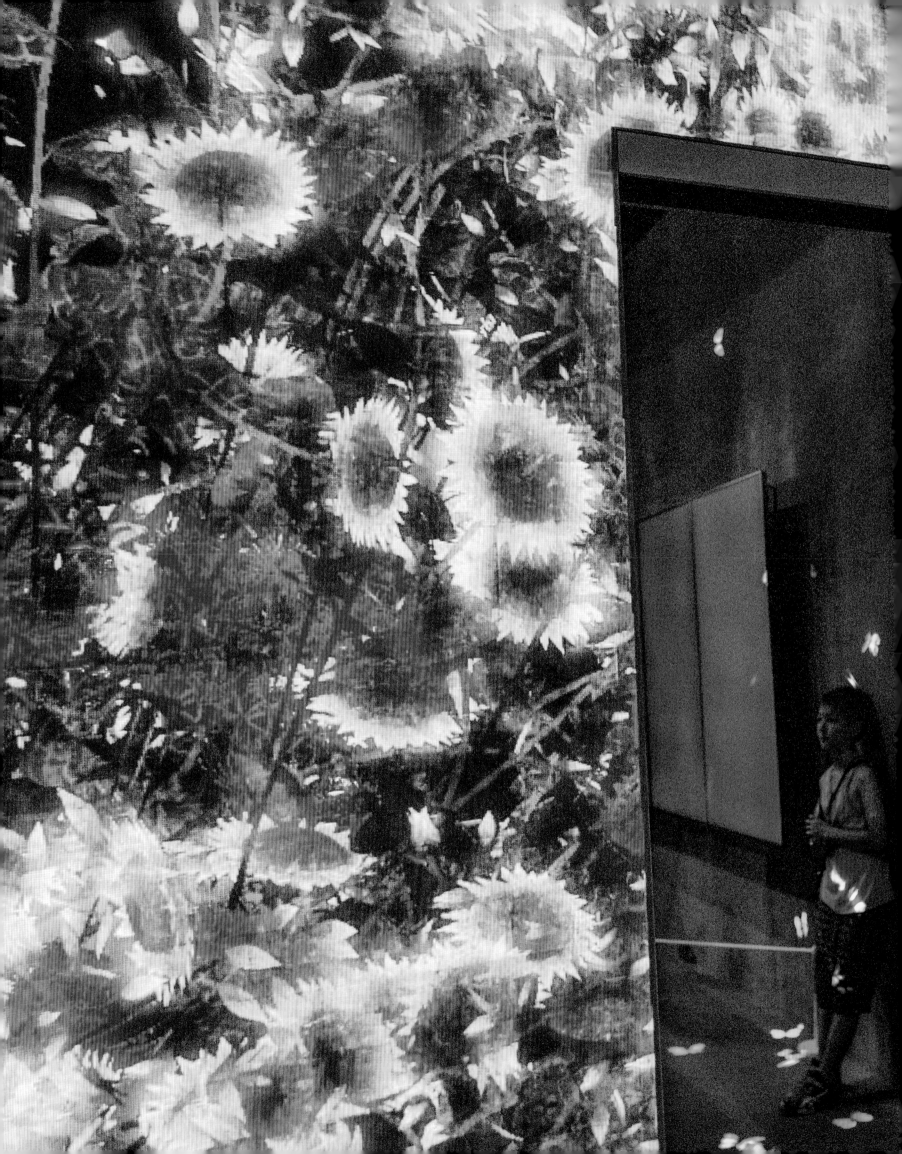

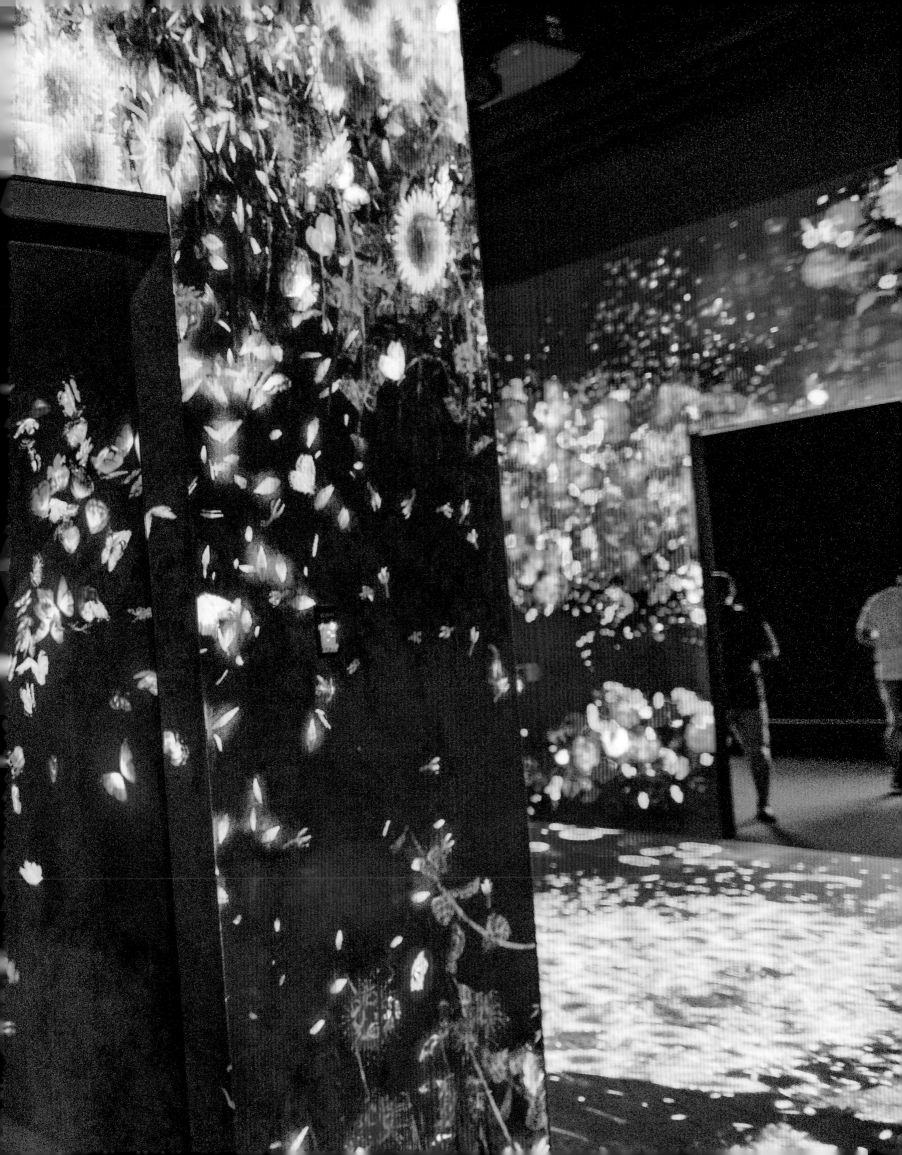

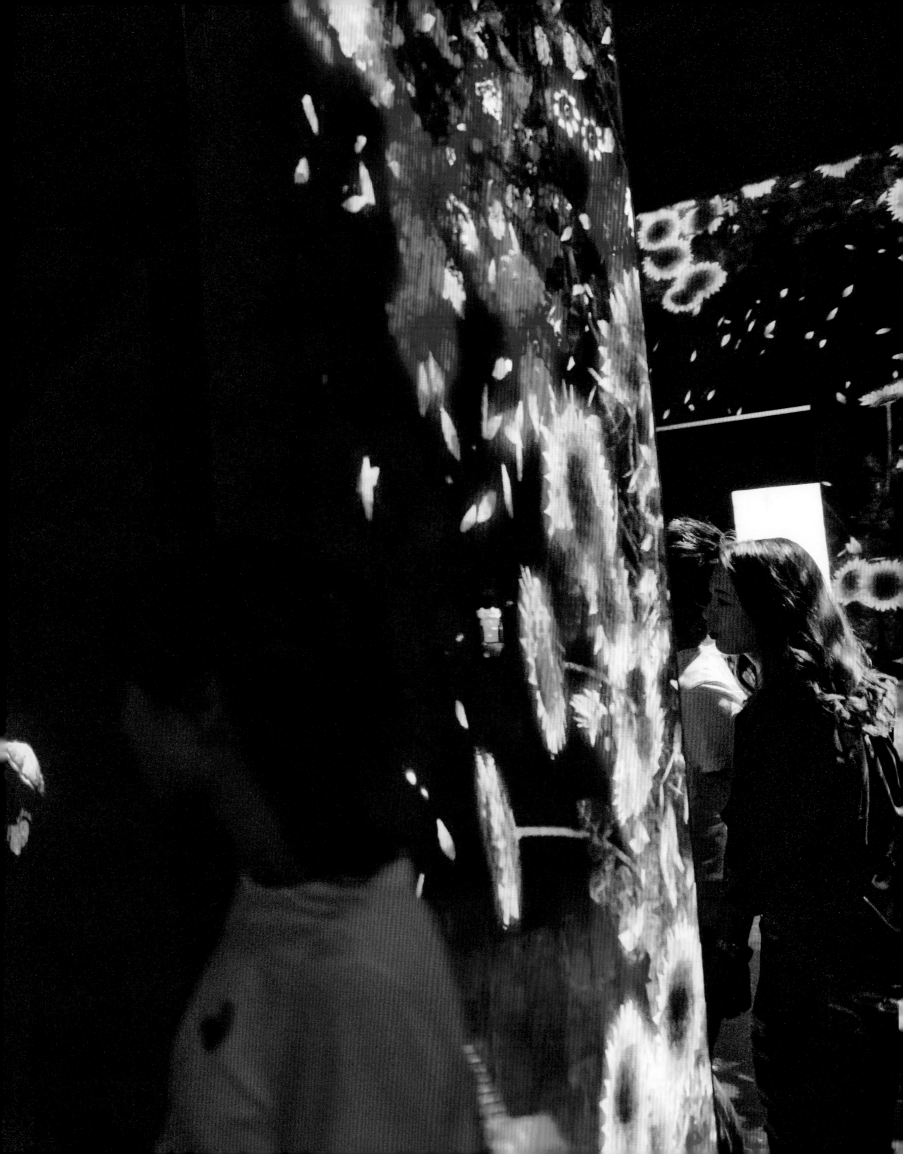

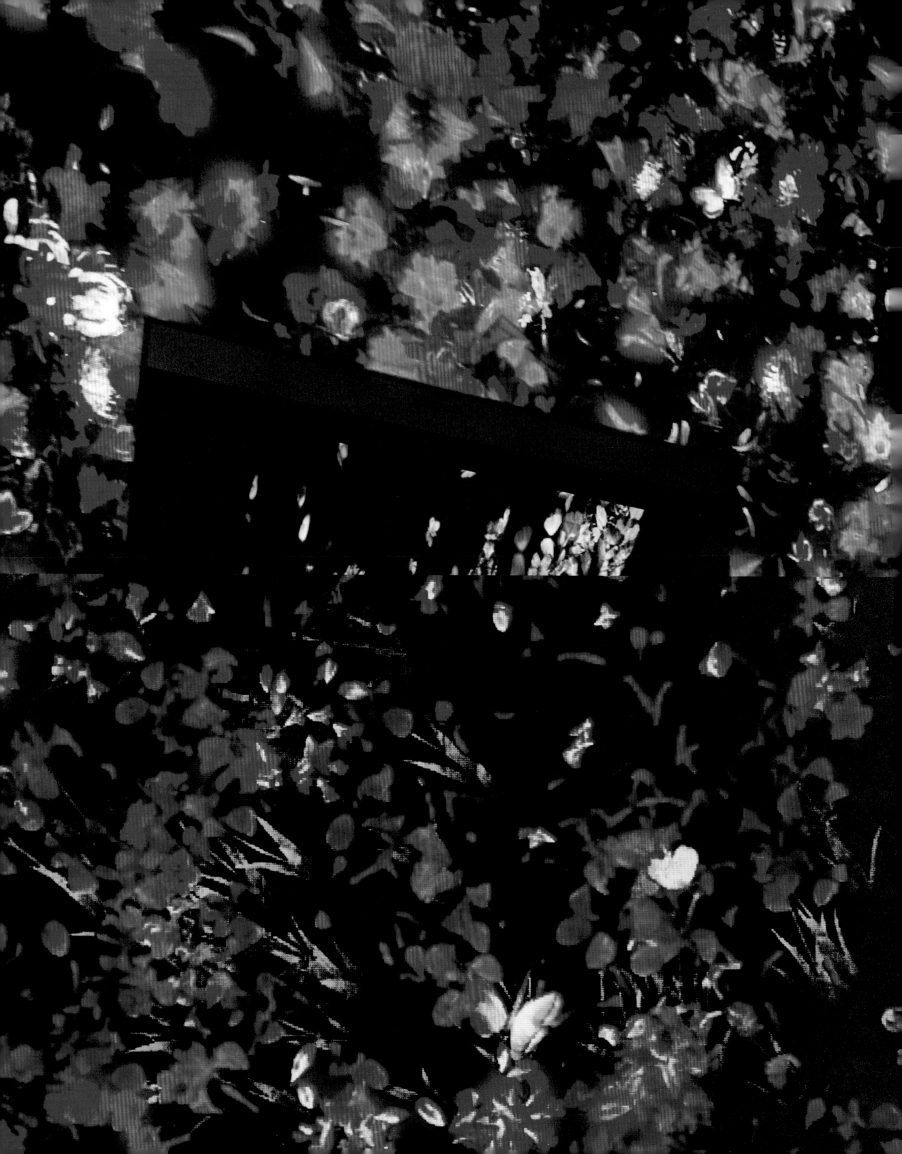

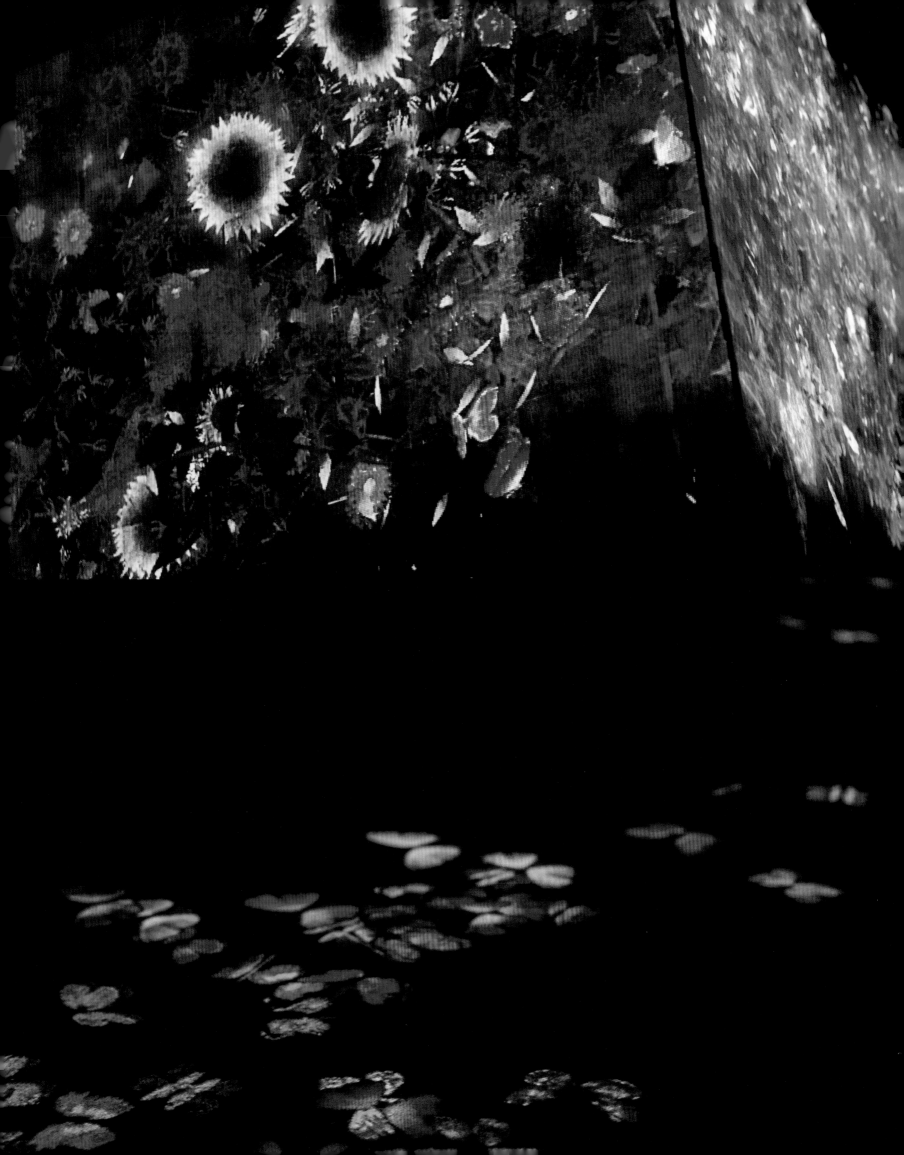

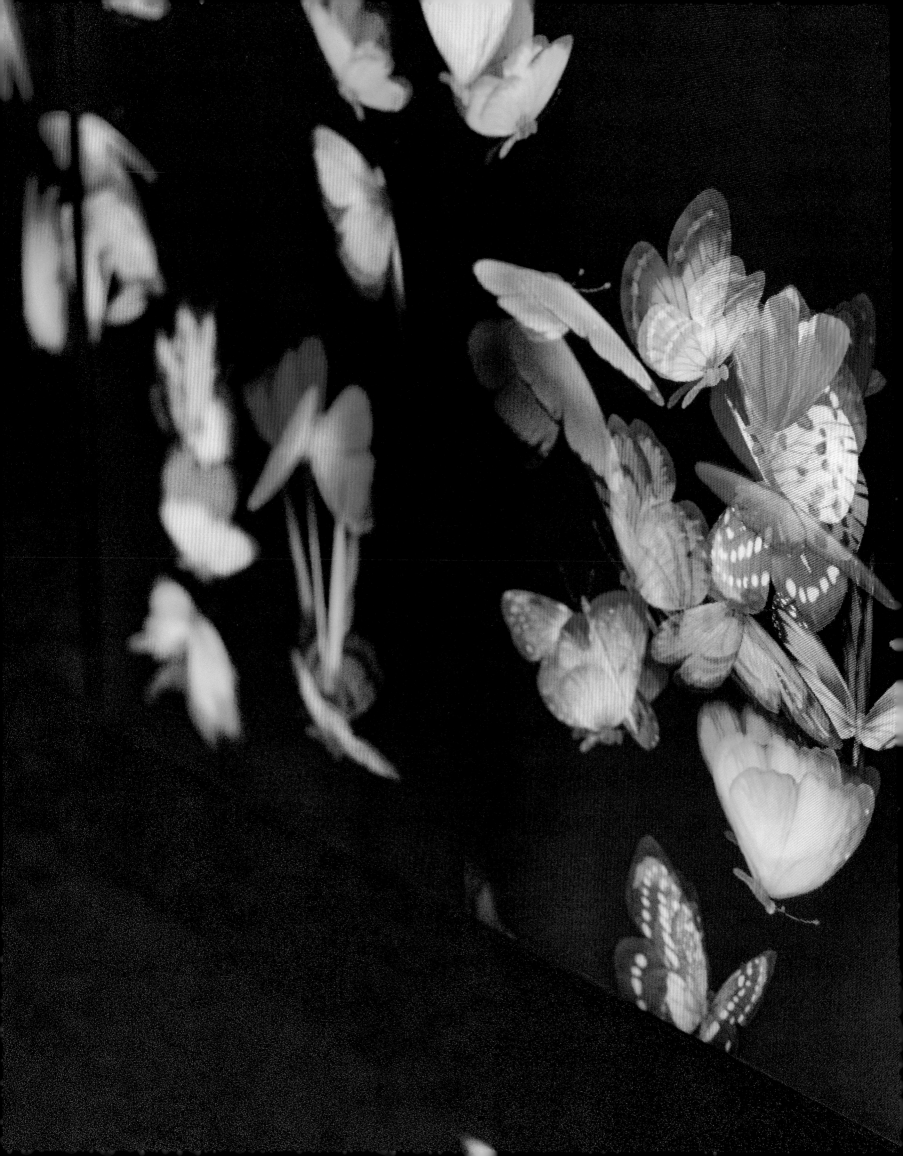

Adam

Booth

Art Director, Computer Graphics

Everybody Plays a Little Bit

Background

I'm from the United Kingdom, and I've been in Japan fourteen or fifteen years now. I studied fine art in the UK, at the University of Birmingham. Then I studied the arts of Africa, Oceania, and the Americas at the University of East Anglia in Norwich, in the Sainsbury Research Unit.

While I was studying, I got interested in Japan, which was completely off my curriculum. At

that time, I was more interested in South America—arts of the Olmec and Aztec and Maya, but also contemporary works.

I was introduced to Japanese art through a Rinpa exhibition at the British Museum in London. I was struck by the contemporary feel to it, even though it was about five hundred years old. I came to Japan, and eventually I got a scholarship to study Japanese painting at Tokyo University of the Arts. I stayed on until I got my doctorate.

I was looking for some things to do, and I came across teamLab. What teamLab was doing—looking very hard at traditional Japanese paintings and aesthetics and using technology to reinterpret them—was fascinating. I was particularly interested in the way Inoko-san [Toshiyuki Inoko, teamLab's founder] was attempting to create space that is like that in folding screens or *emakimono*, illustrated handscrolls. They're very open for you. You can look at them in many different sections, or you can look at them as a whole.

Iconography

I've always been interested in iconography and what elements in art mean. When I came to Japan, I saw paintings of elephants by Tawaraya Sōtatsu [c. 1570–c. 1640]. They're not elephants, but they're elephants. And my thesis started off from that: "What are these? I can tell it's an elephant, but maybe that's only because people tell me it's an elephant."

It's a simplified style, but it's also coming from the tradition of religion and ways of thinking and seeing the world from different cultures. So I try to collect lots of elephants and other symbols and iconography from art and compare it and see how things have come to the shape they are.

In my own paintings, I started messing around with iconography to try and get people engaged in the work by having something that makes them go, "Ah," but then makes them think about the work.

Technology and Art

Before I came here, it wasn't really my intention to work with digital art. But I remember that when I got my ZX81, one of the first home computers, I tried to make little characters on it. It was a challenge to try and represent something visually through code. I think that's always stayed with me.

When I started at teamLab about ten years ago, the technology was only just coming out. As I've been working here, it's been so exciting because now the technology is really there to make stuff that's both high quality and interactive and immersive. That's why we've been able to do something like the *teamLab Borderless* exhibition. With the advancements in technology, we started thinking, "Well, do we have to have one artwork as a finished piece?"

Now teamLab's work has evolved, and we're trying to break down the borders between works so that it's like another world. With current technologies, time is so much more relevant now that things are changing constantly. Your experience of an artwork could be quite different each time you view it. One day, you might see all red flowers, and that might stir you in some way. But you could go at a different time, and it would be all yellow sunflowers, and that would make you happy. What other people are doing and how they interact with the work can also change your feelings toward it.

Teamwork

I do art direction for a lot of the kids' projects, such as the *Athletics Forest* in *teamLab Borderless*. And I do quite a range of things, to be honest. I design the shapes of 3-D models, and I do textures for them. I also direct people who are making models, so I both practice and direct.

We work in teams, but we often bring in other people to get different ideas and opinions. It's become very evident that no one person can make or do what we do. There are a lot of challenges involved because we're trying to maintain a quality for the aesthetics, the interaction, and the digital/technical side.

I might have an idea about how something could look. But then the engineer or the interactive guy will say, "Well, we could do it this way." They have their set of skills, but even though they can do amazing things, they don't quite know how to make it into something. We have to have teamwork to do what we want to do.

It's important for me to touch technology in some way so that I can understand the back side of things, to a certain extent. I like that. It's really enjoyable, actually, to try to understand what's going on in the background.

As an artist collective, we like creating or experimenting with what is achievable, making new experiences, immersive experiences, making art that hopefully appeals to young people and the new generation. And perhaps inspiring other people to think about not just technology and art but also nature and their relationship with the world.

I was thinking about social networks, which have lots of people who are a little part in making something. The idea of mass collaboration may never have existed to quite the extent that it does now. In a way, having so many people here at teamLab is just something natural today. Everybody plays a little bit, which is very interesting.

Art and Play

Inoko-san was amazed that people, particularly in the West, bring their kids to galleries. It got him thinking, "Why not? Let's get everybody involved." It's important for us to get children to enjoy the art but also to take part in it. If they want to draw, we try and make them run and jump and move around.

We're not interested in making games for phones. We want to make art physical and immersive, something that moves the children and gets them communicating with each other through their bodies. At *Athletics Forest,* we deliberately made the floor a little uneven. It's an artificial nature, but maybe it will get children back in touch with nature. Because that's something we've been thinking about.

I'm interested in what will be left over in children's brains from all the sensory input at *Athletics Forest.* There are all these lights and colors and changes and things. Probably it creates quite an impression on them, like going to the movies.

We want adults to enjoy it too. So we try and make it visually appealing for them as well. The kids are proud to have taken part, but then the adults are amazed by what the kids are doing, and also they're very much a part of it themselves.

This text is edited and excerpted from an interview with Karin G. Oen on December 24, 2018.

A Vast Ocean,

a Boundless Sky:

The Digital Liberation of

teamLab

I

Miwako Tezuka

FLOWERS,
BIRDS,
WAVES,
WATERFALLS,
AND CALLIGRAPHY — there are many obvious
connections between these recurring motifs in teamLab's
digital work and in traditional Japanese art. teamLab
makes its historically resonating choices of imagery
according to its theory of Japanese spatial perception,
"ultrasubjective space" *(chōshukan kūkan)*, where
there is no boundary between the object (the image)
and the subject (the viewer).[1] In such space, the image
constantly engages the viewer to actively perceive
rather than passively receive information. This kind
of engagement with art is often found in traditional
Japanese architecture originally built for the upper class,
such as imperial villas, aristocratic mansions, castles
of warlords, and powerful Buddhist temples. Through
paintings on walls, ceilings, and various movable
partitions like sliding doors *(fusuma)* and folding screens
(byōbu), traditional artists aspired to create immersive
environments that transcend—not only metaphysically
but also physically—the division between inside and
outside. To do so, they often filled rooms with painted
images of elements and aspects taken from nature

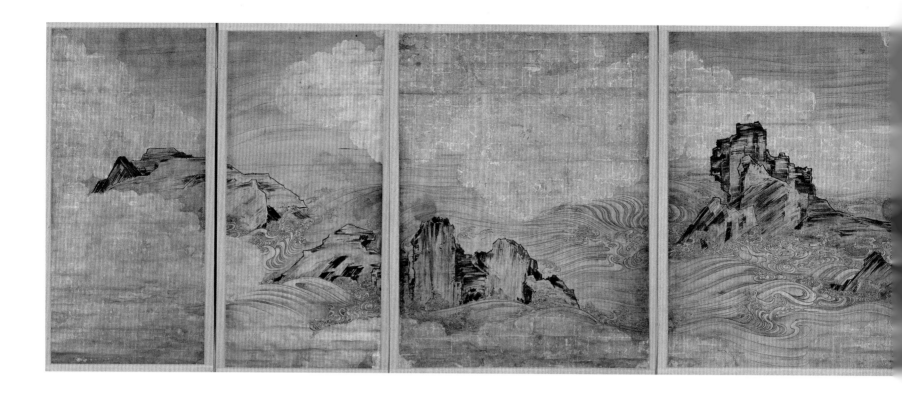

that embraced the audience inside.² Taking a cue from teamLab's choice of classic motifs, this essay ruminates on the way this twenty-first-century technologist group mines the fluid nature of Japanese architecture and adapts it into its digital installations. teamLab's creative approach may present an aspiration for a paradigmatic impact on art, technology, and also society.

A VAST OCEAN

One of the rooms at Eikan-dō hall of Zenrin-ji Temple in Kyoto presents a quintessential example of the synergistic relationship of the image and the architectural space. A series of sliding doors around the room was originally decorated with a panoramic painting by Hasegawa Tōhaku (1539–1610), who is considered to be one of the greatest masters of ink painting in Japanese art history. It shows a dramatically singular motif of billowing waves (fig. 1). As if cast into the vast ocean with a rugged coastline, viewers would have found themselves amid the image of moving water wherever they chose to stand or sit in the room.³ The painting was an integral part of the architectural space, and viewers were literally inside the painting. This physical condition provided an opportune situation for the artist to thoroughly concentrate on capturing something conceptual and beyond the visible—the life force of nature that flows through people. When seeing the painting section by section, the space appears ambiguously flat without a vanishing point. This flatness is

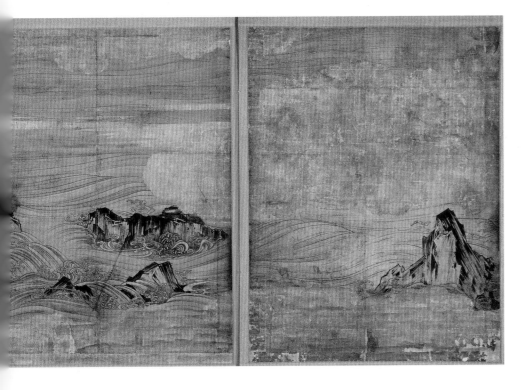

1
Hatō-zu (Waves), c. 1599.
By Hasegawa Tōhaku (Japanese; 1539–1610).
Sliding-door paintings remounted as twelve hanging scrolls; ink and gold leaf on paper. Four scrolls: height 185.0 cm, width 140.5 cm (each image); two scrolls: height 185.0 cm, width 89.0 cm (each image). Zenrin-ji Temple, Kyoto.

2 OVERLEAF
Gold Waves—Continuous, 2018.
By teamLab (est. 2001). Sound by Hideaki Takahashi (b. 1967).
Digital installation with sound.

further magnified by the use of gold leaf, whose reflectiveness keeps the viewers' gaze on the surface rather than giving an illusion of depth.

The vital liquid force of the painting is imparted not by realism but by a rhythmic undulation of lines, sometimes quietly thin and calm, and other times twisting and curling as if dancing. The waves break here and there as they crash into sternly solid, jagged boulders contoured and textured with sharp and crystalline brushstrokes called ax-cut strokes. The contrast between the calm and the turbulent as well as black and gold must have transformed the room into an overwhelming sensory field—more real than realism— that could even inspire sounds of waves in the viewers' minds. And yet, since the support of the painting was movable, the compositional rhythm was always changeable by simply opening or closing the sliding doors, breaking away from a single relationship between the image and the viewer.

teamLab does not claim to draw inspiration from this specific sixteenth-century work by Tōhaku. After all, there are numerous paintings from throughout Japanese history with the motif of the ocean and waves. Yet today's "ultra-technologist" collective inherits Tōhaku's level of audacity and his approach to the seamless merging of the object and the subject in its works focusing on the wave motif, such as *Black Waves* (2016) and *Gold Waves—Continuous* (2018, fig. 2).[4] In creating the continuously looping movement of the waves, teamLab analyzed movements of particles in water and effectively translated them into bundles of glowing lines in a computer-generated three-dimensional space. When lines are densely packed, they create the impression of solid volume; when sparse, they appear sinuously soft.

The vitality of the waves is amplified programmatically and also spatially as the projection of the digital image engulfs the installation space. And, importantly, this projection does not exclude the viewers; as they walk around the space, they merge into the image when the projection is cast onto their bodies. The customary distinction between the projection screen and the audience does not exist in this space; in fact, disregarding such distinction is encouraged as one viewer sees another become part of the waves and

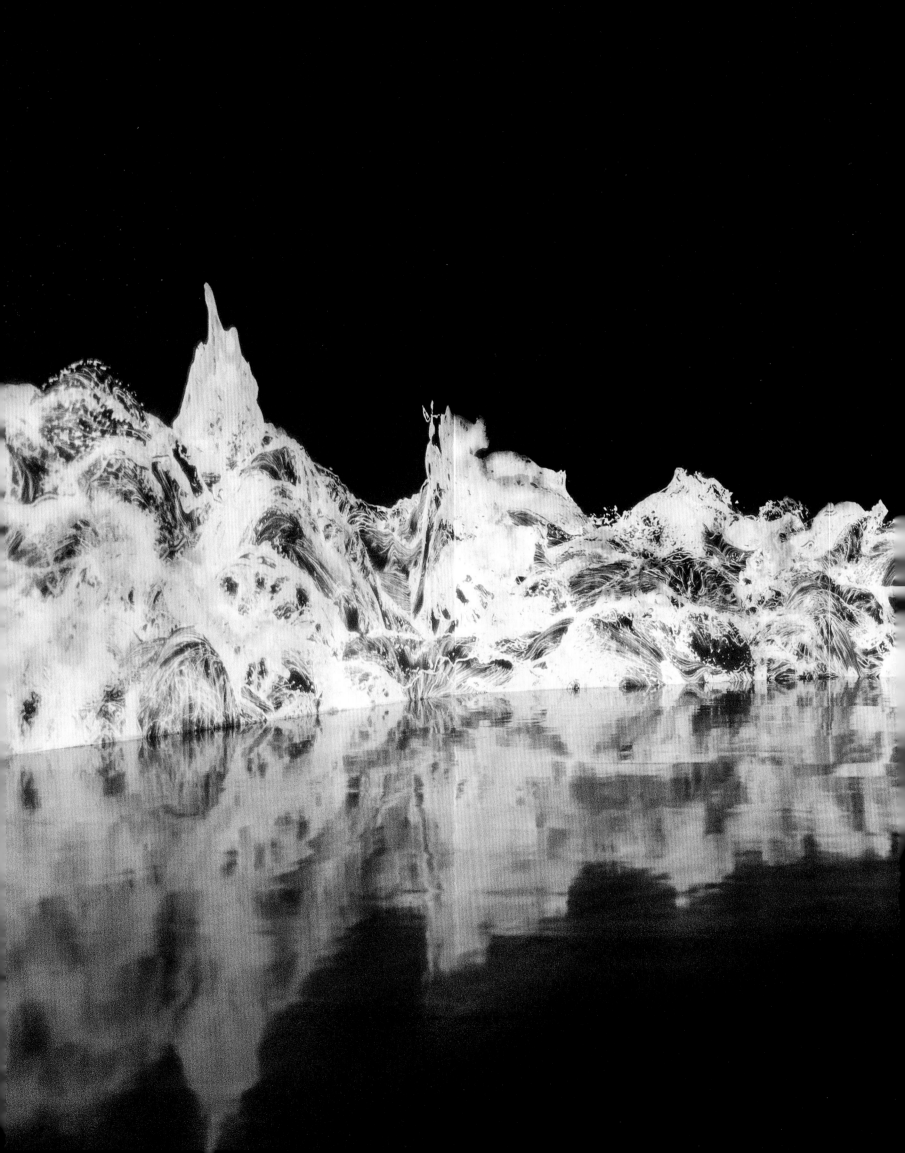

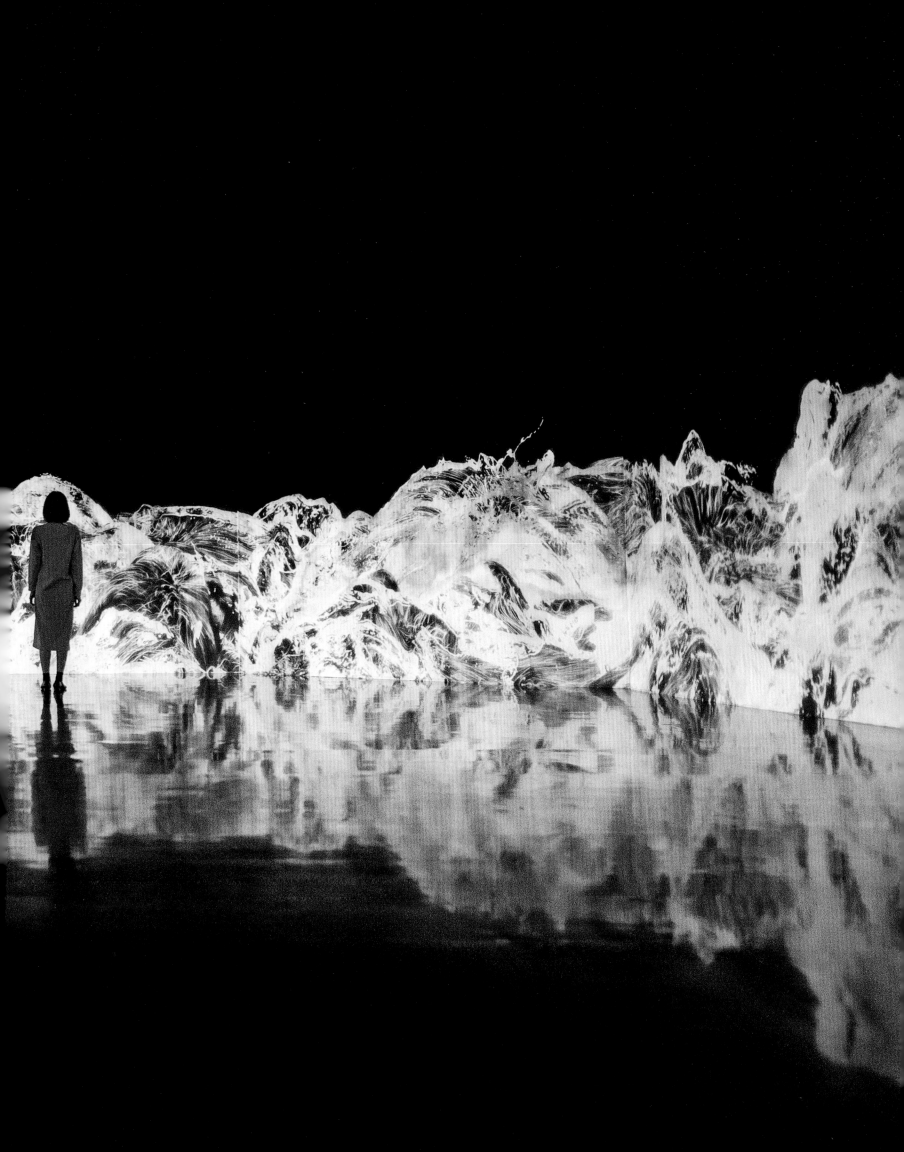

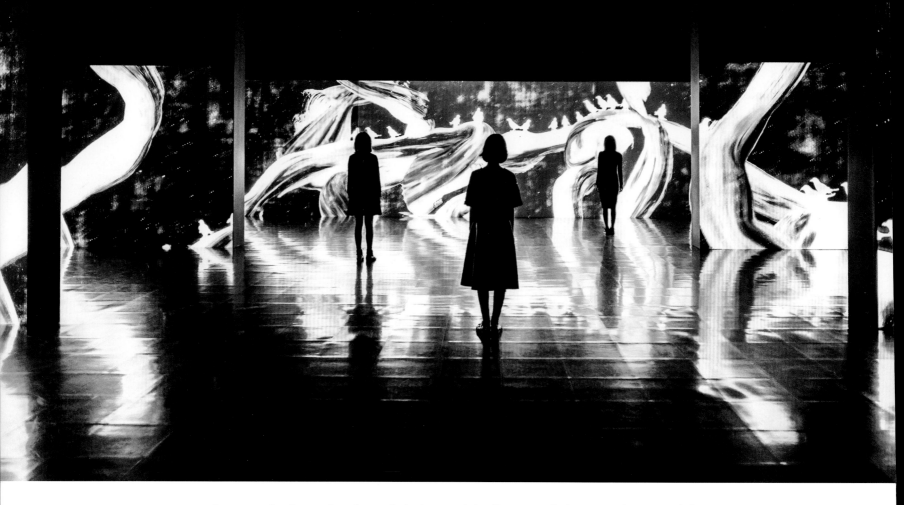

3
*Crows are Chased and the
Chasing Crows are Destined to
be Chased as well, Division in
Perspective–Light in Dark*, 2014.
By teamLab (est. 2001). Sound
by Hideaki Takahashi (b. 1967).
Seven-channel video with sound,
4:20 min.

4
Uro-zu (Crows and herons),
after 1605. By Hasegawa Tōhaku
(Japanese; 1539–1610).
Left screen of a pair of six-panel
folding screens; ink and colors on
paper. Height 154.2 cm., width
354 cm each. Yusaku Maezawa
Collection, Chiba.

vice versa. In the works of teamLab, interactivity lies not only between the art and the
viewer but also among the viewers. teamLab states:

> In premodern Japanese painting, oceans, rivers, and other bodies of water were
> expressed as a series of lines. These lines give the impression of life, as though
> water [were] a living entity. This form of expression leads us to question why
> premodern people sensed life in rivers and oceans. Also, why did they behave as
> if they themselves were a part of nature? Perhaps something can be discovered
> by fusing the fixed objective world of today's common knowledge with the
> subjective world of premodern people.[5]

Seeing every element that constitutes our surroundings as "a living entity" allows for an
empathetic perception and comprehension of the world. As teamLab implies, the objective
perspective of the world assumes separation of the object being viewed from the subject that
is viewing. But the goal teamLab sets for its work is the creation of a space where there is no
such objectification.

Analyzing the premodern style of Japanese architecture helps us understand the
kind of viewer experience teamLab is trying to revive. Through flexible structural designs
and images that move with them, Japanese architecture maintains a fluidity of space inside
and outside and a close connection to the natural environment.[6] teamLab's formation of a
borderless and empathetic nature of viewing is derived from this spatial fluidity in Japanese
architecture. The world has largely replaced this spatial flexibility with an anthropocentric
logic that forms "today's common knowledge."[7] But teamLab is recalibrating a constantly
transactional space not just as a physical platform but also as an immaterial digital platform.

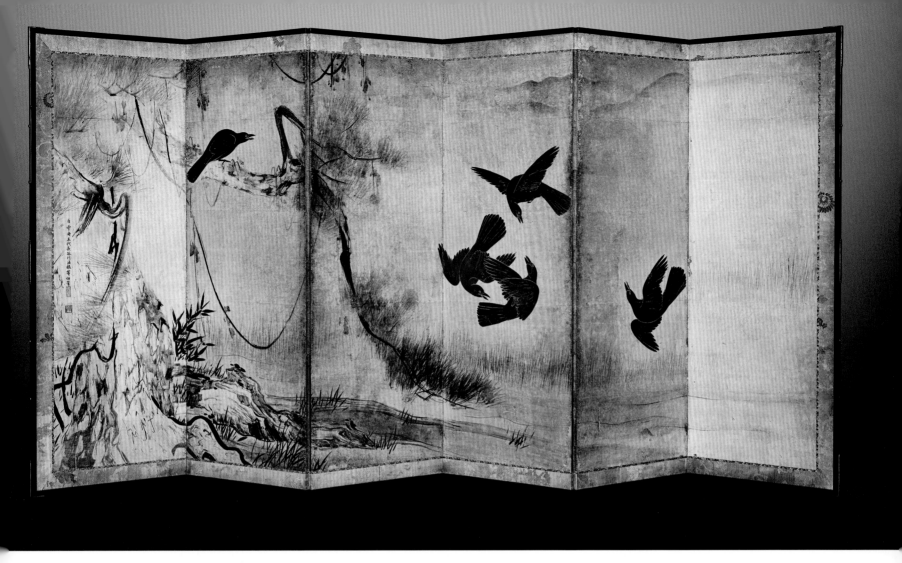

A BOUNDLESS SKY

As unabashedly contemporary as its use of digital technology and presentation is, teamLab steadfastly focuses on examining the tradition of Japanese visual expressions and how this modality may reflect the way premodern people perceived the world. There is, thus, always a curious art-historical déjà vu sensation when encountering teamLab's work. For example, the 2014 installation of *Crows are Chased and the Chasing Crows are Destined to be Chased as well, Division in Perspective—Light in Dark* has multiple points of reference to historical masterpieces of Japan. Like the wave, the bird is a recurring motif in Japanese painting throughout history and a key component of the classic bird-and-flower painting (*kachō-ga*). teamLab's *Crows* features mythical three-legged crows called *yatagarasu*, symbols of the sun and messengers of the will of the gods. For the duration of their digital apparition, they fly around in a visually undefined dark space, chasing each other and, after colliding, turning into colorful flowers and scattering their petals (fig. 3).

 Uro-zu (Crows and herons, fig. 4), another work by Hasegawa Tōhaku, is a bird-and-flower painting from the late Momoyama period (1573–1615) that can be compared to *Crows*. It takes the form of a pair of folding screens, which are often used as movable partitions in traditional Japanese architectural spaces. When both screens are fully extended, the painting is more than twenty-three feet long and five feet high. Most relevant to *Crows* is the left screen, in which four crows frolic in midair while another, perched on a strangely elongated pine tree branch, looks on at their aerial dance. The composition generates a sense of movement and is rendered in brushstrokes supple with liquid dexterity. Barely anything

is visible in the background. A grass-covered field and distant mountain ranges are scarcely there. The black bodies of the birds seem to be the only concrete presence. They make a stark contrast to the nebulous atmosphere lingering in the gold-toned background. Everything else seems as though still in a process of physically manifesting itself.

Beyond the obvious connection of their ornithological motif, *Uro-zu* and *Crows* share another characteristic. They both suggest a potential fluidity of our spatial perception, one freed from the prescribed logic of perspective. teamLab's crows, soaring in digital space and "leaving trails of light in [their] wake," create "spatial calligraphy."[8] They move at such high speed that viewers cannot keep a steady focus on any one thing at any moment. The installation further denies the one-point perspective as the images of the birds and calligraphic lines move freely in and out of a series of five large freestanding projection screens, standing in three parallel, equally distanced layers. One long, centered screen stands along the back wall. Four other, shorter screens are set toward the left and right of the room, two on each side, in staggered positions. In this manner, the central space of the room appears to be opened by splitting the first two layers of screens as you enter the room. The effect is close to that of a series of rooms in a traditional Japanese building where sliding doors allow for flexible spatial arrangements; they are closed for privacy or opened for less intimate or larger gatherings of people. teamLab claims:

> Ultra Subjective Space allows us to freely "split" the plane into parts. If you view only a part of a painting, you enter the space represented by only that part. You can also divide by "folding" the plane.[9]

In essence, an ultrasubjective space is extremely malleable, just like Japanese architecture. Sliding doors can split a space and folding screens can create layers of imagery in a room. Yet each change to the space or its imagery reveals a new spatial aspect rather than fragments the room. Immersed in *Crows*, in a dark room lit only by projections, viewers can literally chase after images of birds, from one screen to another, as if they themselves are part of the installation. Their bodies turn into shadowy figures that cross in front of multiple projection screens—in and out, from one surface to the other—commingling with the artwork in its frenzied atmosphere. And those screens never compartmentalize the

relationship between the work and spectators-turned-participants; rather, in the darkened gallery, they mark the space in shifting layers and intensify the sense of motion.

Similarly, Tōhaku's crows appear in a boundless expanse poised by calligraphic traces—from flowing lines of tree branches, through swishes of pine needles, to sinuous curves of hanging vines. The viewer's eye and mind engage with these trajectories packed with signs of movement. The vigorous action is as much a part of this classic painting as it is in teamLab's twenty-first-century counterpart.

Pairs of folding screens such as *Uro-zu* are most often displayed side by side in modern gallery settings, with each panel evenly spread open to produce a symmetrical balance. However, in their original context screens were displayed with varying arrangements according to specific spaces and occasions. This is illustrated in a monochrome picture scroll of the *Tale of Genji* in the collection of the New York Public Library (fig. 5). A pair of zigzagged screens stand facing each other at the lower left of the composition. They are partially overlaid with two parallel partitions obstructing a part of the painting on the rear screen. The arrangement of multiple screens creates a complex assemblage of different angles and planes in the room.

Such flexibility expands the field of visual and spatial experience and frees viewers from the rules of symmetry and predetermined order. Tōhaku's *Uro-zu*, too, could be arranged in a variety of configurations. Because the world depicted in it does not rely on a singular vanishing point, viewers' relationship to the image would simply shift, rather than dislocate, when its panels moved. This shift could present a new aspect of nature or a narrative. Where there are no perspectival rules to follow, "All the viewers can take part in an artwork from their own individual positions, without any priority over anybody else."[10] This, indeed, is an ultimately subjective approach to art that is shared by Tōhaku and teamLab.

A VAST OCEAN LETS THE FISH SWIM;
A BOUNDLESS SKY LETS THE BIRD FLY

teamLab's harvesting of inspiration from Japanese architectural and artistic masterpieces should not be seen merely as a nostalgic return to a bygone era or as a maneuver to forge a national or cultural identity. As a medium, digital technology—unlike, say, screen paintings or hanging scrolls—does not suggest a specific cultural identity.

Instead, the change in the type of audience for traditional Japanese art and teamLab's experiments should be considered. While Tōhaku produced works for and only accessible by upper-class, elite Japanese viewers, teamLab is creating for a global mass audience. Characteristics of today's public and how these characteristics affect the nature of art were already anticipated by a number of 1960s new-media artists, for example, Hiroshi Kawano (1925–2012). As an aesthetician and the first artist in Japan to create computer art, he prophesied that art would become a medium of mass telecommunication for people. Kawano stated in 1969:

> Contemporary society is being newly created by participation of the masses....
> I think artists and designers who use computers need to establish their own
> methodological principles based on scientific theories. At the same time, they
> need to be socially and politically responsible for utilizing and maintaining
> computer art for people's peace and happiness.[11]

For teamLab, digital technology can free art from materialism. The physical components of its work—such as the screens discussed above—are secondary to this utopian belief. The physicality of art, which conventionally invests a unique object with a value based on its philosophical reception or other economic considerations, is a shackle that keeps at bay the paradigm shift from art as material to art as mass communication with the audience. Setting its theory of ultrasubjective space as its methodological principle, teamLab is testing a new value of art by integrating viewers into various degrees of interactivity with its work. Some of teamLab's work includes motion-sensor systems that literally merges viewers' bodies with projected images and leads to meta-level interactivity among the viewers. In this way audience members are agents of compositional changes. Moreover, the viewers' acts of sharing images of and comments on teamLab's art on social-media platforms have become a constitutive element of the art of the collective. In this paradigm, ultimately, shared information is the art and the audience is its medium. teamLab's founder Toshiyuki Inoko says:

> Through the blurring of the borders between people and artworks, the viewers
> themselves become part of those works, and their relationship with "the
> other" starts to change as well. The relationships that one usually maintains
> in the city—separating oneself from "the other"—now become one stage of a
> continuum. We provide the opportunity for people to reflect on and rethink the
> borders that they had assumed existed between themselves and others.[12]

There is a Zen Buddhist phrase, "A vast ocean lets the fish swim; a boundless sky lets the bird fly."[13] It alludes to an ultimate state of freedom when people shed the shield of self-consciousness and are fully in their authentic element. If the digital liberation pursued by teamLab could be achieved and we start seeing no division between the self and the other, between inside and outside, or between art and technology, such art may yet reveal a completely new paradigm of social existence that is safer than that of today and infinitely empathetic.

1 teamLab frequently uses the term ultrasubjective space. See, for example, "Ultrasubjective Space: Pre-Modern Knowledge and Ancient Japanese Spatial Recognition," teamLab, accessed June 5, 2019, https://www.teamlab.art/concept/ultrasubjective-space/. Yuki Morishima's essay in this catalog elucidates this theory in relation to the characteristics of traditional Japanese painting.

2 It is said that the early Chinese ink painter Zong Bing (375–443), after falling ill, decorated his room with painted landscapes of places where he had once traveled. In this way he could still enjoy the journey in his mind's space, even as he lay bedridden. Since the Muromachi period (1392–1573), Japanese painters avidly studied the ink-painting traditions of China—its brushstroke techniques, compositional devices, and subject matter. Yoshiko Fukuda and Rika Heima, *Treasures of Kinkaku-ji and Ginkaku-ji: Sesshu, Tohaku, Sotatsu, and Jakuchu* (Kurume: Ishibashi Museum of Art and Foundation for the Preservation of Arima Memorial Museum, 2013), 11.

3 Tōhaku's paintings have been removed from the sliding doors and remounted as a group of hanging scrolls.

4 "Ultra-technologist" is a term teamLab uses to describe itself. See, for example, "teamLab—Ultra-Technologists," teamLab, accessed July 8, 2019, https://www.teamlab.art/press/widewalls161108.

5 "Black Waves," teamLab, accessed June 5, 2019, https://www.teamlab.art/w/black_waves/.

6 H. Mack Horton, "Introduction," in Kazuo Nishi and Kazuo Hozumi, *What is Japanese Architecture?* (Tokyo: Kodansha International, 1985), 7–11.

7 "Black Waves."

8 teamLab, *teamLab* (Tokyo: teamLab, 2015), 146.

9 Ibid., 49.

10 Ibid., 97.

11 Hiroshi Kawano, *"Konpyūtā āto no rinen"* (The principle of computer art), *Graphic Design* 33 (March 1969), 47–48. Reprinted in Jung-Yeon Ma, *Nihon media āto shi* (A history of media art in Japan) (Tokyo: Artes Publishing, 2014), 70–71. (My translation.)

12 Naoko Aono, "The Vision of Toshiyuki Inoko, a Founder of teamLab," *Pen Magazine International* (August 29, 2018), https://pen-online.com/arts/the-vision-of-toshiyuki-inoko-a-founder-of-teamlab/?scrolled=4.

13 大海從魚躍，長空任鳥飛. This is a Chan (Zen in Japanese) Buddhist phrase originated by the eighth-century Chinese monk Yuan Lan.

CROWS ARE
CHASED AND
THE CHASING
CROWS ARE
DESTINED
TO BE CHASED
AS WELL

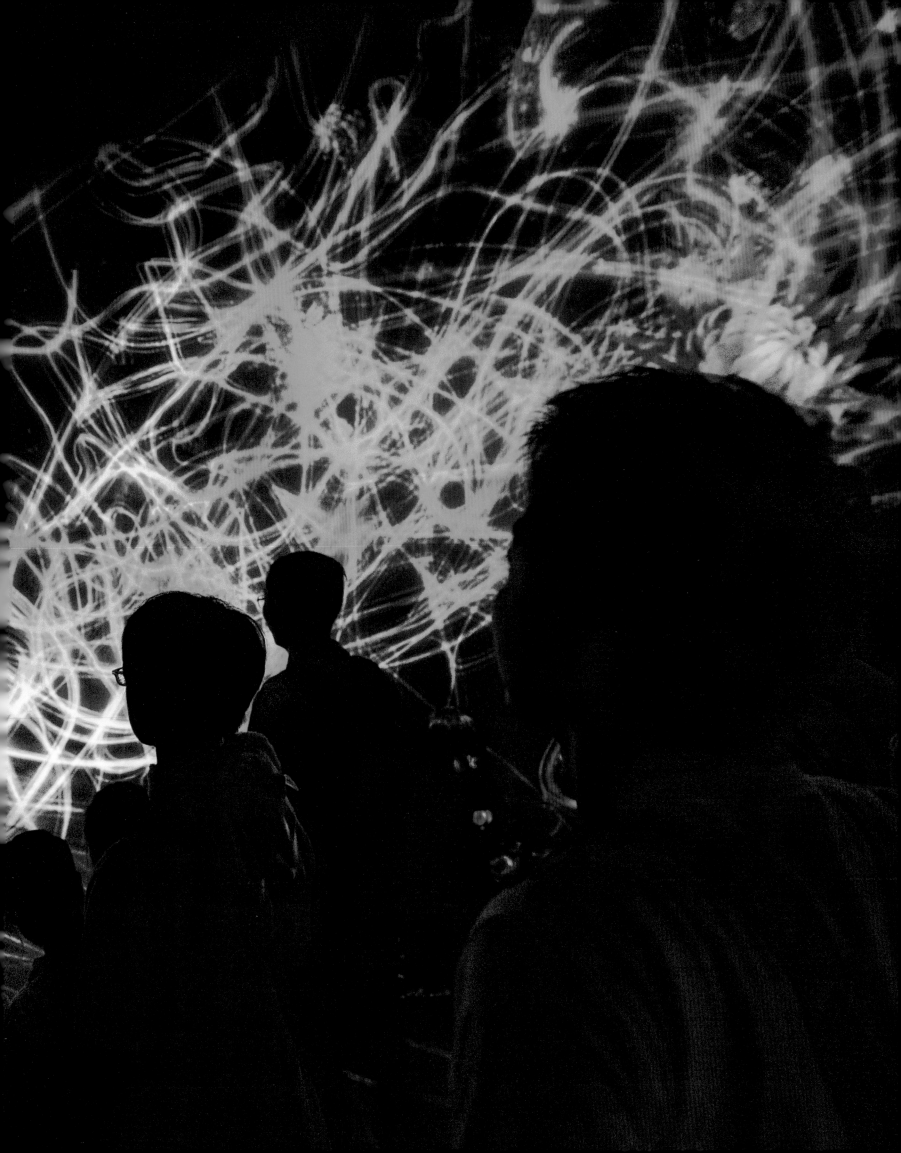

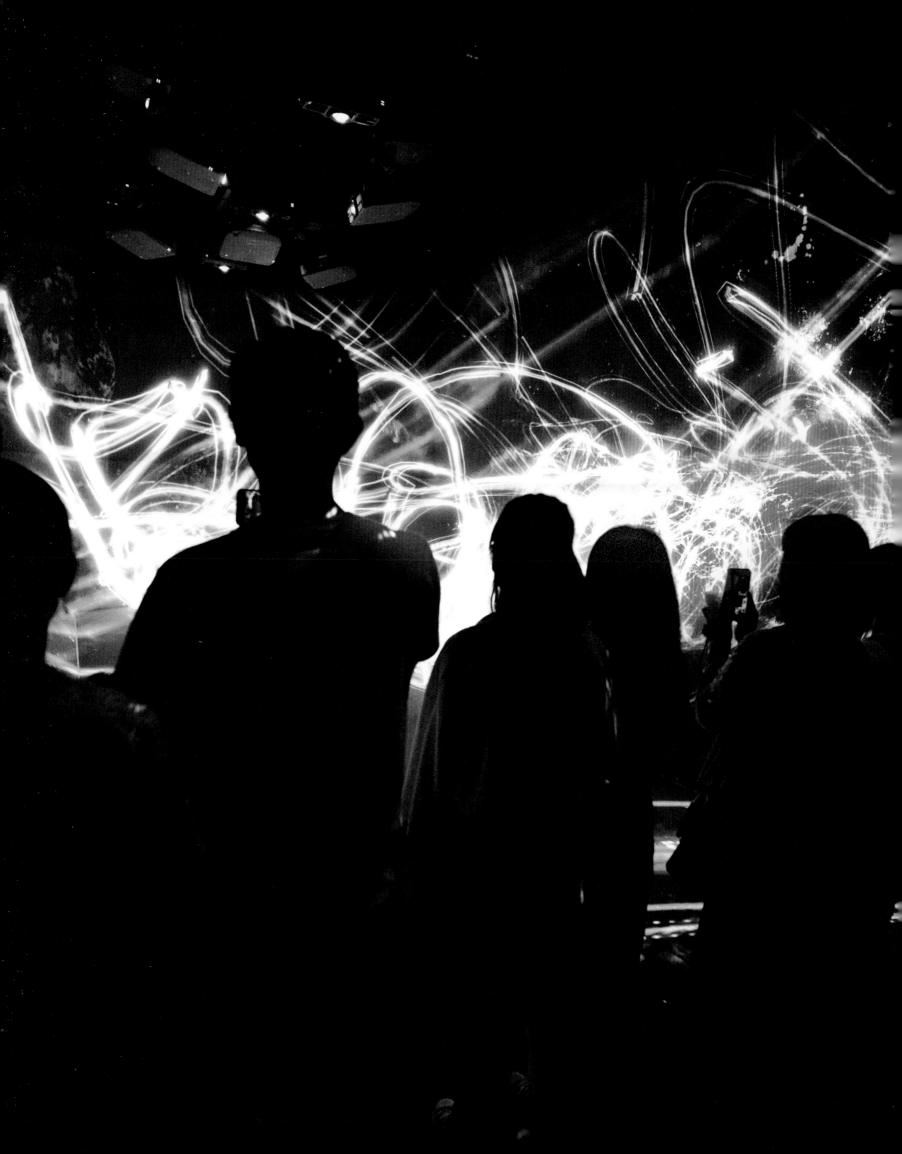

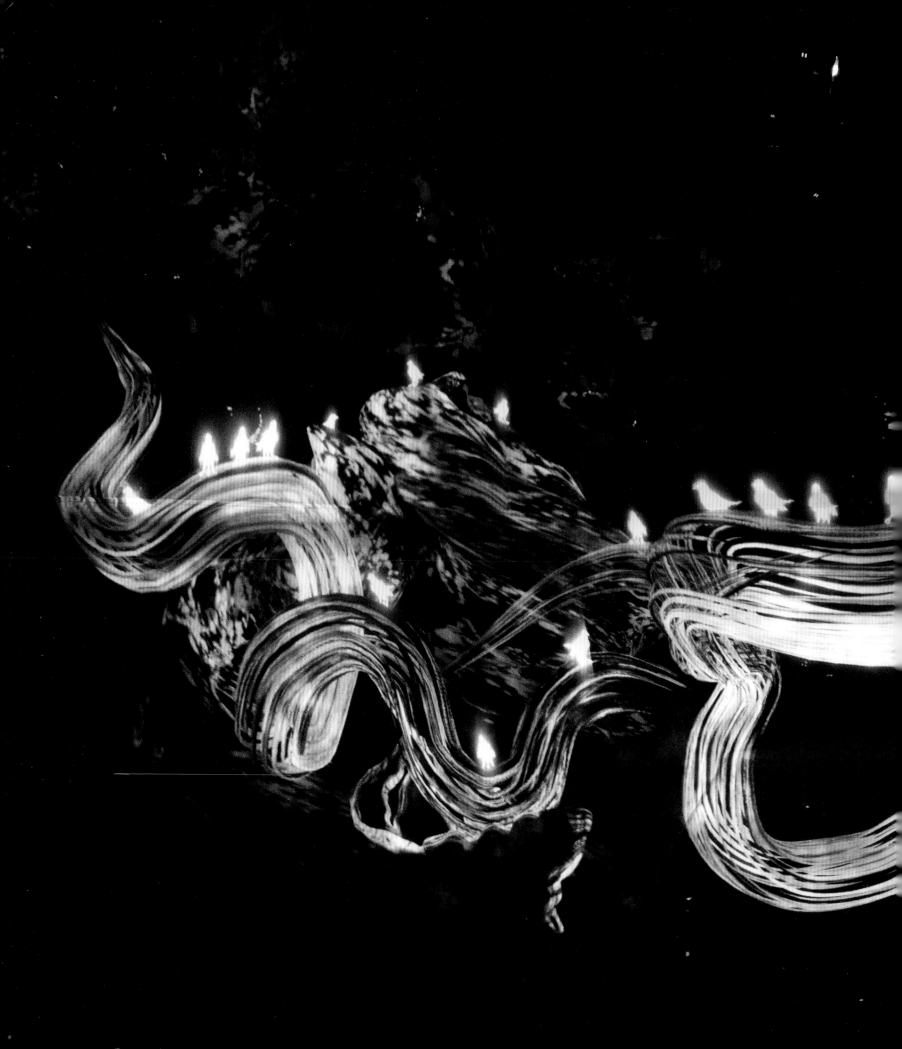

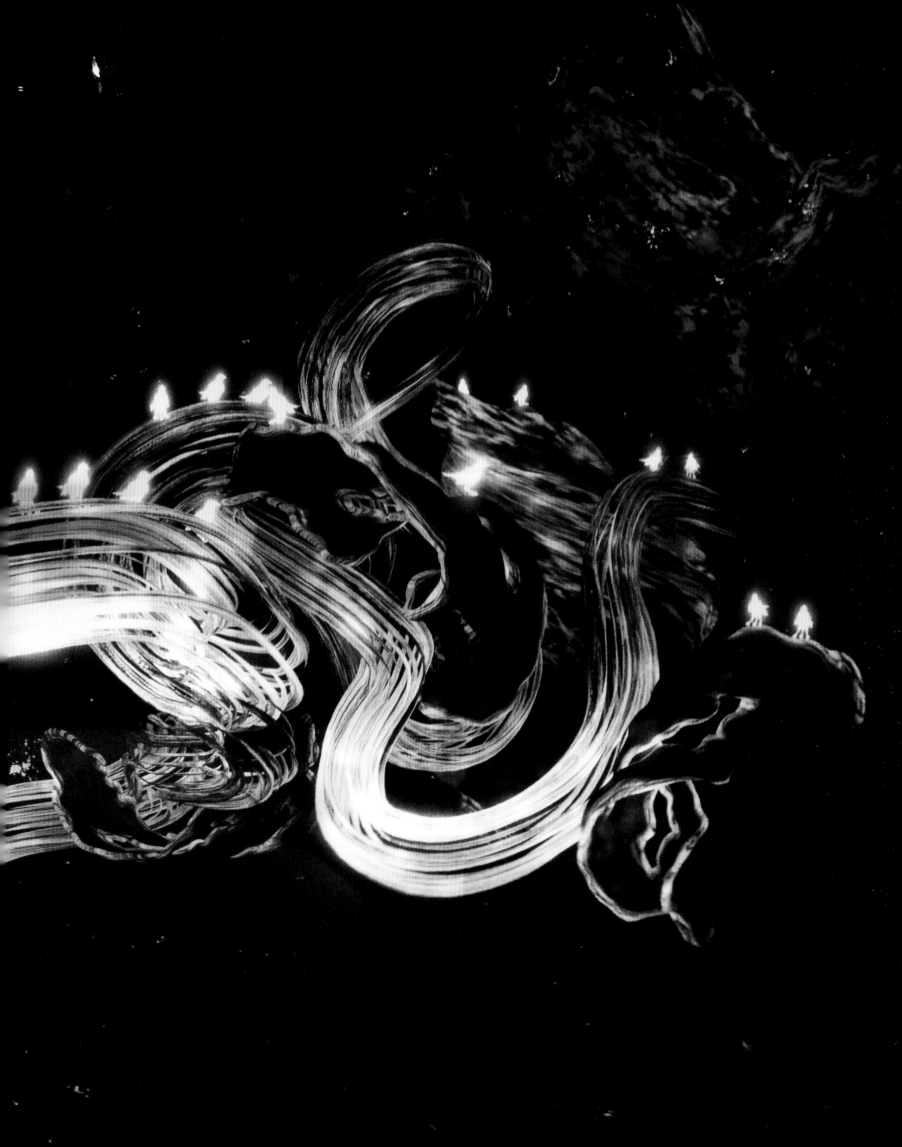

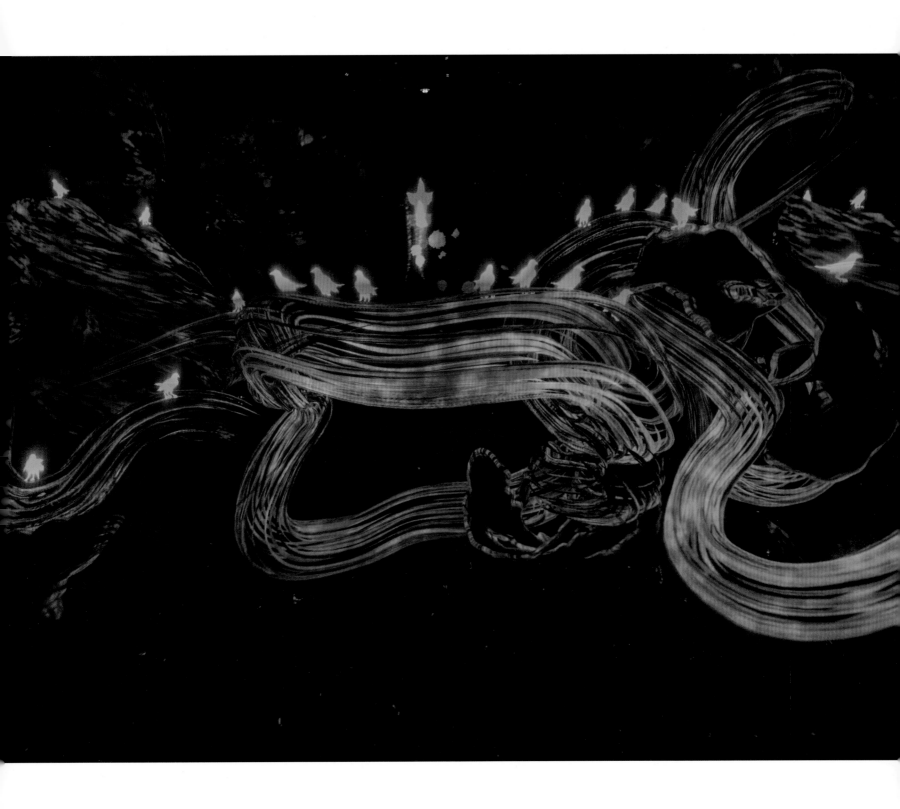

Shogo

Kawata

Architect

The Relationship between Space and Architecture and Art

Background

I'm an architect, and I'm responsible for teamLab Architects. I went to school in Kyoto and was influenced by Dumb Type, a collective of architects and media artists.

In video art, back then, Kyoto was more advanced than Tokyo. Dumb Type got me interested in exploring the relationship between space and architecture and art.

When I was in college, I designed a café with a pillar of light at one spot and sound playing from somewhere else. It mixed where you were with somewhere else. I was thinking somewhat negatively about being connected to other people through the Internet without really having control of it.

I graduated from architecture school in 2003, when Japan did not have a very strong economy. At the same time, the practice of architecture was not exactly what I was interested in. I got a project with a security company to design a lecture room where they taught people how to trade currency. I created a light system for the room. When the price would drop, the room would turn red. When it went up, it would turn blue. We found that as soon as the room became red, everyone left. So the company made me keep the blue light on continuously, regardless of the fluctuation of the currency prices. I saw how people's emotions were changed by things like numbers—things that are completely outside our physical world.

Architecture and Social Change

Architecture at that time was being built according to pre-Internet concepts. It seems architects were using media just to explain themselves, rather than as a tool to think about how society was changing or how it's supposed to be. I'd rather explore how we should approach the new age of technology.

Architecture has been elemental during major social changes. With the agricultural revolution, people started to settle down and construct buildings. During the industrial revolution, building components were mass produced in factories. Now, during the information revolution, I wondered what would be the new way of dealing with space and architecture. That's how I became involved in teamLab's activities.

When I started here fifteen years ago, the Internet hadn't really permeated society and our everyday lives. Now we live between and work across the digital and the real, constantly going between these two domains. That changed our mindsets and also relationships between people. I think that definitely transformed the way we perceive space. That's what I really want to explore, understand, and interpret through what I do at teamLab.

Exploring Space

Since the onset of digital art, it's only been experienced through a given screen size. We take that for granted. But digital work doesn't have to be limited to a certain frame. One of the aims of teamLab Architects is to destroy that limitation. Something as simple as that could change the way we are.

Another thing I'm exploring is the concept of time. Through digital means, we can grow the idea of time into space, which is typically a fixed thing. By introducing digital components, we can actually stretch the axis of time or shrink it. For example, in the digital world we can create seasons within a certain time span that is shorter than a year.

Digital technology can affect the relationship between humans and space. Conventionally, space exists—a building exists—regardless of people. But through digital means, we can transform space by the presence of people or even by the motion of people.

Theory in Practice

The first teamLab piece I was involved with was *Flowers are Crimson*, in 2005. The atypical proportion of the

work—16:9—was created by joining five TV screens into one. This was the first step in going outside of the limitation of one screen. But this merely enlarged the frame. The viewer was not a part of or immersed in the work. Then, with *100 Years Sea Animation Diorama, 2009*, we started to fold the screen to create something more spatial. This has the same proportion as *Flowers are Crimson*. The difference is that the five screens have been folded into a C shape. In the next step in this exploration of space, we divided one frame into smaller frames and spread them throughout the space. The *Forest of Flowers and People* installation at the Asian Art Museum of San Francisco in 2020 is the latest such spatial exploration.

The project *Crystal Forest, Shenzhen* (scheduled for 2021 is an experiment in the city and about the city. It's about the current transformation of cities and how people behave in cities. Urban public space has been increasing through making private space open to the public. For example, Uber and Airbnb are bringing what was originally private to the public. *Crystal Forest* explores inserting a more private experiential space into the city, which is largely public, in order to create some comfort. In this huge urban development in Shenzhen, there is a fully glazed event building. Around it, there are a bunch of pillars with LEDs that change colors. During celebratory events, special effects will travel through this area and out to other parts of the development. Celebration is a most private thing. But through this project, it can be physically shared with other people in the space.

In *An Office Where Animals Live*, 2017, at the DMM headquarters in Tokyo, the role of space has changed. Conventionally, spaces have been determined with specific purposes—restaurant, office, etc. The program determined everything. Because of digital technology, space is no longer necessarily prescribed. Nobody would think this is an office by looking at it. But those who visit it will be surprised or moved to a certain extent. In a typical meeting floor, the receptionist's desk is the information hub. At DMM, all the information is controlled on an iPad. It no longer has to be fixed to a certain location. The human guides have been replaced by digital animals along the walls. A door will be displayed only when necessary. When there's a meeting, the space becomes an office. When there's no meeting, it's completely open for viewing art. With technology, the program or even the function can be changed according to the needs of visitors or users.

We designed DMM's office floor as well. Any kind of work is really difficult to break down into small tasks or roles. In order to help create the feeling that a project is being shared with all the members who are involved, we created a space where workers share the same surface—a one-kilometer-long table. We had to fill almost 1,000 square meters with images to cover the entire surface of the table. I went to the computer graphics team and had them explore methods to do it, and finally they found a way. The table shows waves during the day; during the morning the color is different. Everyone's desk is set at a different angle, so that everyone is facing other people. That creates different ways of communication.

This text is edited and excerpted from an interview with Karin G. Oen on December 24, 2018, with consecutive interpretation by Kazumasa Nonaka.

Minoru

Terao

**Visual Director,
CG Team Leader**

Pushing Japanese Art Forward

Background

I'm an art director and CG animator, and I've been with teamLab since September 2009.

I'm in charge of quality control of the visual aspect of overseas art and entertainment projects. Toshi [Toshiyuki Inoko, teamLab's founder] invited me to be involved in the production of *100 Years Sea Animation Diorama*.

Before teamLab, I worked at an anime studio in Japan, then I was

a freelance visual director. I found a tiny article about teamLab's work, *Flowers and Corpse,* and found it really interesting. It wasn't only because of the way it looked—like it was traditional Japanese paintings—but also that there was clearly computer graphics behind it. I looked at the teamLab website, and it was hiring computer graphic animators, so I applied. Then I met Toshi, and he explained to me what he thinks about not only art, but more about what it is to produce something in our time. I had my own idea about what I wanted to do through animation. And Toshi asked me to be part of teamLab.

When I joined teamLab, it already had completed *Spatial Calligraphy, Flowers and Corpse,* and some installations, but the concept of ultrasubjective space was not yet completely formed. But I saw its potentiality for the future, and I joined.

At that time, I didn't really know about Japanese traditional painting, except for the masterpieces that everyone knows. I started to teach myself about it, gradually. When I thought about the possibilities of joining it with technology or computer graphics or my imagination, my head kind of exploded.

Working with teamLab

When I joined, every member of teamLab was working on just a few projects at a time, and we had no money. Slowly, teamLab started to have projects with slightly larger budgets. Then Takashi [Takashi Kudo, teamLab's global brand director] joined, and we started to present our art to a world audience.

For *100 Years Sea,* there was Toshi working on the general overall concept, and me for the video part, and Takashi for the concept work, and some other members doing other things. The project size was much, much smaller than it is now.

Since I joined, I've worked on a series of artworks and also entertainment projects. Our sort of official debut to the art world was 2011's *teamLab "LIVE!"* exhibition at Kaikai Kiki Gallery in Taipei. But for two years before that, I did a bunch of experiments, including a hologram version of *Spatial Calligraphy.*

For *Life Survives by the Power of Life,* 2011, I proposed the concept to the members. It could start with a video from *Spatial Calligraphy,* and then life could come out from a tree around it to express the whole idea of life and what it is to be alive. Two animators came and finished the whole of the work in three months. That's pretty incredibly short, considering the production time we spend on works now.

A Typical Day

When I'm at teamLab, I typically review a bunch of ongoing projects. I have twenty or thirty projects simultaneously, although my commitment to each varies from overseeing quality control to the hands-on work of creating something. The main tasks for me now are to create the concept visuals to start the project and to determine how the work should be in the end. I'm now not really involved in the direct process other than supervising the work of other animators.

When I work outside of the office, it's usually installing exhibitions. I check the overall quality of the presentation, the colors of the projection to match a standard, the projectors to see that they're evenly spaced, and the painting of the space, as it affects the appearance of the visuals. I also give feedback on the presentation to maybe improve future projects.

If it's a completely site-specific project, I go to the site and work there, doing experiments with the team. At the same time, I communicate with the Tokyo team, because certain things have to be made in Tokyo and then installed on site. For the National Museum of Singapore project, I made multiple long trips—ten days or so—at certain phases of production.

The Future of teamLab

Now teamLab has more projects, and our exhibitions have become bigger—and also successful. A lot of people have seen them. We have a huge audience all over the world. The way we create these projects, and also what we are doing, has led to the future, to some degree. At teamLab we've been trying to create the future of Japanese art within the context of Japanese culture.

Some people may think teamLab is Instagram-conscious art or light art, but in my mind teamLab pushes Japanese art forward. At the same time, what artists did in the past is continuous with what we do at teamLab. It's only that digital technology broadened our variety of expression. It's not that teamLab emerged out of thin air.

We have made or tried to create works that are relevant. We hope that we can survive the test of time. We want to continue to advance the way we create things with new technology, and we don't want to stop.

This text is edited and excerpted from an interview with Karin G. Oen on December 24, 2018, with consecutive interpretation by Kazumasa Nonaka.

BORN FROM
THE DARKNESS
A LOVING,
AND BEAUTIFUL
WORLD

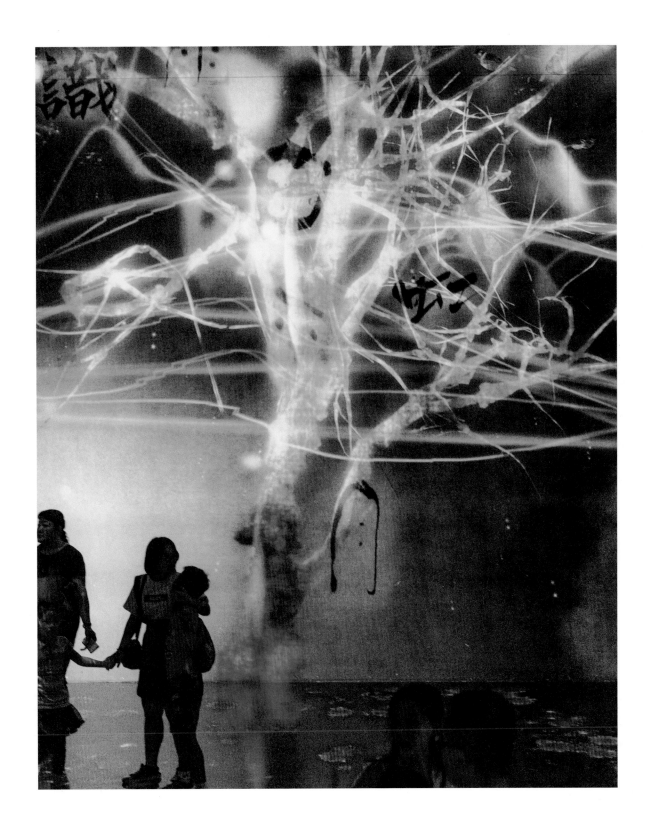

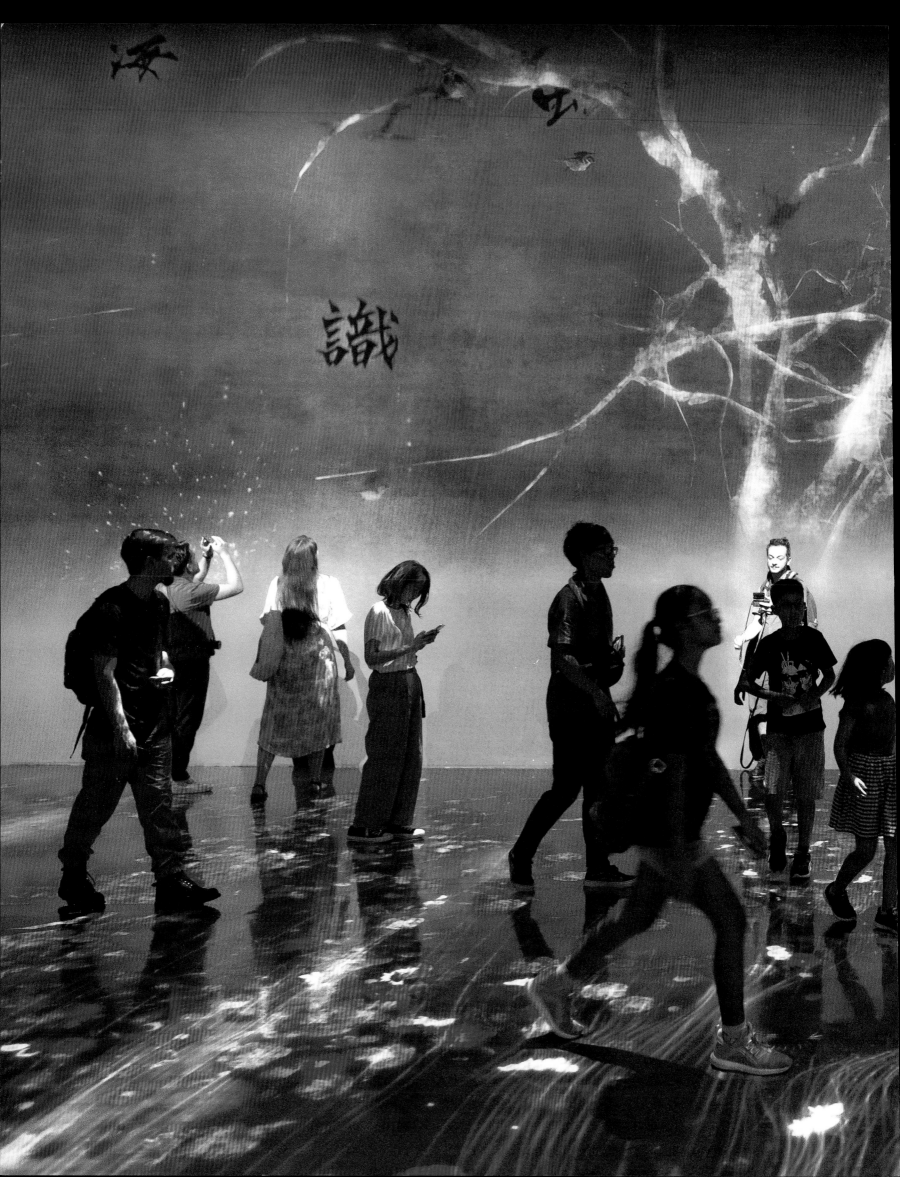

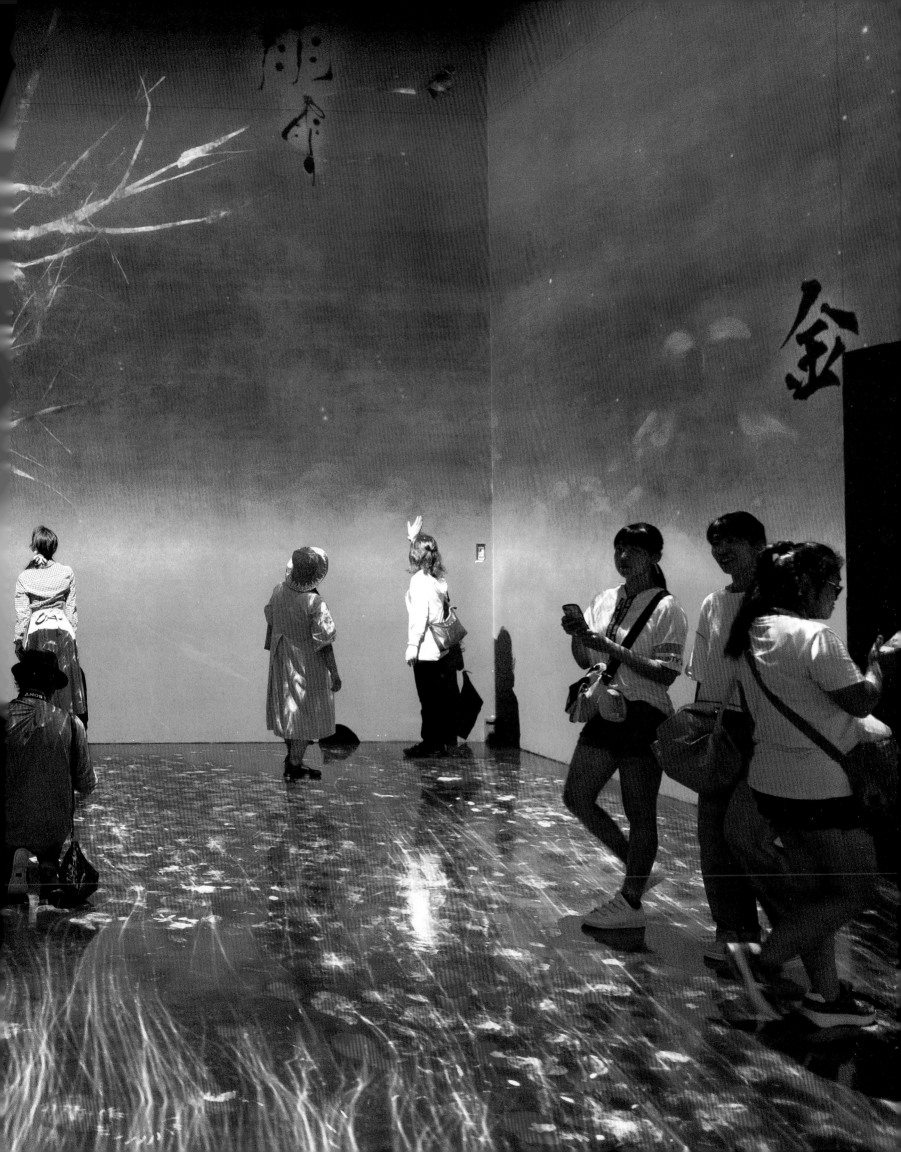

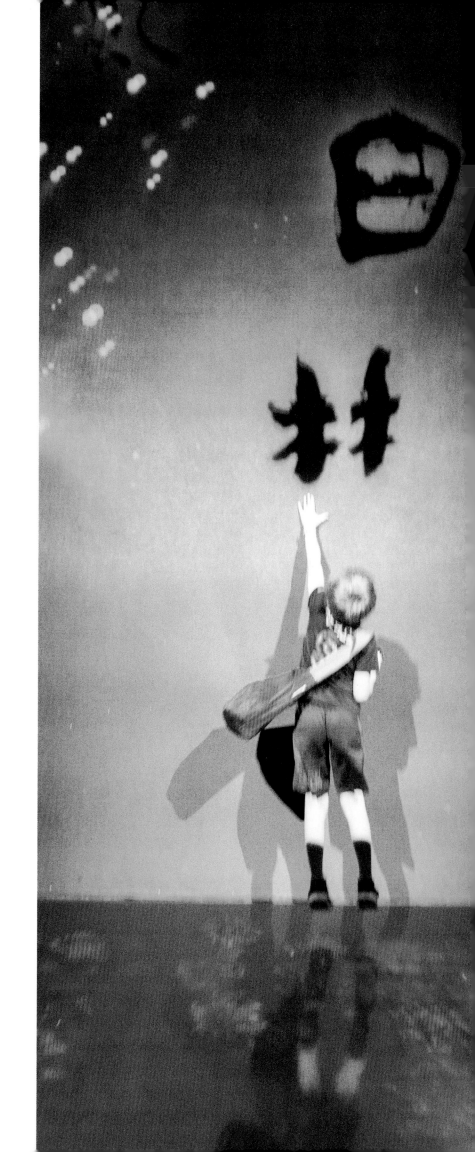

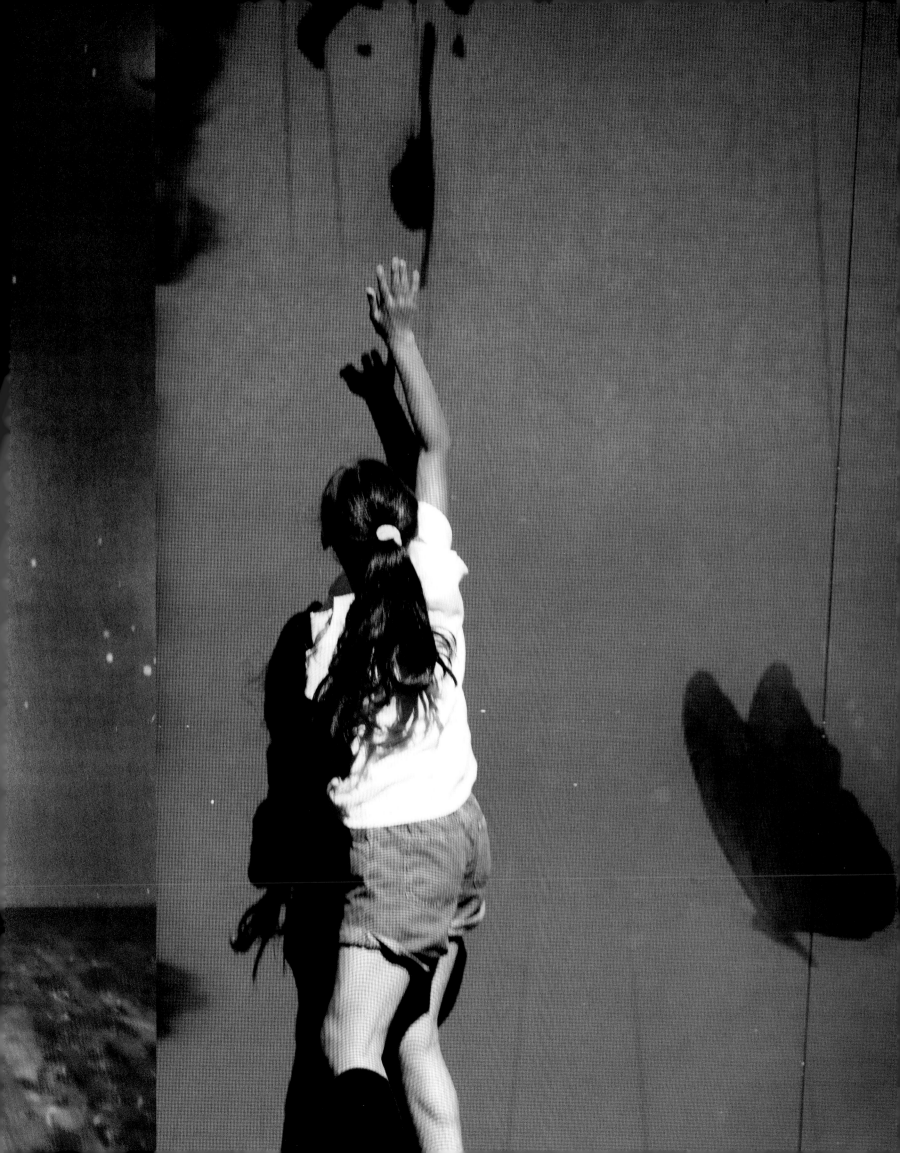

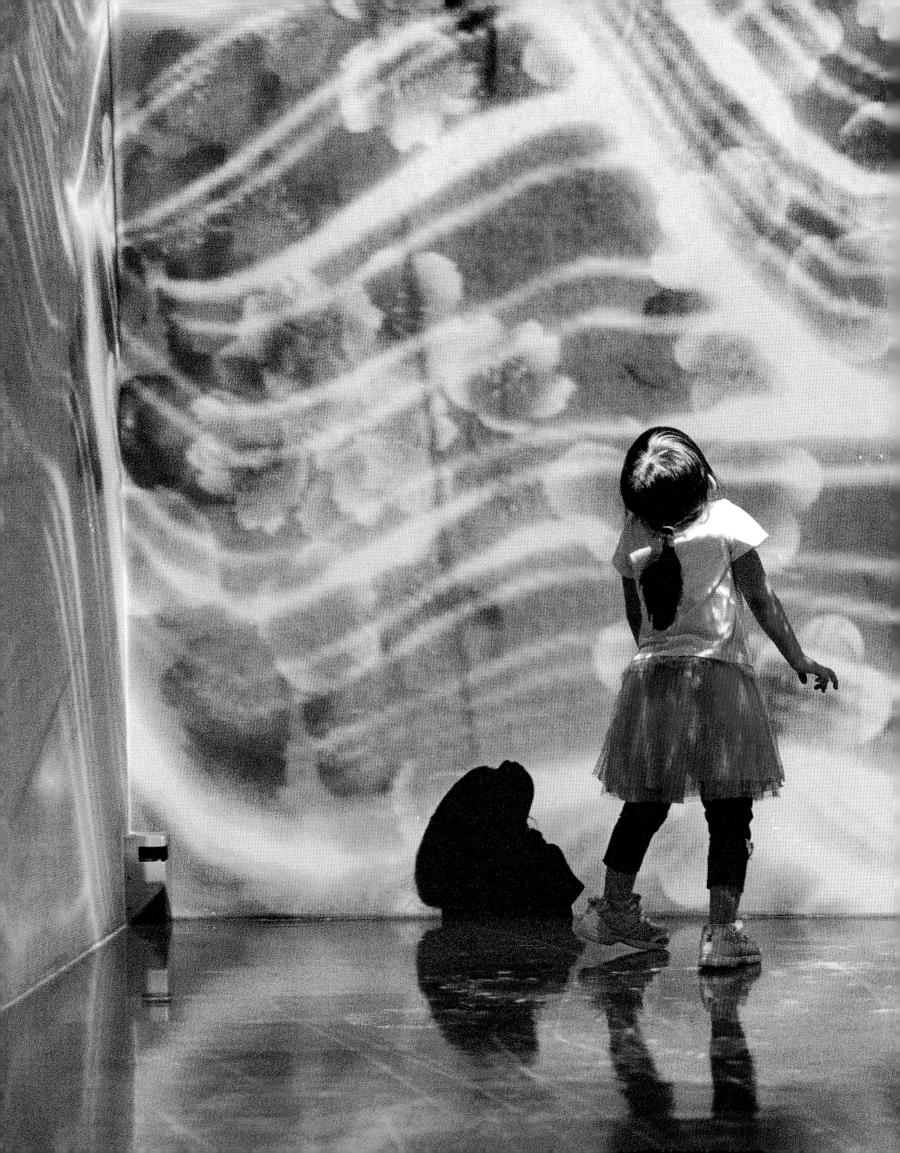

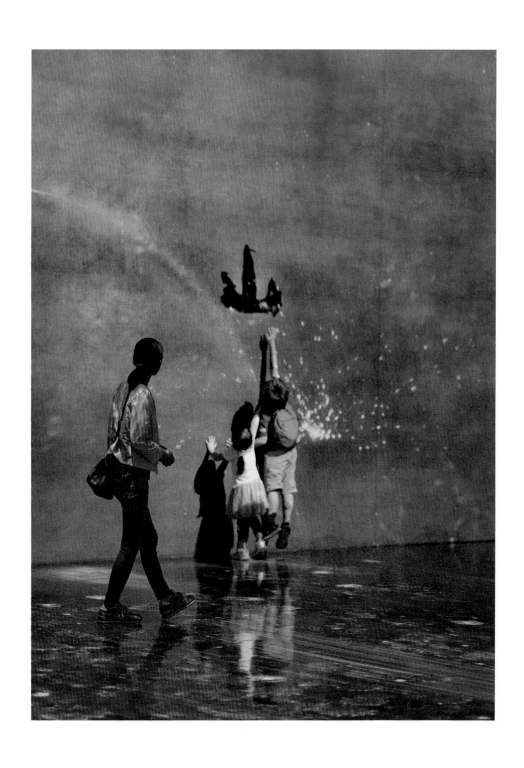

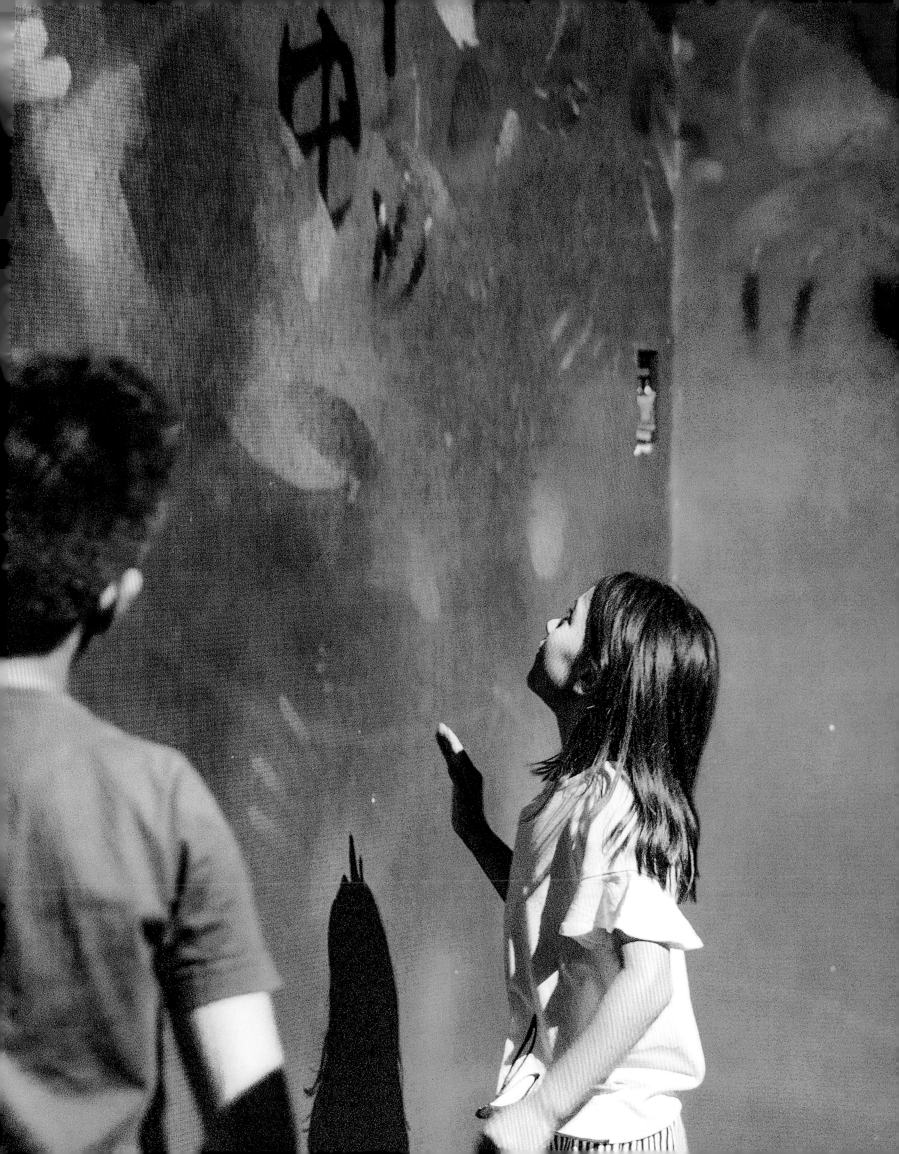

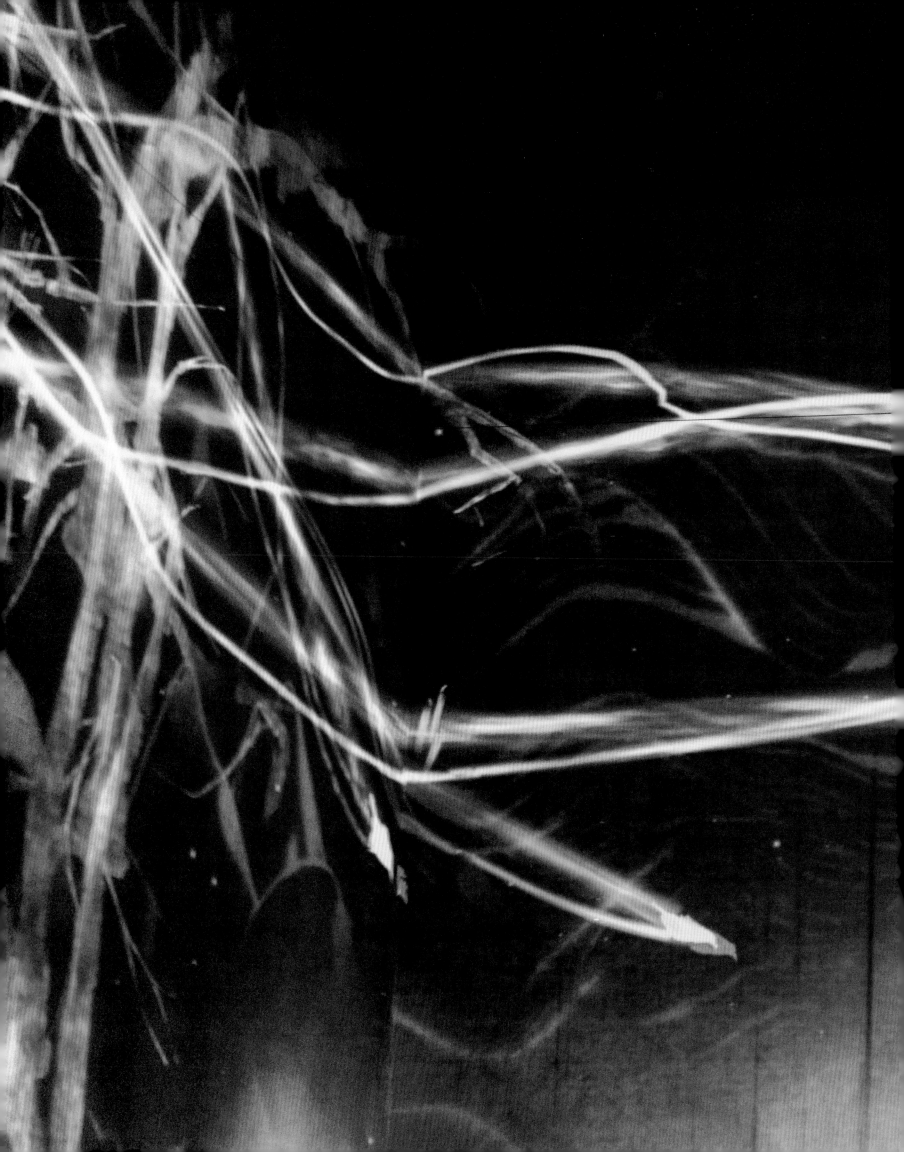

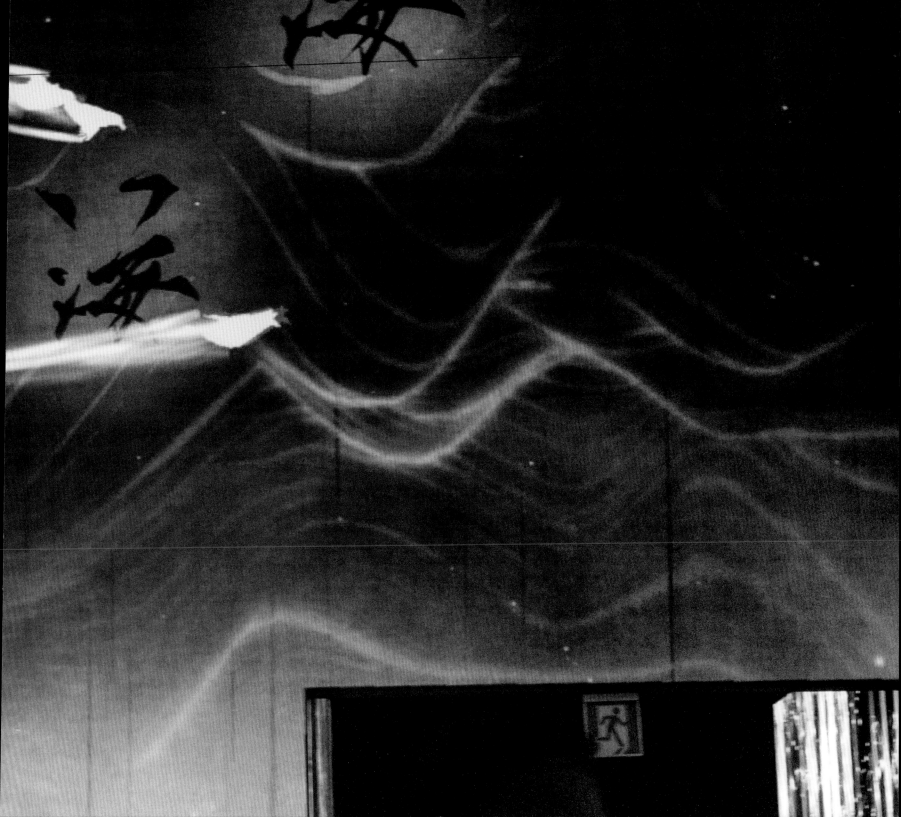

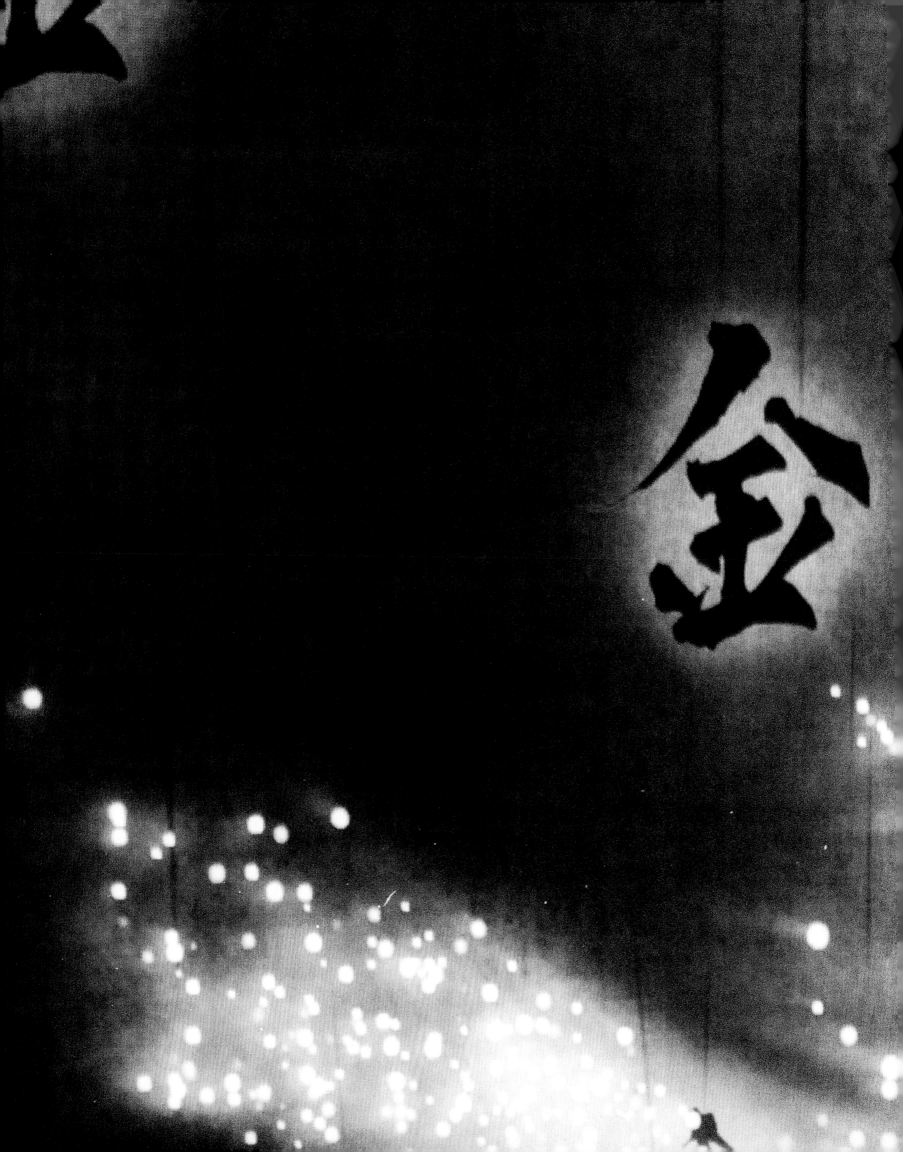

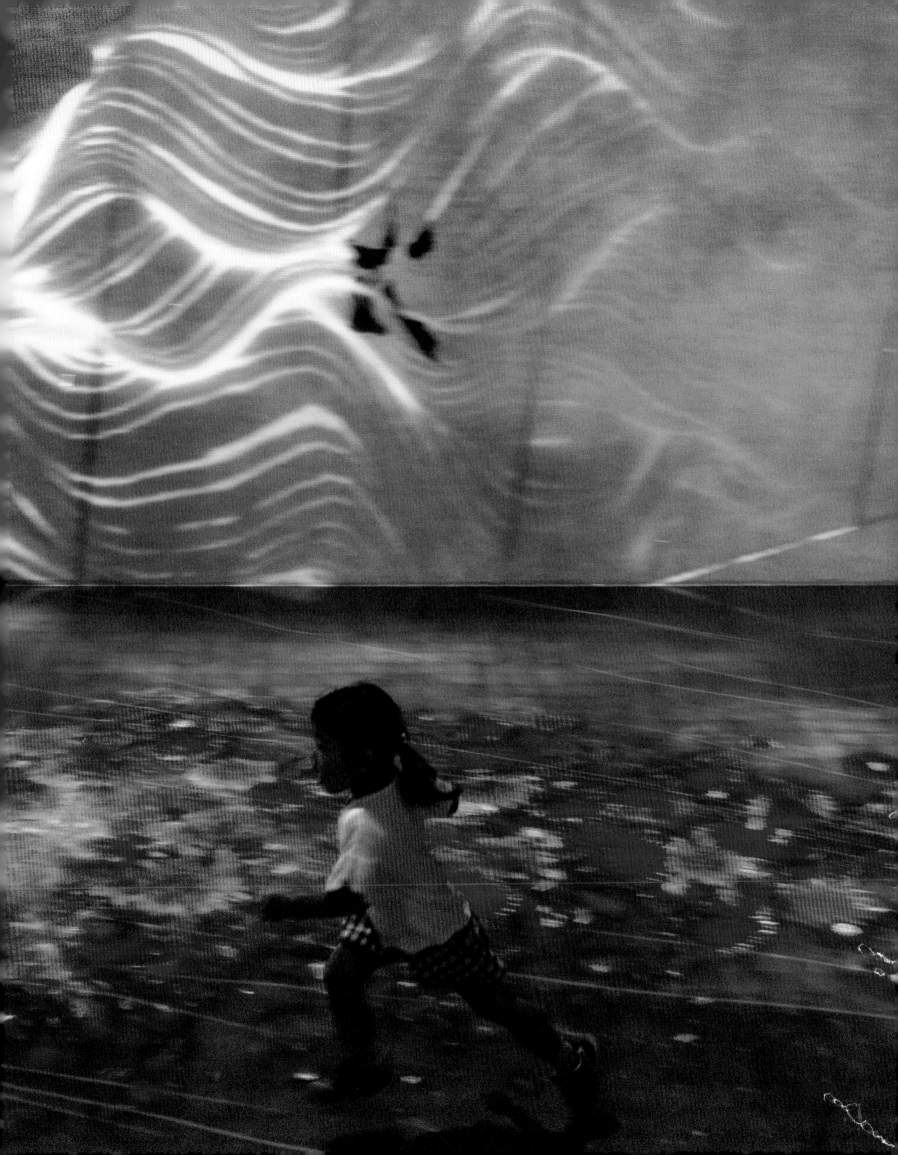

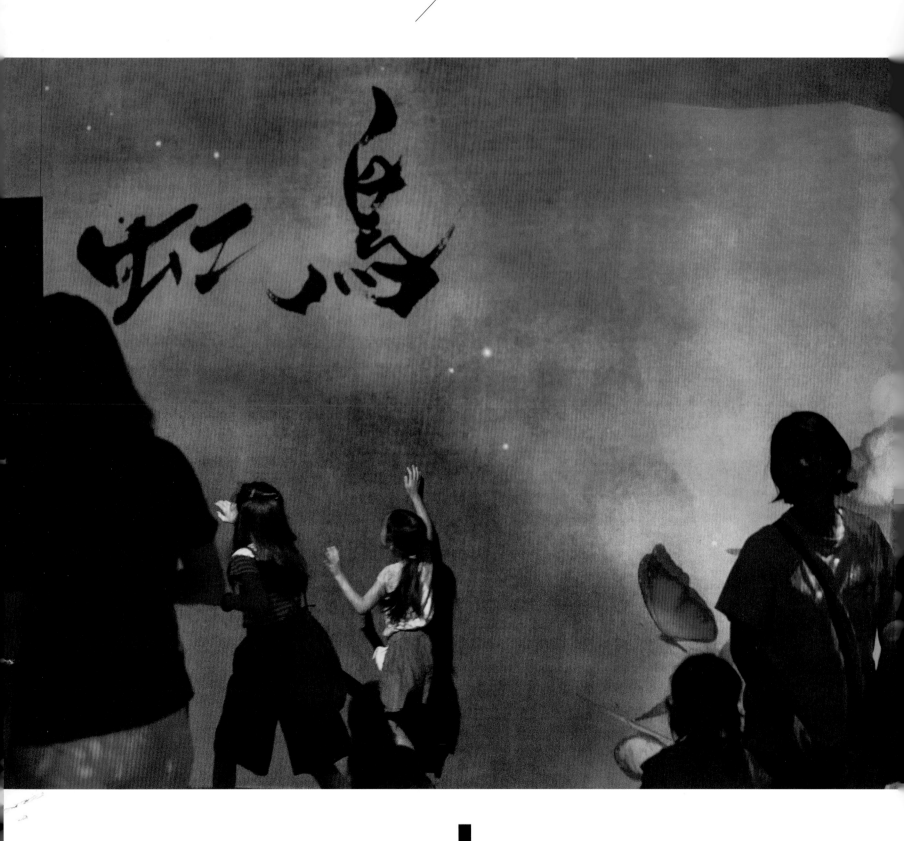

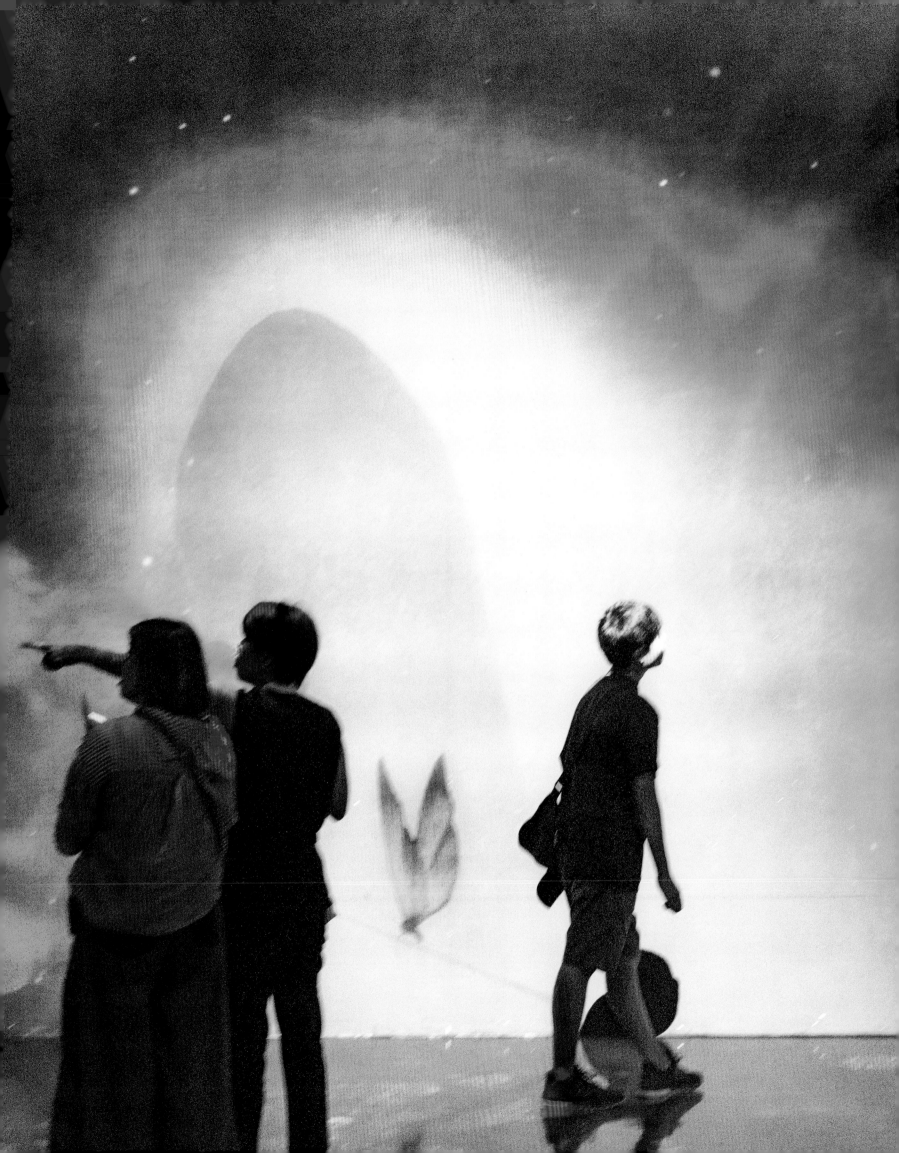

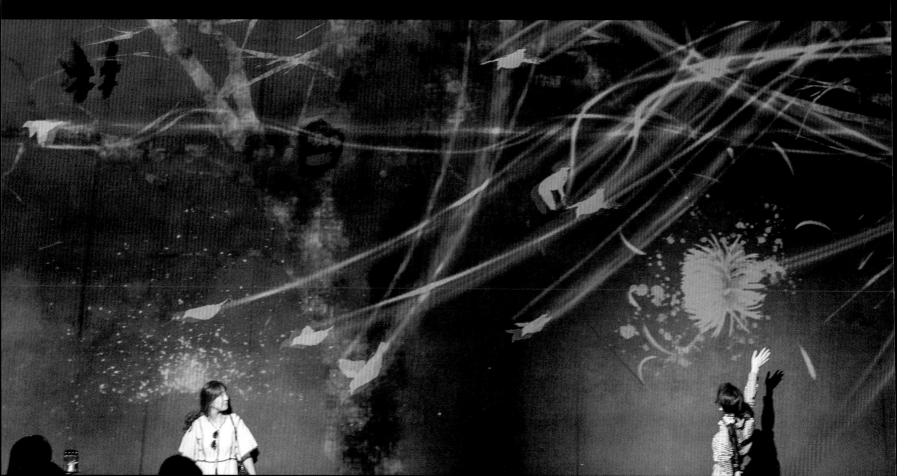

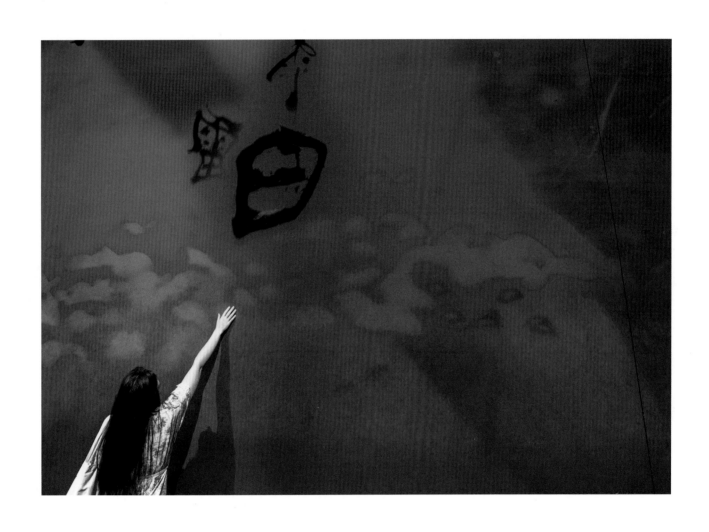

Exhibition Checklist

Forest of Flowers and People: Lost, Immersed and Reborn
2017/2020
BY teamLab (Japanese, est. 2001)
SOUND BY Hideaki Takahashi (b. 1967)
INTERACTIVE DIGITAL INSTALLATION

Sharing Stone, Transcending Space
2019/2020
BY teamLab (Japanese, est. 2001)
INTERACTIVE DIGITAL INSTALLATION

Crows are Chased and the Chasing Crows are Destined to be Chased as well, Transcending Space
2017/2020
BY teamLab (Japanese, est. 2001)
SOUND BY Hideaki Takahashi (b. 1967)
INTERACTIVE DIGITAL INSTALLATION;
4:20 MIN.

Crows are Chased and the Chasing Crows are Destined to be Chased as well, Flying Beyond Borders
2018/2020
BY teamLab (Japanese, est. 2001)
SOUND BY Hideaki Takahashi (b. 1967)
INTERACTIVE DIGITAL INSTALLATION

The Way of the Sea, Transcending Space—Colors of Life
2018/2020
BY teamLab (Japanese, est. 2001)
SOUND BY Hideaki Takahashi (b. 1967)
INTERACTIVE DIGITAL INSTALLATION

The Way of the Sea, Flying Beyond Borders—Colors of Life
2018/2020
BY teamLab (Japanese, est. 2001)
SOUND BY Hideaki Takahashi (b. 1967)
INTERACTIVE DIGITAL INSTALLATION

Reversible Rotation—Cold Light
2019/2020
BY teamLab (Japanese, est. 2001)
SINGLE-CHANNEL VIDEO

Reversible Rotation, Flying Beyond Borders—Cold Light
2019/2020
BY teamLab (Japanese, est. 2001)
DIGITAL INSTALLATION

Flutter of Butterflies Beyond Borders
2015/2020
BY teamLab (Japanese, est. 2001)
SOUND BY Hideaki Takahashi (b. 1967)
INTERACTIVE DIGITAL INSTALLATION

Born From the Darkness a Loving, and Beautiful World
2018/2020
BY Sisyu (Japanese) AND teamLab (Japanese, est. 2001)
SOUND BY Hideaki Takahashi (b. 1967)
INTERACTIVE DIGITAL INSTALLATION

All works lent by the artists

Contributors

Karin G. Oen is associate curator of contemporary art at the Asian Art Museum of San Francisco and deputy director for curatorial programs at the NTU Centre for Contemporary Art Singapore. She is co-author of *Divine Bodies: Sacred Imagery in Asian Art* (Asian Art Museum, 2018).

Clare Jacobson is former head of publications at the Asian Art Museum of San Francisco. She is a design editor and writer and author of the book *New Museums in China* (Princeton Architectural Press, 2014).

Yuri Manabe is a Tokyo-based photographer whose books include *Tokyo Fashion City* (Tuttle, 2019) and *The Tokyo Look Book* (Kodansha, 2007).

Yuki Morishima is associate curator of Japanese art at the Asian Art Museum of San Francisco. She is co-editor of *Kimono Refashioned: Japan's Impact on International Fashion* (Asian Art Museum, 2018).

Miwako Tezuka is consulting curator at Arakawa + Gins Reversible Destiny Foundation in New York.

Asian
Art
Museum

Published by
Asian Art Museum
Chong-Moon Lee Center
For Asian Art and Culture
200 Larkin Street
San Francisco, CA 94102
www.asianart.org

Library of Congress Cataloging-in-Publication Data
Names: Oen, Karin G., 1978– editor. | Jacobson,
 Clare, 1965– editor. | Manabe, Yuri, photographer
 (expression) | Morishima, Yuki, 1974– Ultrasubjective
 space. | Tezuka, Miwako. Vast ocean, a boundless sky.
 | Asian Art Museum of San Francisco, organizer, host
 institution.
Title: teamLab : continuity / edited by Karin G. Oen and
 Clare Jacobson ; with photos by Yuri Manabe ; and texts
 by Yuki Morishima and Miwako Tezuka.
Description: First edition. | San Francisco : Asian
 Art Museum, [2020] | Includes bibliographical
 references. | Summary: "The digital collective teamLab,
 founded in Tokyo in 2001 by Toshiyuki Inoko, addresses
 the line between art and experience. This group—
 comprised of more than four hundred people including
 programmers, designers, and animators—creates
 immersive digital experiences outside the realm of
 the traditional art world, navigating the confluence of
 art, technology, design, and the natural world. In many
 cases, it roots its imagery in historical Japanese art but
 uses the visual language of high-tech rendering and
 animation. Over the past few years, teamLab's projects
 have kept pace with technology and have evolved from
 two-dimensional screen-based animations to room-sized
 interactive installations. This book collects essays,
 interviews, and photographs exploring both the presence
 of teamLab's installations and the ideas and processes
 behind them"— Provided by publisher.
Identifiers: LCCN 2019040122 | ISBN
 9780939117888 (hardcover)
Subjects: LCSH: teamLab (Art collective)—
 Exhibitions.
Classification: LCC N7359.T43 A4 2020 | DDC
 709.2—dc23
LC record available at https://lccn.loc.
 gov/2019040122

Published on the occasion of the exhibition *teamLab:
Continuity* presented at the Asian Art Museum—
Chong-Moon Lee Center for Asian Art and Culture,
April–September, 2020.

teamLab: Continuity is organized by the Asian Art
Museum of San Francisco. Presentation is made possible
with the generous support of Diane B. Wilsey, Karla
Jurvetson, M.D, and an anonymous donor. Additional
support is provided by Ann and Paul Chen, Sakurako and
William Fisher, Beverly Galloway and Chris Curtis, and the
Henri and Tomoye Takahashi Charitable Foundation. This
exhibition is a part of *Today's Asian Voices,* which is made
possible with the generous support of Salle E. Yoo and
Jeffrey P. Gray. Sustained support generously provided by
the following endowed funds: Akiko Yamazaki and Jerry
Yang Endowment Fund for Exhibitions; Kao/Williams
Contemporary Art Exhibitions Fund.

The Asian Art Museum—Chong-Moon Lee Center for Asian
Art and Culture is a public institution whose mission is to
lead a diverse global audience in discovering the unique
material, aesthetic, and intellectual achievements of Asian
art and culture.

Produced by the Publications Department, Asian Art
Museum
Clare Jacobson, Head of Publications
Proofread by Ruth Keffer

Additional editorial assistance by Kazumasa Nonaka of
teamLab

Cover: Light Sculpture Space
ii: *Forest of Flowers and People*
iv: *Flutter of Butterflies Beyond Borders*
42, 96: *Crows are Chased and the Chasing Crows are
Destined to be Chased as well*

Images Credits
All images, unless otherwise noted, © Yuri Manabe.
Photographed at *teamLab Borderless,* Tokyo, and in the
teamLab office, Tokyo, in May and July, 2019.
x–13, 50, 51, 100–102: © teamLab
18, 19, 68, 69, 92, 93, 122, 123, 126, 127: © Karin G. Oen
44: Photograph © Asian Art Museum of San Francisco
46–47, 48: Wikimedia
46b: The Tokugawa Art Museum, © The Tokugawa Art
Museum Image Archives / DNPartcom
98–99: Courtesy of Kyoto National Museum
103: Photo by Yasunari Kikuma
104–105: Spencer Collection, The New York Public Library.
"Scroll3_26" New York Public Library Digital Collections.
Accessed February 24, 2019. http://digitalcollections.nypl.
org/items/510d47e1-da4a-a3d9-e040-e00a18064a99.

Distributed by:
North America, Latin America, and Europe
Tuttle Publishing
364 Innovation Drive
North Clarendon, VT 05759-9436 U.S.A.
Tel: 1 (802) 773-8930; Fax: 1 (802) 773-6993
info@tuttlepublishing.com
www.tuttlepublishing.com

Asia Pacific
Berkeley Books Pte. Ltd.
61 Tai Seng Avenue #02-12
Singapore 534167
Tel: (65) 6280-1330; Fax: (65) 6280-6290
inquiries@periplus.com.sg
www.periplus.com